THE COMPLETE BOOK OF
Calligraphy & LETTERING

THE COMPLETE BOOK OF

Calligraphy

& LETTERING

TABLE OF CONTENTS

CALLIGRAPHY: A BRIEF HISTORY

The beginning of Western calligraphy dates back more than 2,000 years. Early writing was done with brushes as well as reed and quill pens, and calligraphers, or "scribes," used stone, clay tablets, papyrus, and animal skins as writing surfaces. Our modern alphabet has its roots in ancient Rome, where early inscriptions in stone feature all the capital letterforms we recognize today.

During the medieval era, manuscripts, which had been previously copied only by monks, began to be produced in professional workshops. Trained scribes executed the calligraphy, and illumination artists added decorations and gilding (or gold leaf). As reading became more common, demand for personal prayer books increased. Thousands of copies of the devotional Book of Hours were made, and many pages from these books can still be found at antiquarian book markets.

In the 15th century, the invention of the movable type printing press eliminated the need to copy books manually, so calligraphy soon fell into general disuse. But the printing press also was responsible for elevating calligraphy to a specialized art form, encouraging scribes to refine their skills and develop instruments that could match the intricacy produced by engravers of copper printing plates. The elaborate flourishes and fine handwork of the copperplate style continued through Victorian times.

The modern revival of calligraphy was sparked in the early 20th century during the Arts and Crafts Movement. There are calligraphers teaching today who can trace their "lineage" back to teachers such as Edward Johnston and Rudolph Koch. During the 1970s, Donald Jackson, scribe to the Queen of England, conducted workshops in the United States that generated intense interest in calligraphy. Inspired by his visit, lovers of the art form founded a number of guilds that continue to be active today. Now there is even an international community of Internet calligraphers called "Cyberscribes," which began in the 1990s.

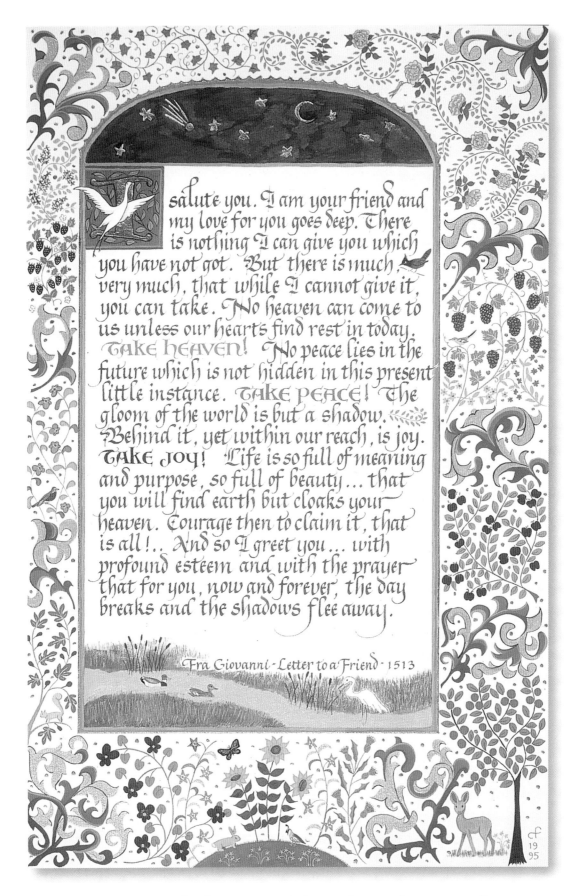

Looking to the Past A study of Fra Giovanni's famous historical manuscript, "Letter to a Friend" by Cari Ferraro. Ferraro adapted the border from the illumination used in the Book of Hours to create this piece of artwork.

PART 1
TRADITIONAL CALLIGRAPHY

Chapter 1
INTRODUCTION TO CALLIGRAPHY

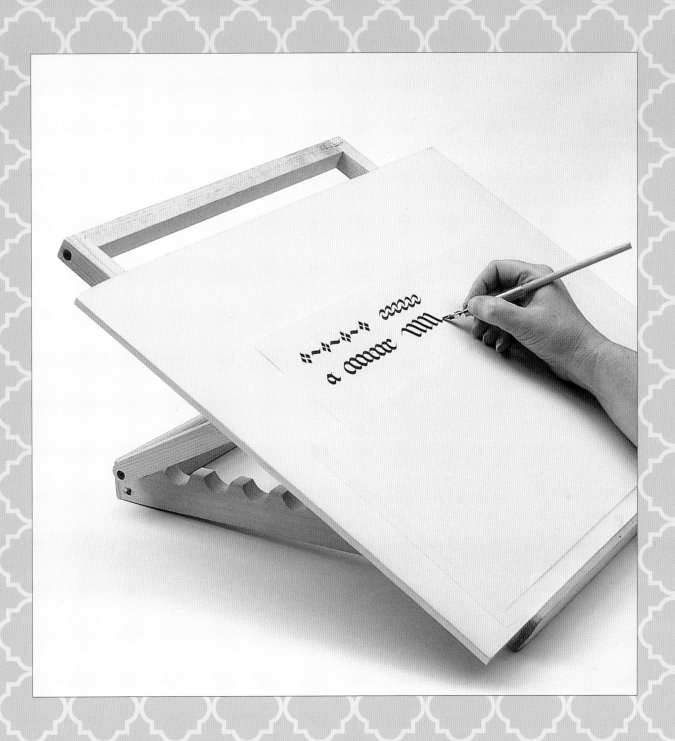

TOOLS & MATERIALS

You have many choices when selecting writing tools for hand lettering. Pencils are often used for layout, but you can use a pointed brush, broad-edged brush, pointed pen, broad pen, ruling pen, parallel pen, or markers for the letters. These tools can be used interchangeably, meaning that you can use the ruling pen instead of the pointed brush for a variation on any of the alphabets, depending on your skill level. Some tools have to be modified or prepared. Artists and craftsmen of the past did this routinely, but now we expect to go to the art supply store, remove a tool from its packaging, and have it work exactly the way we want it to.

Pens, brushes, and inks are not all created equal. There are no industry standards. Additionally, we each have our own preferences. Each tool has a cost-to-benefit ratio. You will be more comfortable with some than you will be with others. Experiment with different brands to discover your personal preferences.

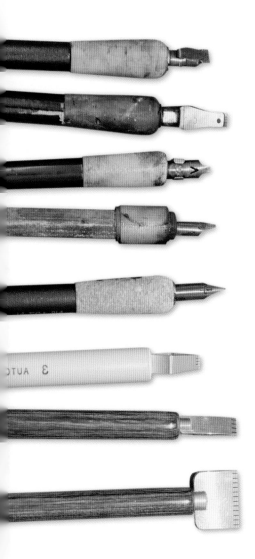

PENS

Broad-Edged Pens

The broad-edged pen may be the easiest of lettering tools for beginners. It's popular because of the natural thick-and-thin ribbon it makes, which has been adapted to the Western alphabet. Broad-edged pens come in the form of dip pens for calligraphy, automatic pens for larger letters, and fountain pens. Broad-edged pens (sometimes called flat pens) can be used for many of the styles in this book; however, you may have to do a little manipulation with them to achieve some of the desired effects.

Pointed Pens

Pointed pens do not automatically produce thick and thin lines, but rather rely on pressure from the writer to produce variation in line weight. Pointed pens are made from different metals and have differing amounts of flexibility. Preferences vary, so you will have to try both. The White House employs calligraphers that use the pointed pen to create beautiful work for presidential affairs. It can also be used for informal work, but the downside is that it takes a lot of time to learn to control. Line weight variations depend on adding and releasing pressure, so the nibs have a tendency to catch on paper fibers and splatter. This pen requires patience.

Ruling Pens

This is a forgiving tool and can be quite fun. A ruling pen has a knob on its side that you can turn to move the blades closer together, which produces a thin line, or farther apart to increase the flow of ink. They create forms that seem random and free—the opposite of traditional calligraphy. You can vary the weight of line by changing from the side to the tip. It is a highly versatile tool, thus I recommend that you have several. You may purchase new ruling pens, but you can also find a variety of shapes and sizes in antique stores, as they used to be part of drafting sets. Ironically, ruling pens were designed to draw very precise lines, but now they are part of every calligrapher's tool kit as a tool that liberates and allows for experimentation. The downside is that you must learn to put the components together correctly or you could end up with a mess.

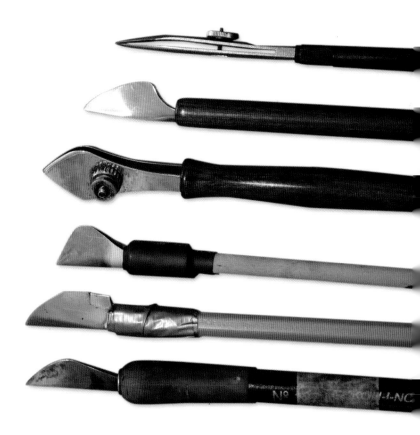

BRUSHES

Pointed Brush

The pointed brush may be the most versatile lettering tool available. It comes in a wide variety of shapes, sizes, and bristle lengths. Like the ruling pen, the pointed brush is a wonderfully expressive tool open to wide variation. The characteristic "brushmark" is highly desirable. You can create work that has interesting texture and line with little practice, yet it can be challenging to exert control and produce consistent work. Many people turn to this brush to create illustrations or logos just for the mark-making element, even though they plan to digitally manipulate the strokes.

Broad-Edged Brush

The broad-edged brush is a versatile tool that shares the comfort of the broad pen but is good for surfaces that are not pen friendly, like fabric or thin Japanese paper. It's also a good tool for creating large letters, especially on a wall. The downside is that it has a fairly high learning curve and is not ideal for beginners. Broad-edged brushes have a ferrule (the part of the brush that holds the bristles onto the handle) that is either flat or round.

Inks & Pigments

Inks and pigments fall roughly into dye-based, pigment-based, and carbon-based categories. Carbon and pigment come mixed with water and binder. Some are waterproof, but they use a binder that is not generally good for your tools, so be careful. Carbon-based inks are permanent and don't fade over time. You can also grind your own ink with an ink stone and a Chinese or Japanese ink stick. Higher quality produces better ink, and one ink stick can last for many years, so they are very economical. You can control the density and blackness with this method, and there are no harmful additives or shellac as there sometimes are in store-bought bottled inks. Dye-based inks should be used for practice because they are loose, which can lead to an interesting effect in writing. They will not clog your pen, but your work will fade over time.

Other pigments you might use are gouache, watercolor, and liquid acrylics. Gouache and watercolor are similar, although gouache is more opaque and dries to a velvet flat finish. Watercolors are transparent and are good when you want to see some variation in the color.

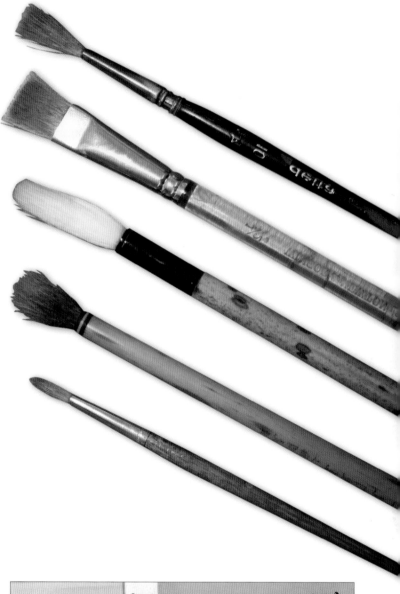

Chinese writing brushes, ink stick, and ink stone

NIBS

Nibs (also called "points") are writing tips that are inserted into the end of a pen holder. Nibs come in a variety of shapes and sizes, depending on the task they are designed to perform— each releases the ink differently for a unique line quality. For example, the italic nib has an angled tip for producing slanted letters, whereas the roundhand nibs feature flat tips for creating straight letters. Keep in mind that nib numbers can vary in size from brand to brand.

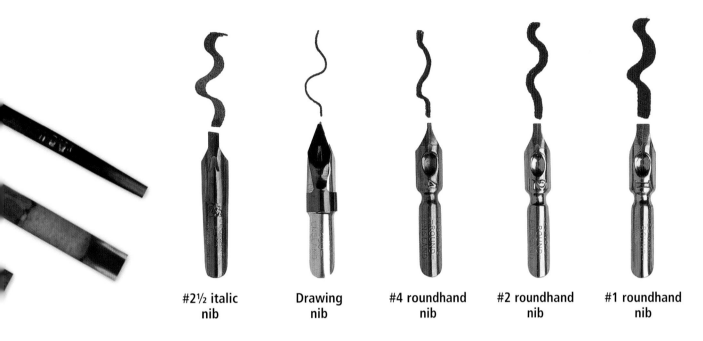

| #2½ italic
nib | Drawing
nib | #4 roundhand
nib | #2 roundhand
nib | #1 roundhand
nib |

RESERVOIR

A reservoir (pictured at right) is a small metal piece that slides over the nib to help control the flow of ink from the nib for smooth writing. Each brand of nib will have its own particular reservoir.

PEN HOLDER

The broad end of a pen holder has four metal prongs that secure the nib. The tool should be held like a pencil, but always make sure to hold it so that the rounded surface of the nib faces upward as you stroke.

ASSEMBLING THE PEN

Calligraphy pens are simpler than they appear. Their design is centuries old, and need not be improved upon. They consist of a handle, nib, and reservoir (which can be removed for easy cleaning). Most handles are a standard size, but it is a good idea to purchase your nibs and pen holder from the same manufacturer to ensure that they will fit.

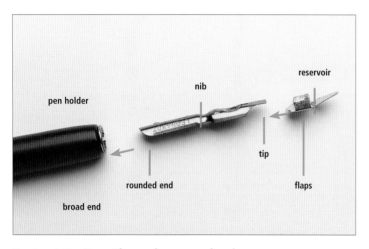

Parts of the Pen Shown here are the three components needed to assemble the pen: the pen holder, the nib, and the reservoir. As indicated by the arrows, the nib slides into the pen holder, and the reservoir slips over the nib.

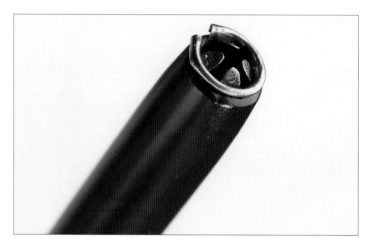

The Pen Holder The pen holder grips the nib with four metal prongs. These prongs are made of thin metal and can be manipulated to better hold the nibs after they warp from use. Gently press the prongs toward the outer ring of the pen holder for a tighter fit.

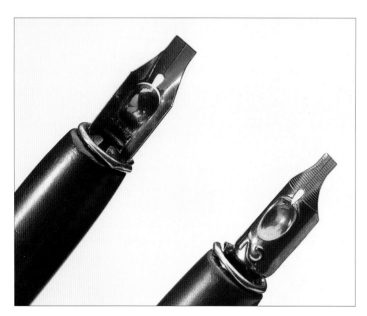

Inserting the Nib Slide the rounded end of the nib into the area between one of the metal prongs and the outer ring of the pen holder until it fits snugly and doesn't wobble. If your nib wiggles, remove it, rotate the pen holder a quarter turn, and slide in the nib. The pen at left shows the nib from beneath, and the pen on the right shows the nib from above.

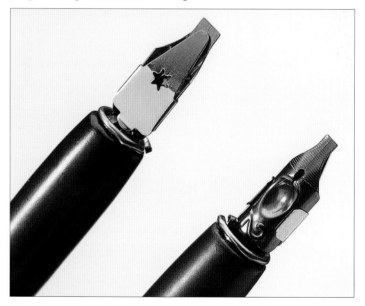

Attaching the Reservoir The gold-colored reservoir slips over the nib, cupping the underside to create a "pocket" for the ink and touching the nib near the tip to control the ink flow (left). The two flaps of this piece slide over the sides of the nib, as shown on the right. (Note that the drawing nib comes with an attached reservoir.)

SETTING UP YOUR WORK AREA

ARRANGING MATERIALS

Right-handed scribes using a dip pen should place everything on the right; however, when filling a pen with a brush, your palette or ink should be on the left. Left-handed scribes should reverse the position of the materials.

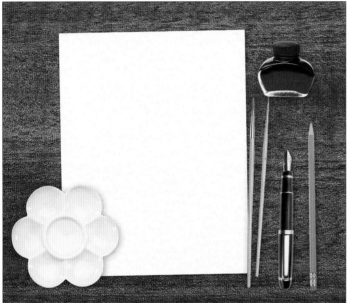

Right-handed scribes

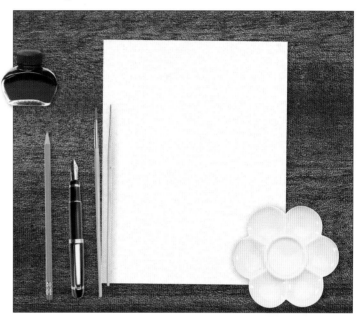

Left-handed scribes

DEVELOPING GOOD HABITS

To maintain your comfort level, take frequent breaks to relax your hands, back, and eyes. As you are lettering, move the paper from right to left to keep your working hand centered in front of your eyes. Clean your pen by dipping just the tip of the nib in water and wiping it dry, even if you're just stopping for a few minutes.

PREPARING THE BOARD SURFACE

Tape a few sheets of blotter paper, newsprint, or paper towels to the board to form a cushion under the paper. This gives the pen some "spring" and will help you make better letters. You also can work on top of a pad of paper for extra cushion. To protect the paper, place a guard sheet under your lettering hand, or wear a white glove that has the thumb and first two fingers cut off. This protects the paper from oils in the skin, which resist ink.

POSITIONING THE WORK SURFACE

A sloping board gives you a straight-on view of your work, reducing eye, neck, and shoulder strain. The work surface affects the flow of ink—on a slant, the ink flows onto the paper more slowly and controllably. To prevent drips during illumination, you will need to work on a relatively flat surface. Practice lettering at different angles.

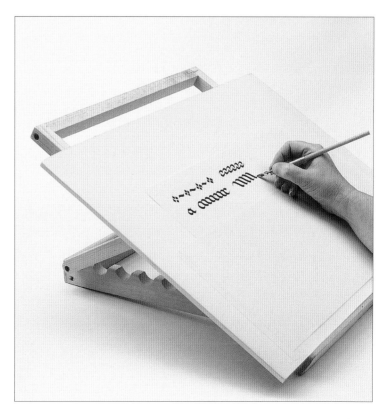

GETTING STARTED

Dip pens require a little preparation and maintenance, but when properly handled, they are long-lasting tools. Before you jump into writing, you'll need to learn how to assemble, load, manipulate, and clean a dip pen. Have a stack of scrap paper handy, and take time to become familiar with the unique character of the marks made by each nib.

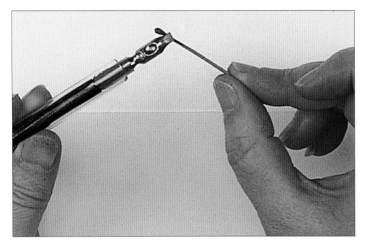

Preparing New Pen Nibs New nibs are covered with a light coating of oil or lacquer and need preparation to make the ink or paint flow properly. Wash new nibs gently with soapy water, or pass the tip of the nib through a flame for a few seconds, as shown; then plunge it into cold water.

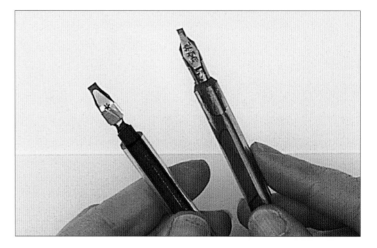

Adjusting the Reservoir After slipping the reservoir onto the nib, adjust it (using fingers or pliers) so that it's about 1/16" away from the tip (too close interferes with writing; too far away hinders the ink flow). If it's too tight, you'll see light through the slit while holding it up to a light source.

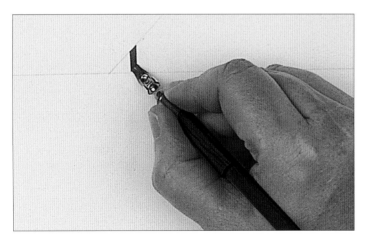

Understanding Pen Angle The angle of the flat end of the nib to a horizontal line is known as the "pen angle." It determines the thickness of the line as well as the slant of stroke ends and serifs (small strokes at the end of letters). For most lettering, you'll use an angle of 30 degrees to 45 degrees.

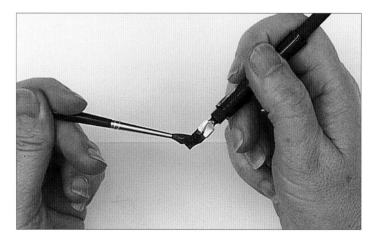

Loading the Pen It is best to use a brush or dropper to load the nib; if you dip your nib into the ink, you are more likely to start every stroke with a blob of ink. Regardless of how you load your pen, it's always a good idea to test your first strokes on scrap paper.

TIP
If you choose to dip the nib rather than load it with a brush, hold the nib against the side of the palette well (or ink bottle) to drain off the excess after dipping.

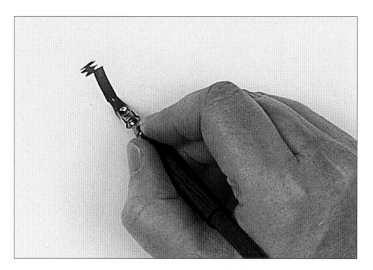

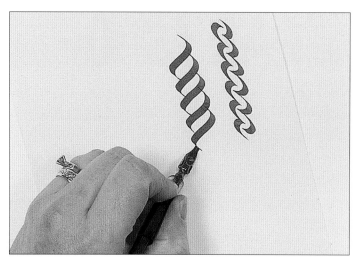

Making Even Strokes First get the ink flowing by stroking the pen from side to side, making its thinnest line, or by rocking it from side to side. Keep your eye on the speed and direction of the pen as you move it. Apply even pressure across the tip to give the stroke crisp edges on both sides.

Techniques for Left-Handed Scribes To achieve the correct pen angle, you can either move the paper to the left and keep your hand below the writing line or rotate the paper 90 degrees and write from top to bottom. (You'll smear the ink if you write with your hand above the writing line.)

UNDERSTANDING THE BROAD PEN

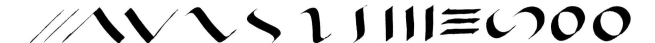

Practice Basic Shapes Start by making simple marks as shown above, and keep the pen angle constant to create rhythm. Pull your strokes down; it is more difficult to push your strokes, and doing so may cause the ink to spray from the nib. Practice joining curved strokes at the thinnest part of the letter, placing your pen into the wet ink of the previous stroke to complete the shape.

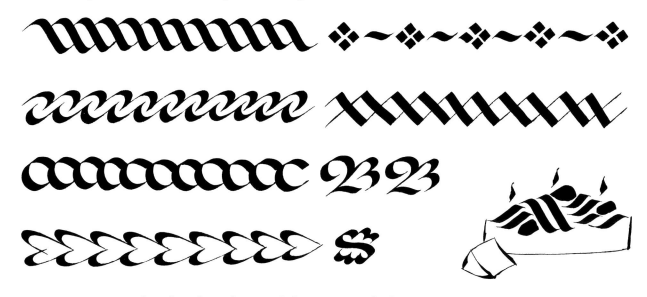

Draw Decorative Marks Medieval scribes often used the same pen for lettering as they used to decorate the line endings and margins of their texts. The broad pen can be used like any other drawing tool; practice drawing a variety of shapes to learn more about the pen's unique qualities. For instance, turn the paper to create the row of heart-shaped marks.

PARTS OF LETTERS

This diagram will familiarize you with the terms used throughout the rest of the book. As you can see below, the various stroke curves and extensions of calligraphic lettering all have specific names—refer to this page when learning how to form each letter. Below you'll also see the five basic guidelines (ascender line, descender line, waist line, baseline, and cap line), which will help you place your strokes. (See page 21 for more information on ruling guidelines.)

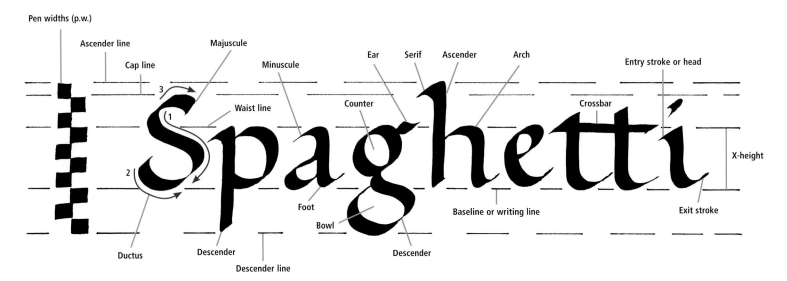

FORMING THE LETTERS

The term *ductus* refers to the direction and sequence of the strokes, which are indicated throughout with red arrows and numbers around the *exemplars* (or letter examples). Broad pen letters are formed with a series of separate strokes, so it's important to follow the recommended ductus while learning. However, with experience, you'll develop your own shortcuts to forming the letters.

LEARNING PROPER TERMINOLOGY

The terms "uppercase" and "lowercase" come from the era of hand-set type, when individual metal letters were stored in shallow cases; therefore, these terms should not be used in calligraphy. It's better to use the terms "majuscules" (for uppercase letters) and "minuscules" (for lowercase letters). Also avoid using the term "font," which generally refers to computer-generated letters; when referring to different hand-lettered alphabets, use the term "style" or "hand."

PREPARING THE PAPER

No matter what your skill level, you'll usually need guidelines when doing calligraphy. Without these helpful marks, your writing can lose the rhythm, consistency, and visual alignment that make calligraphy so pleasing to the eye. Follow the steps below to prepare your writing surface with all the necessary guidelines. Remember that you can easily erase light pencil lines when finished, removing any trace of them from your completed work.

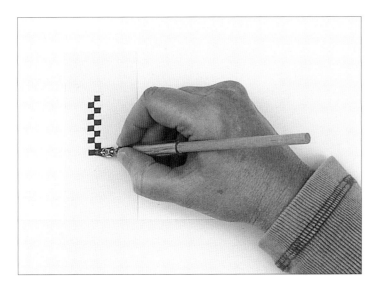

Make a Paper Ruler On a small piece of paper, mark a series of short pen-width lines, as shown. Turn the pen 90 degrees and begin at the base line, forming a set of stacked squares. Using the pen width as the unit of measurement will keep your letter height in proportion with the line thickness. Each practice alphabet has a designated pen width (p.w.) height, indicating the number of squares needed.

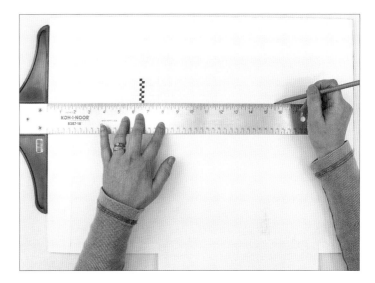

Mark the Guidelines Place the paper ruler along the edge of your paper and use it to position horizontal guidelines across the paper. A T-square is easier to use than a regular ruler, as you can draw guidelines that are perfectly perpendicular to the vertical edge of your paper. Mark the baseline, waist line, ascender line, descender line, and cap line (if working with majuscules).

IMPROVE YOUR LETTERING WITH PRACTICE

- Warm up your arm and hand first to gain a sense of control, and remember to take frequent breaks.
- Begin each exercise with the largest nib; this makes it easier to see the contrast between thick and thin strokes created by the broad pen.
- Use smooth, lightweight, translucent paper with a sheet of guidelines placed beneath it for practice.
- Choose the lettering style you like best to practice first. The examples in this section are some of the easiest to learn and require the least pen manipulation or twisting of the pen holder.
- Practice lettering and establishing a rhythm by writing an o or n between each letter. As soon as you feel comfortable forming letters, start writing whole words.
- Directly trace the letter shapes using a scan or photocopy to practice; this is helpful for beginners and may help you better understand pen angle. Each style page (pages 44-65) indicates at what percentage the letters have been reproduced. Simply enlarge the letters to 100% on a photocopier for tracing purposes. (For example, if the letters are at 75%, divide 100 by 75. When you get the answer—1.33—convert this to a percentage [133%] and copy your letters at this size.)
- Calligraphy, like dance or yoga, requires practice to achieve grace and flow. Relax and enjoy a peaceful time as you train your hand to shape each letter.

Chapter 2

BASIC CALLIGRAPHY STYLES

//

SANS SERIF

Sans Serif is a basic, simple letter style that is quite easy to execute with a broad-tipped pen (such as the #1 roundhand). It is a thick-and-thin Roman alphabet without serifs.

The vertical down stroke and horizontal strokes are made with a firm wrist action; the curved strokes are guided with the fingers. The pen angle is 35° with no rotation of the pen.

Below, the various elements of Sans Serif have been broken down into separate practice strokes. Practice these basic strokes until you feel comfortable with your pen. The angle of the pen creates the thick-and-thin characteristic of the letterforms—little pressure is needed.

PRACTICE STROKES

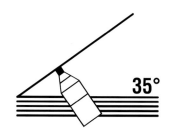

MAJUSCULES

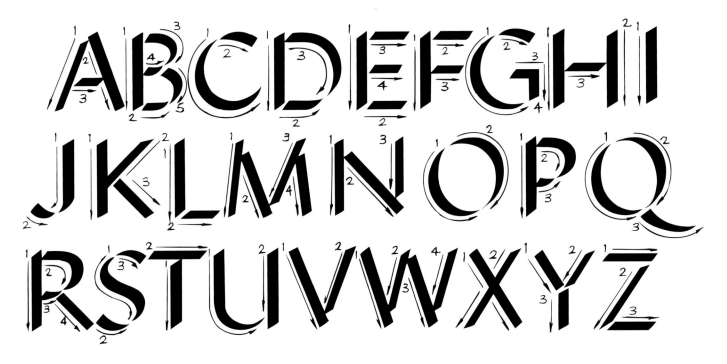

MINUSCULES

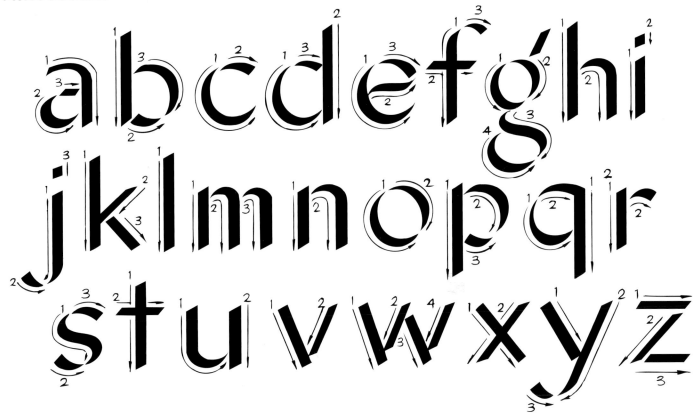

MAJUSCULES

ABCDEFGHI
JKLMNOPQ
RSTUVWXYZ

MINUSCULES

abcdefghi
jklmnopqr
stuvwxyz

ROMAN

Roman letters are the foundation for many of the alphabets we use today. Roman stone cutters and scribes developed the classic form. There are many variations of the Roman alphabet, but the basics remain unchanged.

The Roman majuscules are made with a pen angle of 30°. The serifs are executed by first making an almost horizontal stroke across the bottom of the letter. Then the pen is arced to the right and then to the left to finish the serif. A short vertical stroke with the pen edge is made and then filled in to finish letters C, E, F, G, L, T, and S.

The elements of the Roman alphabet have been broken down into separate practice strokes. First practice the strokes and serifs, and then practice the actual letterforms.

PRACTICE STROKES

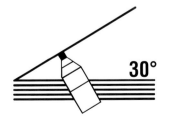

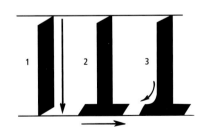

SERIF DETAIL

1. Pull the stem stroke to the guideline.

2. Make a short horizontal stroke.

3. Place the pen tip on the stem and swing an arc to the left.

ABCDEF
GHIJKLM
NOPQRS
TUVWX
YZ ROMAN

CHANCERY CURSIVE

Chancery Cursive is a favorite with calligraphers because of its beauty, function, and speed of execution. Chancery Cursive is an italic letter style that is ideal for manuscripts, poetry, diplomas, awards, testimonials, or any situation requiring a mass of copy. The beautiful form blends well with most calligraphic alphabets. The majuscules can provide distinctive flourishing at the beginning of a piece.

Chancery Cursive lends itself beautifully to the broad-tipped pen. The letter shapes are tall, rather than fat. The pen angle is 45° and the letter stroke is 10° to 15° off the vertical. The pen does most of the work and little pressure is needed.

Below are the broken-down elements used to create each letter of the Chancery alphabet. Practice these strokes, and then follow the sequences to execute the actual letterforms.

PRACTICE STROKES

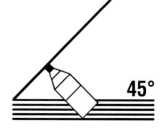

45°

MAJUSCULES

A B C D E F G
H I J K L M
N O P Q R S T
U V W X Y Z

MINUSCULES

a b c d e f g h i
j k l m n o p q r
s t u v w x y z

BATARDE

Batarde is a beautiful angular alphabet that was developed in France during the 15th century. Batarde is a natural for the broad-tipped pen. It is a very angular form and the strokes are made with little difficulty. It is best to use one of the broad-tipped pens to achieve the sharp ribbon effect.

The pen is held at a 30° angle. The majuscules are quite wide and contrast well with the tightly packed minuscules. Batarde combines beautifully with Chancery Cursive and other italics.

Again, use the practice strokes to master the basic elements of the Batarde alphabet. Then use the stroke sequence to complete the letters of the alphabet.

MAJUSCULES PRACTICE STROKES

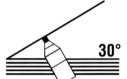

MINUSCULES PRACTICE STROKES

MAJUSCULES

ABCDE
FGHIJK
LMNOP
QRSTU
VWXYZ

MINUSCULES

abcdefghij
klmnopqrs
tuvwxyz

NUMERALS

Here are several styles of numerals that should be appropriate with most letter styles. It is not necessary to use the same form as the rest of your message. A distinctive numerical style can add interest to your piece.

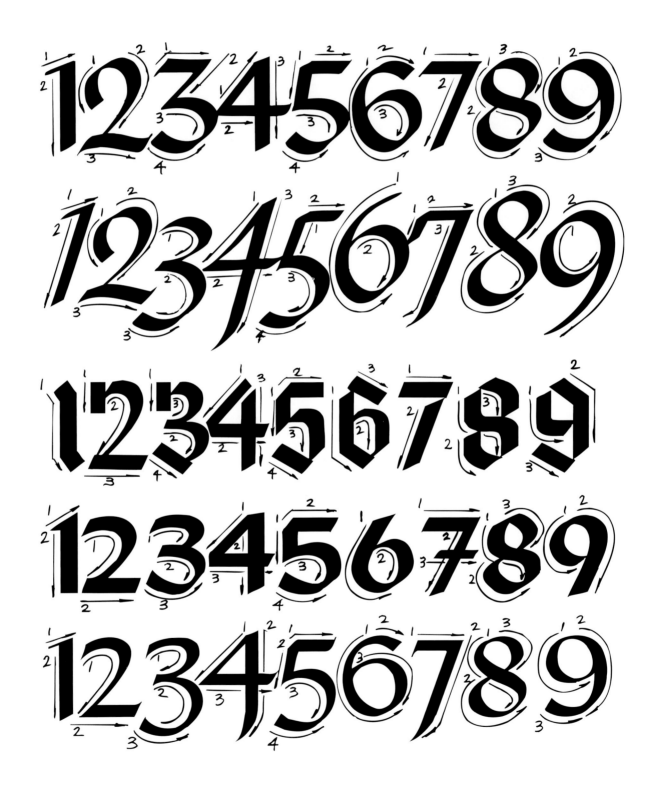

123456789

123456789

123456789

123456789

123456789

BASIC PRACTICE SHEET

Scan or copy this page to use for practicing your hands.

A | *aby*

FLOURISHES & BORDERS

Once you become comfortable with creating the letters and alphabets in this section, you can begin to embellish them with beautiful flourishes and swashes, and surround them with decorative borders—the possibilities are endless!

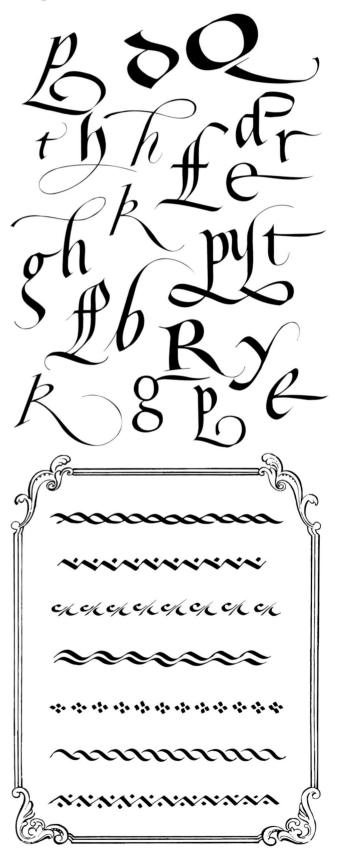

FLOURISHES AND SWASHES

The stylish addition of flourishes and swashes serves a double purpose by enhancing the space and adding unexpected interest. But it is important that these strokes be added with discipline and planning. The bold ribbon swash is done with the same broad pen as the lettering. A smaller pen is used for the more delicate swashes, and a fine-point pen is used for the hairline flourishes.

BORDERS

Borders can be made in a variety of styles, from very simple to ornate. They are often used to set a theme or create a mood. They can be used to enhance a name, title, or logo. In print they can draw attention to a specific space. A border might completely surround the lettering or be only on the top, bottom, or sides. They must retain the character of the subject and the lettering used.

⟡ DESIGN

Now let's mix calligraphy with creativity. First remember that good lettering design emphasizes important words, creates interest, and expresses the proper mood and feeling. This is achieved through contrasts of size, weight, form, and direction. Study the following example to see how you can use these contrasts to create unique designs that complement the nature of the text.

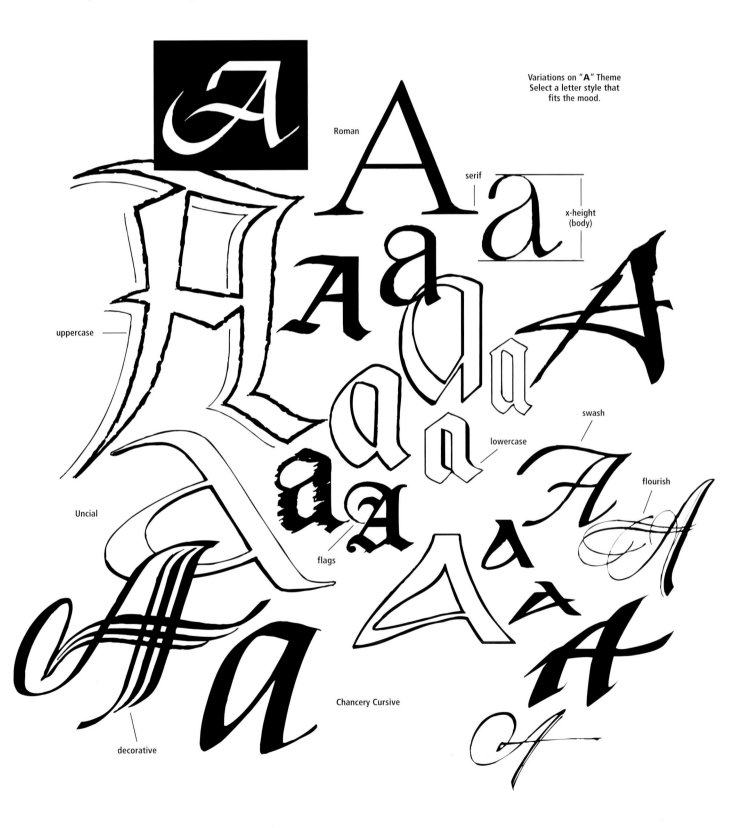

Variations on "A" Theme
Select a letter style that fits the mood.

Roman

serif

x-height (body)

uppercase

swash

flourish

lowercase

Uncial

flags

decorative

Chancery Cursive

Chapter 3

TRADITIONAL ALPHABETS

SCRIPSIT

Scripsit

SCRIPSIT

SCRIPSIT

SCRIPSIT

SKELETON HAND

Mastering the skeleton hand gives you the basic skills for learning all the other hands. This hand features the basic underlying structure (or skeleton) of the letterforms. Practicing these letters will train your hand to remain steady while drawing straight and curved lines. These letters were made with the drawing nib, which makes a thin stroke, but you can use a fine-line marker or a pencil for practice if you wish. As you re-create the letters of this hand, as well as any other hand, remember that part of the charm and appeal of hand lettering is the imperfections. While these hand-lettered alphabets follow the general rules, they won't align exactly on the guidelines.

MINUSCULES

Learning the subtleties of the letter shapes will make the difference between creating plain-looking letters and beautiful ones. Notice that the **o** fills the entire width of a square (equal to 4 grid boxes by 4 grid boxes). Other round letters are about 7/8 the width of that square, and most of the other minuscules (except for the **i**) are 3/4 the width of the square. Proportion and alignment, as well as consistency, all play a part in giving your writing a clean look and producing characters that are easy to read. As you can see, certain letters share common shapes. Practice the different styles using these letter families. By practicing the letters in these groups, you will learn the forms faster.

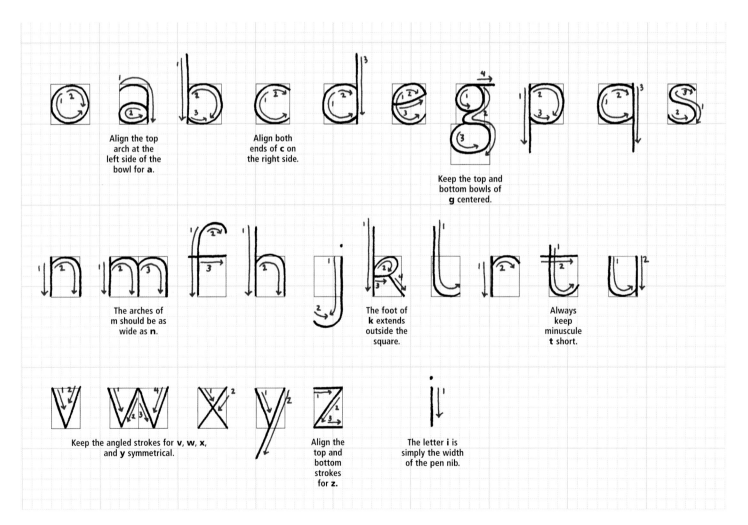

Align the top arch at the left side of the bowl for **a**.

Align both ends of **c** on the right side.

Keep the top and bottom bowls of **g** centered.

The arches of m should be as wide as **n**.

The foot of **k** extends outside the square.

Always keep minuscule **t** short.

Keep the angled strokes for **v**, **w**, **x**, and **y** symmetrical.

Align the top and bottom strokes for **z**.

The letter **i** is simply the width of the pen nib.

Form these letters using the drawing nib.
This hand is shown at 85% of its actual size.

MAJUSCULES

When drawing majuscules, also called "Romans" by calligraphers, understanding the correct proportions will allow you to consistently form handsome-looking letters. Note that the shape of the o, which is the "mother" of every alphabet, will determine the shapes of almost all the other letters.

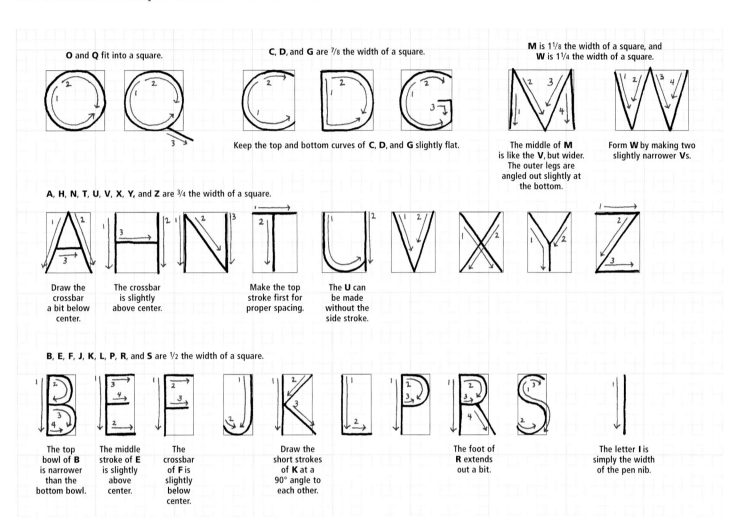

O and **Q** fit into a square.

C, **D**, and **G** are ⅞ the width of a square.

Keep the top and bottom curves of **C**, **D**, and **G** slightly flat.

M is 1⅛ the width of a square, and **W** is 1¼ the width of a square.

The middle of **M** is like the **V**, but wider. The outer legs are angled out slightly at the bottom.

Form **W** by making two slightly narrower **V**s.

A, **H**, **N**, **T**, **U**, **V**, **X**, **Y**, and **Z** are ¾ the width of a square.

Draw the crossbar a bit below center.

The crossbar is slightly above center.

Make the top stroke first for proper spacing.

The **U** can be made without the side stroke.

B, **E**, **F**, **J**, **K**, **L**, **P**, **R**, and **S** are ½ the width of a square.

The top bowl of **B** is narrower than the bottom bowl.

The middle stroke of **E** is slightly above center.

The crossbar of **F** is slightly below center.

Draw the short strokes of **K** at a 90° angle to each other.

The foot of **R** extends out a bit.

The letter **I** is simply the width of the pen nib.

TIPS

- Remember to experiment! Always test new nibs and papers before starting a final work to see how they respond to the paints or ink.

- You may need to adjust the thickness of the watercolor or gouache according to the angle of your work surface or lay your paper at a less oblique angle to work.

- Keep your work area clean, and check your fingertips when handling finished work. Keep a damp paper towel nearby to wipe off your fingers before touching the paper.

- Do not press down on your pen nib too hard because it will drag on the surface of the paper and may stick in one spot, causing a blot.

- Use a constant speed as you form your letters; this gives your work a rhythm and helps you make the letters more consistent.

SKELETON HAND PRACTICE SHEET

Scan or copy this page to use for practicing your hands.

FOUNDATIONAL HAND

Begin your practice of broad pen lettering with the Foundational hand—the letter shapes are simple, formed by very basic strokes, and most familiar to your eye. This style was adapted in the early 1900s from a 10th-century bookhand by Edward Johnston. It's a great choice for beginners and when legibility is important.

MINUSCULES

The minuscule letters are easier to master, so begin writing these out before you start on the majuscules. Follow the ductus for each letter, and practice until you are able to form straight up-and-down strokes and smooth, round shapes.

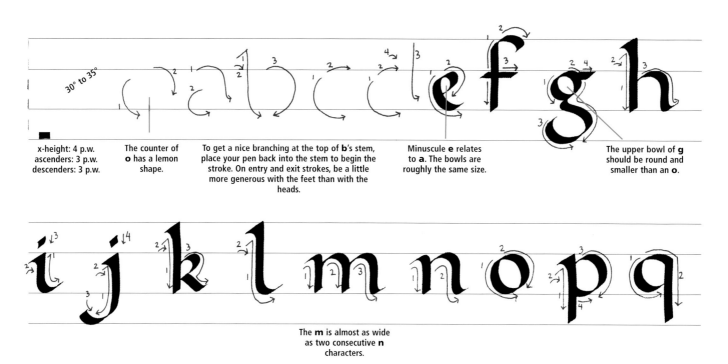

x-height: 4 p.w.
ascenders: 3 p.w.
descenders: 3 p.w.

The counter of **o** has a lemon shape.

To get a nice branching at the top of **b**'s stem, place your pen back into the stem to begin the stroke. On entry and exit strokes, be a little more generous with the feet than with the heads.

Minuscule **e** relates to **a**. The bowls are roughly the same size.

The upper bowl of **g** should be round and smaller than an **o**.

The **m** is almost as wide as two consecutive **n** characters.

Keep the ear of **r** short.

The first strokes of **v**, **w**, **x**, and **y** are formed with the pen angle closer to 45° to make them a bit thicker.

For **z**, flatten the pen angle when making the diagonal stroke (2) to broaden it.

Create the curve of the bracketed serif with a second stroke.

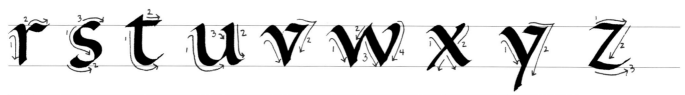

Each style page in this section features the word "Scripsit" (Latin for "**he/she wrote**") to give you an idea of what each style looks like when the letters are put together.

Form these letters using a #1 roundhand nib.

This hand is shown at 85% of its actual size.

MAJUSCULES

As you are familiar with modern letterforms, which are similar to classic Foundational majuscules, it should be easy for you to learn this hand. Practice writing similar letter groupings: round letters, arched or half-round letters, and angled letters. Then write words that use both majuscules and minuscules to develop a sense of spacing and proportion when writing them in combination.

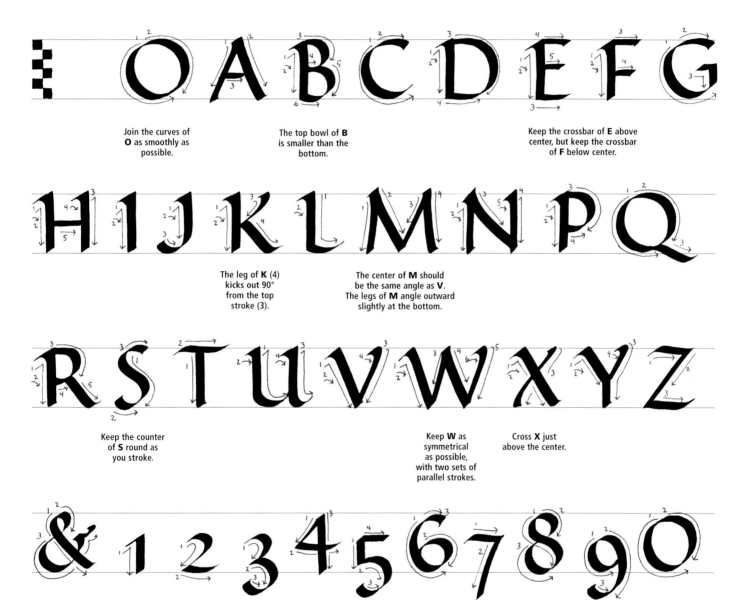

Join the curves of **O** as smoothly as possible.

The top bowl of **B** is smaller than the bottom.

Keep the crossbar of **E** above center, but keep the crossbar of **F** below center.

The leg of **K** (4) kicks out 90° from the top stroke (3).

The center of **M** should be the same angle as **V**. The legs of **M** angle outward slightly at the bottom.

Keep the counter of **S** round as you stroke.

Keep **W** as symmetrical as possible, with two sets of parallel strokes.

Cross **X** just above the center.

Form these letters using a #1 roundhand nib.

This hand is shown at 85% of its actual size.

These numerals are called "old style" and are meant to be used with the minuscules, as they also go above and below the x-height.

KEEPING VISUAL BALANCE

Majuscules should be a little shorter than the minuscule ascenders (in this case, six pen widths). To keep the majuscule and minuscule letters visually balanced, use a 25° to 30° pen angle (slightly flatter than on minuscules), which makes a broader stroke.

FOUNDATIONAL HAND PRACTICE SHEET

Scan or copy this page to use for practicing your hands.

30° to 35°

x-height: 4 p.w.; ascenders: 3 p.w.; descenders: 3 p.w.

ᔑUNCIAL HAND

One of the oldest hands, Uncial (pronounced "un-shul") in many ways is the easiest to learn. This hand can be considered commoncase, as it has elements of both majuscules and minuscules. As you work, keep the letter shapes wide and round. Ascenders and descenders are very short, in keeping with this hand's essentially majuscule style.

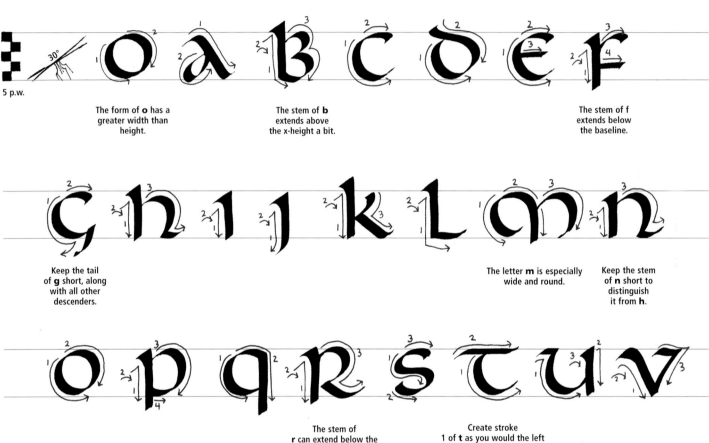

5 p.w.

The form of **o** has a greater width than height.

The stem of **b** extends above the x-height a bit.

The stem of f extends below the baseline.

Keep the tail of **g** short, along with all other descenders.

The letter **m** is especially wide and round.

Keep the stem of **n** short to distinguish it from **h**.

The stem of **r** can extend below the baseline just a bit.

Create stroke 1 of **t** as you would the left side of **o**.

Keep **w** wide and round, like **m** upside down.

Form these letters using a #1 roundhand nib.

This hand is shown at 85% of its actual size.

SERIFS

Uncial serifs start with a wedge-shaped stroke. Begin with a 30° angle at the start of the stroke and move the nib up and to the right to create a thin line; then pull the nib straight down, toward you, forming the stem stroke of the letter. Fill in the small angle of the wedge with a short curved line.

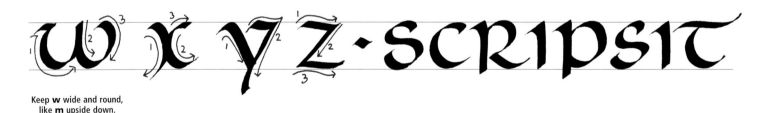

RUNIC VERSALS

Uncial does not have a set of majuscule letters, but you can use these runic letters in combination with Uncial letters. Runic letters were often used as versal letters, or decorative letters originally used at the beginning of a chapter or a verse. Wonderful examples are found in famous manuscripts, such as the Book of Kells and Lindisfarne Gospels. Runic letters were among the most versatile letterforms. The spiked shapes of these letters offer an opportunity for creativity. Medieval Celtic scribes often drew spirals, interlace, and animal heads from the ends of the strokes. These are "drawn" letters and can be made using a pencil, a brush, or a narrow nib, as shown here. These are called "compound letters" because multiple strokes are used to make them.

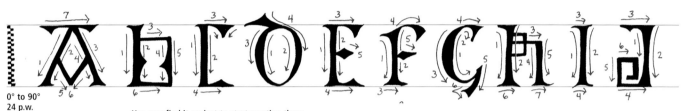

0° to 90°
24 p.w.

You may find it easiest to start creating these letters with a fine-line marker or drawing nib.

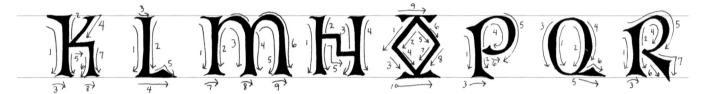

The round forms of these letters are based on an oval **O** rather than a round one, although the actual **O** is diamond-shaped.

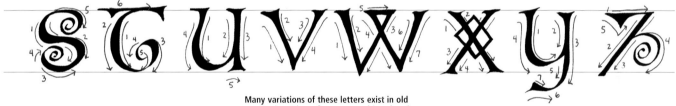

Many variations of these letters exist in old manuscripts. They often appeared in colored panels of letters surrounded by red dots.

For boxes and swirls, add extra strokes as shown in the letter examples. To draw the triangular serifs, turn the broadhand nib and use the corner, as shown at left.

As you explore these hands, keep readability in mind. This particular style is difficult to read when used to create whole words, so it's best to use these angular and decorative letters as focal letters (for example, to begin a page).

Form these letters using a #4 roundhand nib or a drawing nib. This hand is shown at 85% of its actual size.

CREATING LETTER STEMS

Double stroke the stem letters, leaving a small gap between each line. Then close the stems at the top and bottom with short, curved strokes. Complete by filling in the stem letters with ink, if desired, as shown in the letters above.

UNCIAL HAND PRACTICE SHEET

Scan or copy this page to use for practicing your hands.

30°

5 p.w.

BLACKLETTER HAND

The common characteristic of all blackletter hands is the compression of letters and spaces, which allows more words to fit onto a page. This bold style also features a dynamic contrast of fine hairlines with heavy letters. The first blackletter style shown below is called "Textura Quadrata," or "broken letters," and it often resembles a picket fence. The bottom style, "Batarde," is a cursive blackletter hand that was the primary bookhand used in the late Middle Ages.

MINUSCULES

Blackletter hands, also called "Gothic script," are closely packed in appearance; the letters have very little interlinear space, and the ascenders and descenders of the minuscules are short (ranging from $1^1/2$ to 2 p.w.). It gives the page a dark appearance overall.

TEXTURA QUADRATA

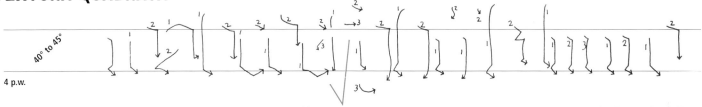

The letter **f** features two distinct hairlines. To create a hairline, lift your nib onto the leading corner and drag the ink.

Notice the absence of curved lines in this hand—even on **o**.

The counter space of most letters is the same width as the inked stroke.

The letter **t** also has a hairline, as in the crossbar of **f**.

BATARDE

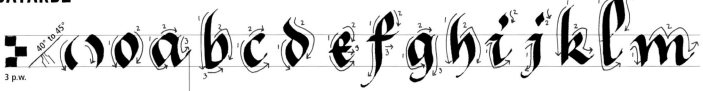

Keep your exit strokes thin, lifting up on the corner of the nib.

Stroke 2 of **h** is an example of a hairline finish stroke.

Stroke 2 of **l** is an optional extra stroke for ascenders.

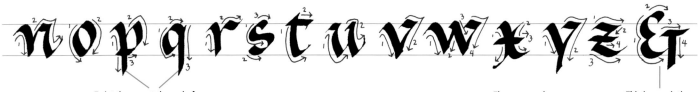

Twist the pen at the end of your stroke to get pointed descenders.

The **e, x,** and **z** feature a thin crossbar.

This is a variation of an ampersand.

Form these letters using a #1 roundhand nib.

MAJUSCULES

Contrast curvy, wide majuscules with the closely packed minuscules. These letters can be used with either style of minuscule on the facing page. Study old manuscripts for examples of the many different styles of Gothic majuscules or create your own variations.

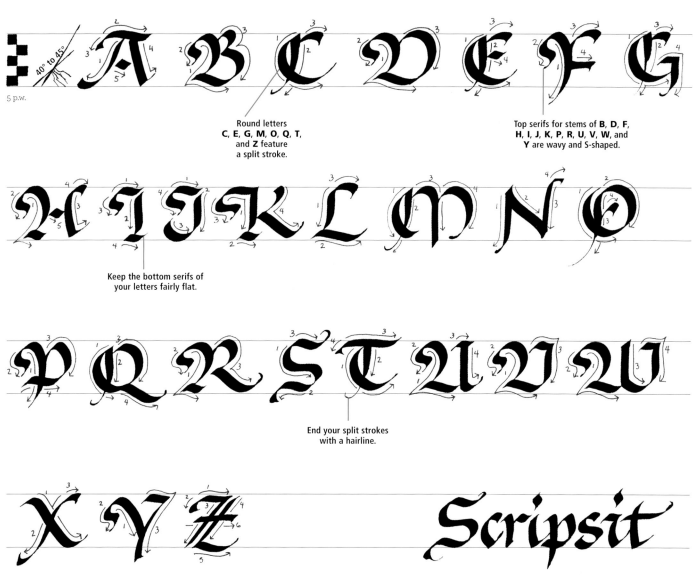

Round letters **C, E, G, M, O, Q, T,** and **Z** feature a split stroke.

Top serifs for stems of **B, D, F, H, I, J, K, P, R, U, V, W,** and **Y** are wavy and S-shaped.

Keep the bottom serifs of your letters fairly flat.

End your split strokes with a hairline.

Z features a long crossbar; two parallel lines make up the diagonal stem.

Form these letters using a #1 roundhand nib.

This hand is shown at 85% of its actual size.

TIP

Use these majuscules for emphasis only. Words created with all blackletter majuscules would be awkward and illegible.

BLACKLETTER HAND PRACTICE SHEET

Scan or copy this page to use for practicing your hands.

40 to 45°

4 p.w.

VERSALS HAND

Traditionally used to begin a verse or chapter in medieval manuscript books, versals are usually seen individually. These versatile letters are used today in expressive calligraphic work; more modern-looking versals can be drawn without serifs. The versals below and at right have been left unfilled to give you a better idea of their structure and how to reproduce them.

ROMAN

This drawn style uses compound strokes. You'll notice that the vertical stem strokes curve in slightly at the center, and the two-stroke verticals and diagonals are about three pen-strokes wide. Draw the skeleton majuscules with a pencil first, keeping to classic proportions.

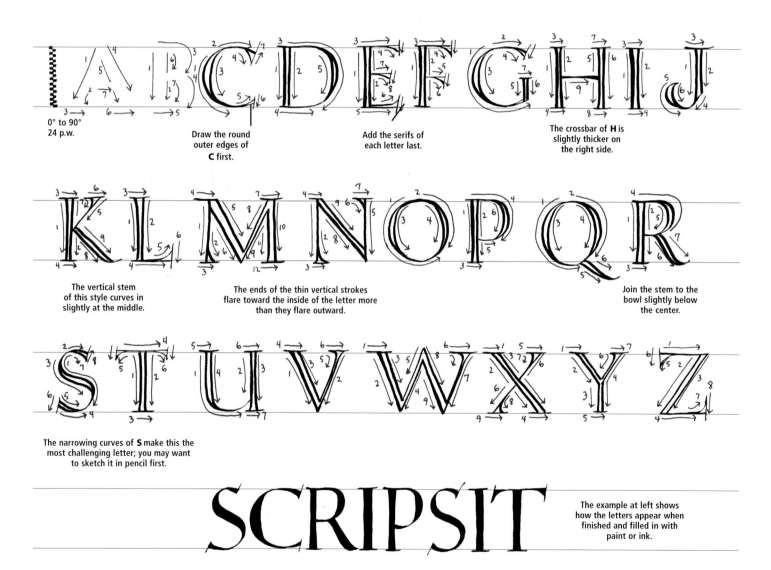

0° to 90°
24 p.w.

Draw the round outer edges of **C** first.

Add the serifs of each letter last.

The crossbar of **H** is slightly thicker on the right side.

The vertical stem of this style curves in slightly at the middle.

The ends of the thin vertical strokes flare toward the inside of the letter more than they flare outward.

Join the stem to the bowl slightly below the center.

The narrowing curves of **S** make this the most challenging letter; you may want to sketch it in pencil first.

SCRIPSIT

The example at left shows how the letters appear when finished and filled in with paint or ink.

Form these letters using the drawing nib.
This hand is shown at 85% of its actual size.

LOMBARDIC

Lombardic letters are generously proportioned versals based on round Uncial forms. These drawn and frequently decorated majuscules often adorned the beginning of verses in sacred medieval texts. Use a smaller nib for refining the letters. In most cases, you will draw the interior strokes first and then build outward. This version has a greater contrast between thick and thin, making the letters more dramatic. Sometimes the fat vertical stems of the illuminated versions of these letters were filled with zigzags or other linework.

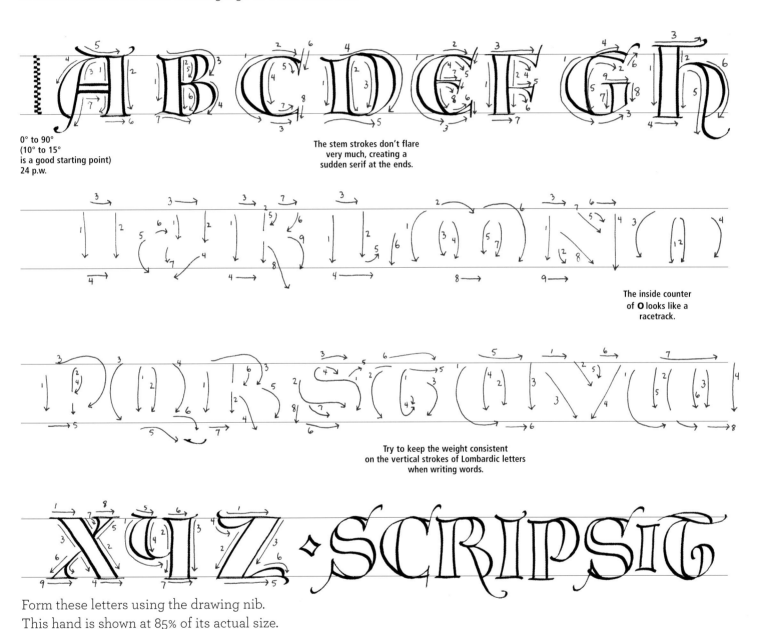

0° to 90°
(10° to 15°
is a good starting point)
24 p.w.

The stem strokes don't flare very much, creating a sudden serif at the ends.

The inside counter of **O** looks like a racetrack.

Try to keep the weight consistent on the vertical strokes of Lombardic letters when writing words.

Form these letters using the drawing nib.
This hand is shown at 85% of its actual size.

BALANCING SIDES

The curved and straight sides of a Lombardic letter, as seen in the **U** at right, are visually balanced—not measured to be an identical width. Note how the widest part of the curved side is actually much wider than the straight, upright stroke.

VERSALS HAND PRACTICE SHEET

Scan or copy this page to use for practicing your hands.

0 to 90°; 24 p.w.

ITALIC HAND

The quickly written Italic hand was developed from humanist bookhand, letterforms from the Italian Renaissance. Based on 10th-century minuscules, this style often was used to produce books prior to the invention of the printing press.

MINUSCULES

These letters are slim, graceful, and very rhythmic. They relate strongly to the handwriting of today, so they should feel very natural for you to form. Each letter leans forward at a 5° to 10° angle to the writing line; this is known as "letter slope."

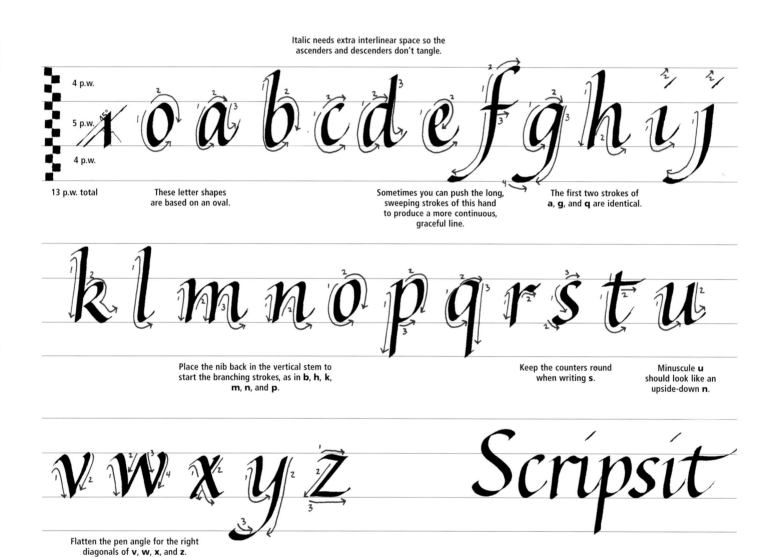

Italic needs extra interlinear space so the ascenders and descenders don't tangle.

4 p.w.

5 p.w.

4 p.w.

13 p.w. total

These letter shapes are based on an oval.

Sometimes you can push the long, sweeping strokes of this hand to produce a more continuous, graceful line.

The first two strokes of **a**, **g**, and **q** are identical.

Place the nib back in the vertical stem to start the branching strokes, as in **b**, **h**, **k**, **m**, **n**, and **p**.

Keep the counters round when writing **s**.

Minuscule **u** should look like an upside-down **n**.

Flatten the pen angle for the right diagonals of **v**, **w**, **x**, and **z**.

Scripsit

Form these letters using a #2½ italic nib.

This hand is shown at 85% of its actual size.

TIP

As you move the pen to form each letter, keep the tip of the nib at the same angle through the entire stroke. To do this, keep your wrist steady, moving the pen by moving your arm, not your hand.

MAJUSCULES

Italic majuscules feature swashes, which are rounded extensions that flow from the basic form of the letter. Avoid writing an entire word in swashed letters; it will look too busy. When writing whole words and lines, these majuscules can be made without the swashes for a clearer, more readable appearance. Remember, a little goes a long way when adding flourishes to your letters.

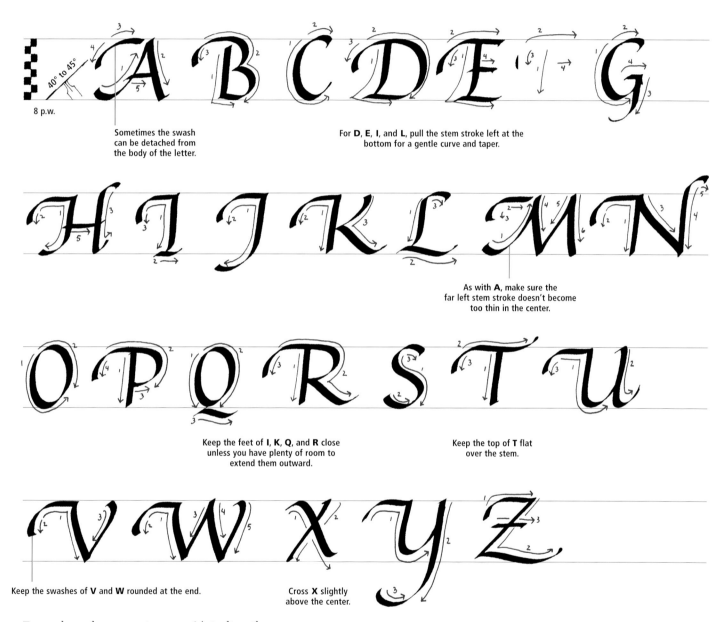

8 p.w.

40° to 45°

Sometimes the swash can be detached from the body of the letter.

For **D**, **E**, **I**, and **L**, pull the stem stroke left at the bottom for a gentle curve and taper.

As with **A**, make sure the far left stem stroke doesn't become too thin in the center.

Keep the feet of **I**, **K**, **Q**, and **R** close unless you have plenty of room to extend them outward.

Keep the top of **T** flat over the stem.

Keep the swashes of **V** and **W** rounded at the end.

Cross **X** slightly above the center.

Form these letters using a #2½ italic nib.

This hand is shown at 85% of its actual size.

DRAWING SWASHES

The swashes on italic majuscules are very generous in width, doubling the width of the entire letter in many instances. Use these large swashes to add emphasis to words or to begin a page.

ITALIC HAND PRACTICE SHEET

Scan or copy this page to use for practicing your hands.

4 p.w.

5 p.w.

40 to 45°

4 p.w.

PLANNING YOUR DESIGNS

When first learning calligraphy, concentrate on how each individual letter is made. The spacing of the letters in a word and the arrangement of the lines of words on a page are an important part of this art form. The composition (the arrangement of all the elements in a completed work) is as important as the individual details.

FOCUSING ON SPACING

When combining letters to form words, the objective is to produce an even visual texture. Remember that the space between the letters is as important as the space inside the letters; the spaces should appear consistent throughout the word and the page. You'll find that spacing is not as simple as it sounds—you shouldn't use the same unit of measurement between each letter, as the edges of adjacent letters create unique space shapes that require different treatment. Instead, place letters based on the volume of space on either side. For minuscules, the vertical strokes should appear evenly spaced. Majuscules, however, require more room and are more difficult to space visually. You can train your eyes to see consistent spacing; try looking at groups of three letters and gauge the space by the shape and volume you see on both sides of the middle letter.

Spacing the Minuscules

You can check your progress by using a tracing paper overlay. Write each of the letters with an **n** between them as an effective spacer. Draw vertical lines along the stems and vertical strokes of your letters; for **s**, draw the line down the middle of the letter. If you've produced consistent spacing, these lines will be roughly the same distance apart (see the first line of letters below).

Spacing the Majuscules

Using the same unit of measurement between letters results in an awkward flow, as shown in "Tabula Rasa" (second line below). Instead, vary the distance so that there is roughly the same volume of space between the letters, as shown in "Tarot" (third line below). Some guidelines for spacing are given in the bottom line below.

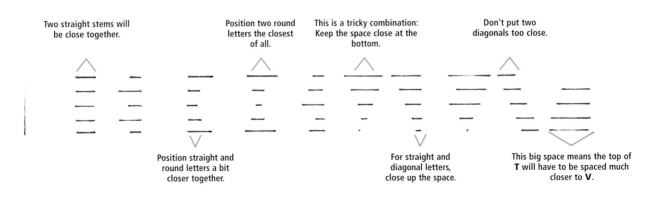

Two straight stems will be close together.

Position two round letters the closest of all.

This is a tricky combination: Keep the space close at the bottom.

Don't put two diagonals too close.

Position straight and round letters a bit closer together.

For straight and diagonal letters, close up the space.

This big space means the top of **T** will have to be spaced much closer to **V**.

SPACING WORDS

To get a feel for the proper spacing between words, write practice sentences with **n** in between each word. The **n** provides a natural-looking space and minimizes variation. Keep spaces to a minimum to prevent rivers (vertical visual gaps down the page created by word spaces).

LIGATURES

Ligatures, the joining of two letters, occur naturally in combinations where extensions or serifs meet at the waist line. However, not all letters in ligatures actually touch, as this might create the look of another letter. Look at the **rn** combination. In the ligature, the **n** simply lacks the serif; if the letters touched, they would resemble an **m** too closely.

terra incognito

fi rn rt rv tt gn
fi rn rt rv tt gn

PREPARING LAYOUTS

Composition is the purposeful organization of elements. Plan out the arrangement of your text before you start writing so you can include all of the material while maintaining a sense of balance. Alignment plays a huge role in the overall layout of a page. Text may be aligned left, aligned right, centered, justified (aligned on both sides of the text block), or asymmetrically placed. To make the text easy on the eyes, keep the margins generous, with the bottom margin larger than the top and sides. The thumbnails below show vertical arrangements (the top row shows effective layouts; the bottom row shows problematic layouts). Remember that layouts may be horizontal as well.

Effective Layouts

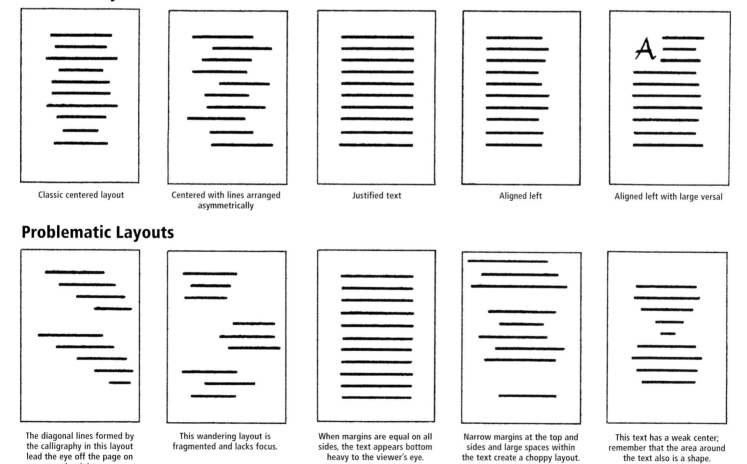

Classic centered layout	Centered with lines arranged asymmetrically	Justified text	Aligned left	Aligned left with large versal

Problematic Layouts

The diagonal lines formed by the calligraphy in this layout lead the eye off the page on the right.	This wandering layout is fragmented and lacks focus.	When margins are equal on all sides, the text appears bottom heavy to the viewer's eye.	Narrow margins at the top and sides and large spaces within the text create a choppy layout.	This text has a weak center; remember that the area around the text also is a shape.

Chapter 4

ILLUMINATED CALLIGRAPHY

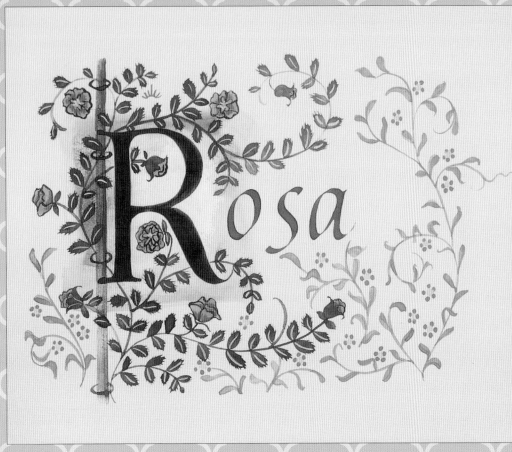

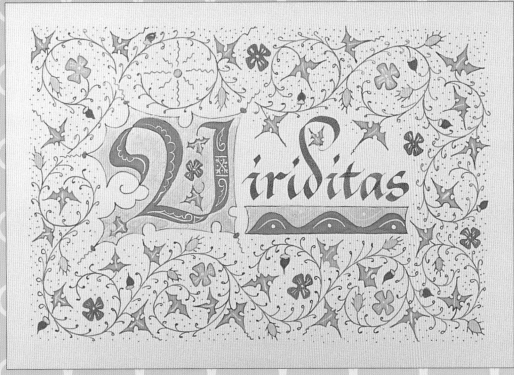

ℰILLUMINATION SUPPLIES

GOUACHE

Designer's gouache (pronounced "gwash") is similar to watercolor paint, but it contains more filler, which makes it opaque. It can be thinned to a consistency suitable for flowing from a nib. You can use the primary colors (red, yellow, and blue) alone, or you can mix them together to create almost any other color. Use gold gouache to add gilded accents that mimic the brilliance of gold leafing.

PAINTBRUSHES

To mix your colors, load or fill the pen, and paint large areas, purchase a large round paintbrush. Also purchase a small round brush for painting fine details. Round paintbrushes have tips that taper to a point—this shape allows the bristles to hold a good amount of moisture while maintaining the ability to produce fine lines. Before you paint, be sure to dampen your brush so that the ink or paint slides off the bristles easily.

PALETTE

A white ceramic palette with several wells will be handy when you mix colors. The wells allow you to keep an array of thinned and mixed colors handy and prevent the colors from running together. A palette with a large center well provides a convenient place to hold clean water for adding to mixes in other wells.

TIPS

- Use distilled water to thin gouache for lettering. Distilled water doesn't contain minerals that can affect pigment.
- The bigger the pen nib, the thinner the paint needs to be. Small nibs require thicker paint or ink.
- A new tube of gouache has a few drops of glycerin at the top to keep paint moist. Squeeze out the glycerin onto a paper towel and discard before using the paint.
- Clean the nib often by dipping only the tip in water and wiping it dry. Be sure all moisture is wiped off the nib before putting your tools away.
- When painting highlights and other details, dip just the tip of the brush into the paint and wipe off any excess on the edge of the palette cup.
- As you work, periodically stir the paint to maintain an even distribution of the water in the paint.
- Work on a flat surface when lettering with gouache to keep the paint from pooling. Dried gouache can be reconstituted with water, but some colors may not reconstitute easily.

WRITING WITH GOUACHE

Lettering with gouache allows you to paint words from your pen. While this technique requires a bit of preparation, the effort is worth the reward!

STEP 1 Squeeze out a pea-sized amount of gouache on the palette—enough for a half page of writing. Add distilled water a drop at a time and mix with a large brush until it is the consistency of cream.

STEP 2 Load the large brush with the mix and drag the brush across the side of the nib (over the gap between the nib and reservoir). If you decide not to use a reservoir, simply drag the brush across the bottom of the nib.

STEP 3 Practice a few strokes and letters. Adjust the thickness of the gouache as needed to get it to flow evenly.

STEP 4 Write a few more letters, and you'll soon understand how to control the flow of paint with consistent speed and proper pressure.

COLOR THEORY

While practicing the basic letterforms, a tube of black watercolor paint (or a bottle of black ink) is all you need. But once you begin making words on a page to display and share, you may want to incorporate color into your lettering. Of all the media you could use, gouache provides the most brilliant color. Gouache is a painting medium similar to watercolor, but it has more opaque filler in it to give a more solid coverage. To complete the illumination projects in this section, you'll need cobalt blue, leaf green, lemon yellow, brilliant red, white, and gold gouache paint. Read on for information about mixing color and how to prepare your pen for writing with gouache.

MIXING COLOR

Learning the basics of color theory allows you to create a spectrum of colors from just a few tubes of paint. All you really need are the primary colors—red, yellow, and blue. These colors can't be created by combining any other colors, but you can mix them together to create virtually any other color. For example, mixing two primary colors together creates a secondary color (green, purple, or orange), and combining all three primaries results in a neutral brown or gray. The color wheel below illustrates the relationships of primary and secondary colors. The wheel also suggests two versions of each primary, giving you an ideal starting palette for mixing a range colors.

COLOR WHEEL

Make "tints" by adding white to colors, as shown on the outer edge of the color wheel. For darker "shades," add black. To gray a color, simply add a bit of its complement (the color directly across the color wheel). You can achieve neutral colors by mixing nearly equal amounts of complementary colors, as shown in the center. For a neutral gray, use more blue; for brown, more red; and for ochre, more yellow.

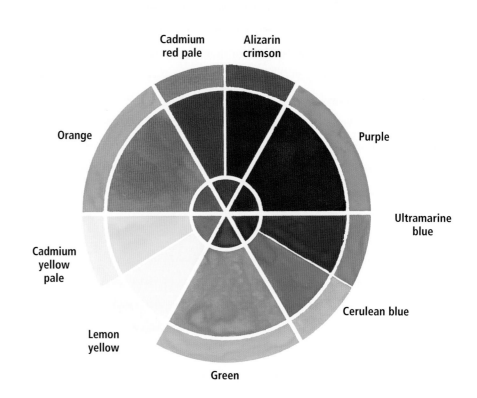

Cadmium red pale

Alizarin crimson

Orange

Purple

Cadmium yellow pale

Ultramarine blue

Lemon yellow

Cerulean blue

Green

DYNAMIC COMPLEMENTARY COLORS
Complementary colors appear opposite each other on the color wheel, and they appear brighter when placed next to each other, as shown above. Complementary colors often are used to create dramatic contrasts in artwork.

HARMONIOUS ANALOGOUS COLORS
Analogous colors appear next to one other on the color wheel. Because their hues (or family of colors) blend smoothly together, they impart a harmonious feeling when used together in a work of art. Above is a range of analogous colors from lemon yellow through cerulean blue.

 + + =

RICH NEUTRAL COLORS
Make neutral grays and browns by mixing the three primary colors together, varying the proportions to alter the final result.

 + = + =

GRAYED DARKER COLORS
Many artists prefer not to use black to darken colors, but to add a touch of a color's complement to the original paint color to create a rich-looking neutral shade. This example shows greens that have been neutralized (or grayed) with a touch of red.

DESIGNING A QUOTE

A short quotation makes a great subject for learning to place words in a layout. Choose a saying that will comfortably break into two or three lines, but not one that is so wordy that you won't want to practice writing it a few times.

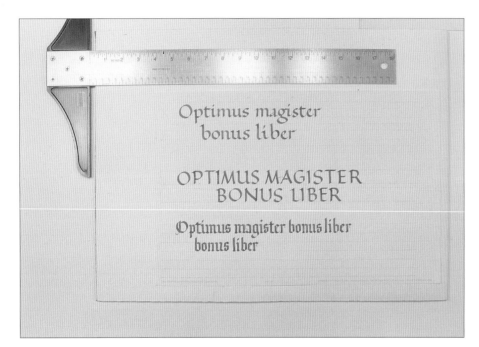

STEP 1 Practice writing your quote in different hands; then choose the most suitable hand for the message. This Latin quote roughly translates to "The best teacher is a good book," so I chose the easy-to-read Foundational hand. Use a #1 nib to write your quote on layout or grid paper. At this stage, don't worry about the arrangement of the words.

STEP 2 Practice drawing an image that's appropriate for your quote. I drew a small book, using the same nib held at the angle that was used for the lettering. Experiment with suggesting text lines and varying line weight. Keep the sides of the book vertical to echo the straight lines of the letters.

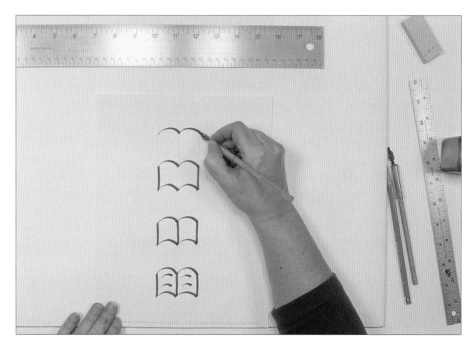

STEP 3 Now cut out each word and your drawing to make separate, movable pieces. Place the pieces in different arrangements on a large piece of blank white paper. Decide which layout is most pleasing to your eye.

STEP 4 After you choose an arrangement, view your layout within borders. Cover the layout with tracing paper; then use two L-shaped pieces of black mat board or four strips of black paper to crop your layout and determine the margins. Once you're satisfied, you can create the final artwork.

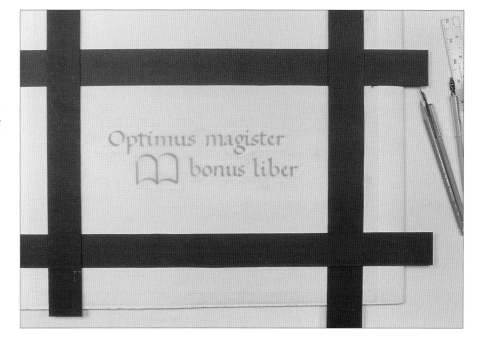

ADDING A DECORATIVE ELEMENT

To add visual interest, use a broad pen to make a simple drawing that complements the idea and the letter style of your quote. Using the same pen width to create the drawing and the letters will make the drawing flow visually with the text. At the right, the open book illustrates the word "liber," which means "book." Using red gouache draws attention to the drawing.

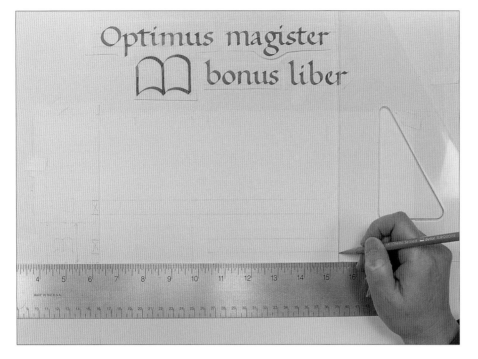

STEP 5 First draw the baselines on art paper with a pencil; place a light x at the beginning of each baseline to distinguish it. Make a paper ruler for the hand you're using, and lightly draw the rest of the horizontal lines on the paper. Transfer the vertical guidelines by placing the layout directly above the art paper. Use an artist's triangle to help position your marks.

STEP 6 Warm up your hand by practicing on another sheet of paper before starting your final work. Refer to the cut-out words placed above your work when producing the final writing. Soon you'll be able to letter it without using the layout—and eventually without the ruled guidelines.

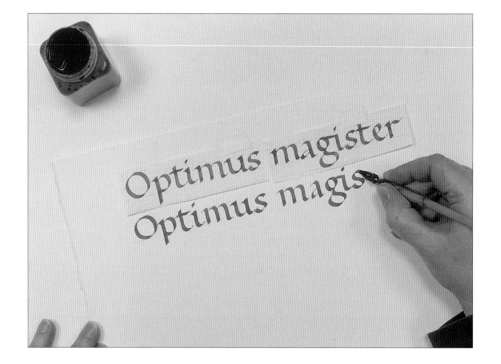

TIP

You may find it easier to work on your final piece when you've ruled two or three sheets of art paper, as in step 5. This reduces "performance anxiety" and lets you move on quickly to another paper if you make a wobbly mark or don't like the quality of your strokes.

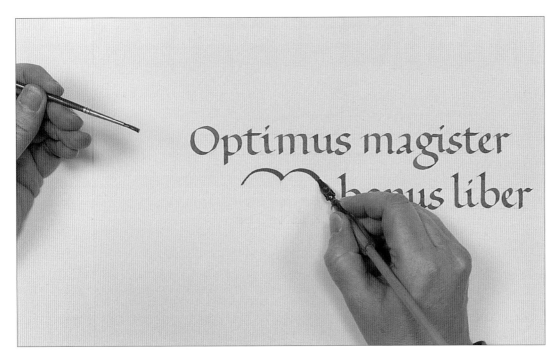

STEP 7 After completing the words, use red gouache to draw the book. When the ink and gouache are completely dry, carefully erase the pencil lines. Cut a corner off your eraser with a craft knife, so you can erase in small areas. Be careful not to scrub the red gouache when erasing.

STEP 8 Now you have an expressive, but simple, illustrated quote. Be sure to save some of your early projects—it will be interesting to look back at them in a few months to see how far you have progressed!

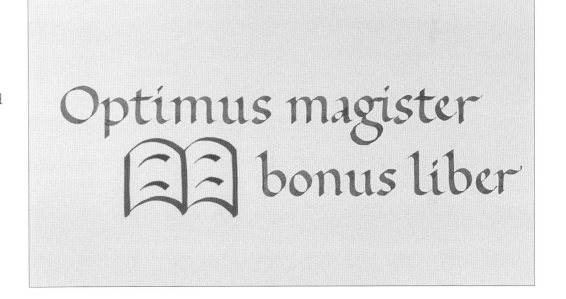

CHANGING THE LAYOUT

After you write your practice words, cut them out. Try different layouts with them. You may opt for a classic centered layout, like the one shown here, rather than the horizontal layout above. To find the center of each word, draw a vertical line on the center of the background paper; then fold each word in half to find its center. Align each word's center to the line on the paper, and attach the words to the paper with low-tack or artist's tape to use as a guide.

ILLUMINATING LETTERS

The word "illumination" comes from the Latin word *illuminaire*, which means "to light up or enlighten." In calligraphy and book art, it refers to decorating a page with bright colors and shimmery gold. Decorated majuscules and intricate borders lit up the pages of ancient books and offered an exciting way to provide colorful focal points among black lettering. You can achieve the same look.

LETTERING IN THE ANCIENT RUNIC STYLE

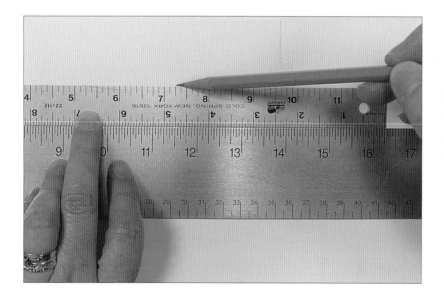

STEP 1 Rule two parallel lines one to two inches apart on art paper. As a shortcut, you can draw lines along both edges of a ruler.

STEP 2 Use a pencil to lightly draw a word on the art paper between the two parallel lines. In this case, the word is "Maria."

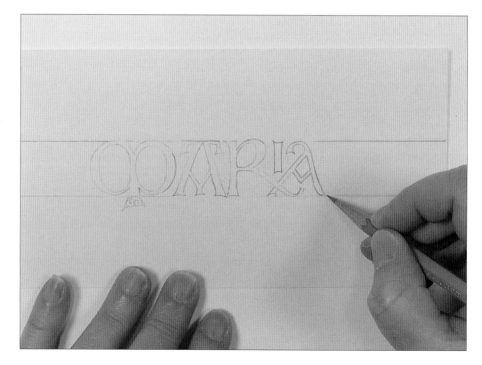

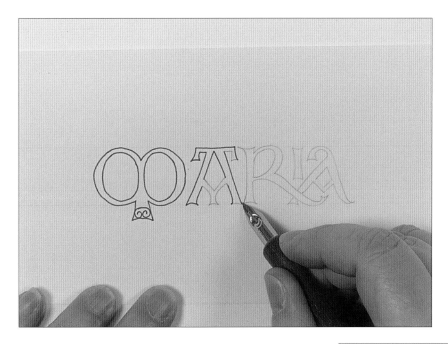

STEP 3 Use the drawing nib; a narrow, flat nib; or a small brush to outline the letters with black paint. Let the ink dry and carefully erase the pencil outlines.

STEP 4 At this point, use a thick nib or small brush to fill in the letters with black paint, carefully moving your tool within the outlines.

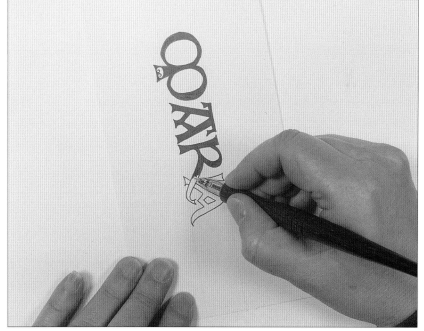

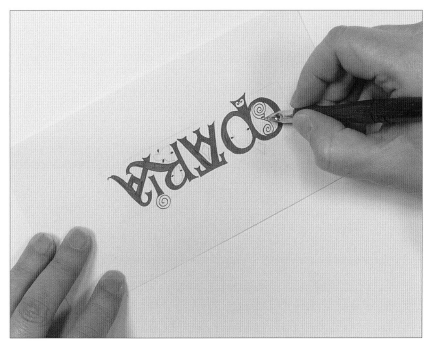

STEP 5 Draw designs in the counter shapes and add some decorative spirals. The spiral used in the left counter of the *M* is a simple *S* shape with a fuller bottom. Draw a border around all the letters, and ink in the spirals.

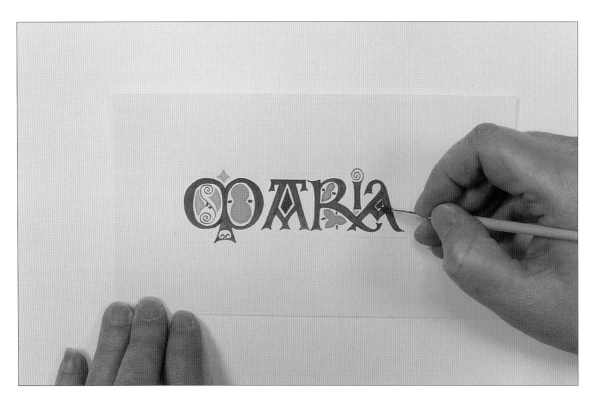

STEP 6 Prepare several intense mixes of gouache paint. As you work across the word and fill in the counters with shapes, alternate your paint colors.

STEP 7 Use red gouache in the drawing nib to apply rows of red dots around the letters and the borders of the panel. Try to space your dots evenly, but don't worry if your dots don't exactly line up—this imperfection will give your work a natural, organic quality.

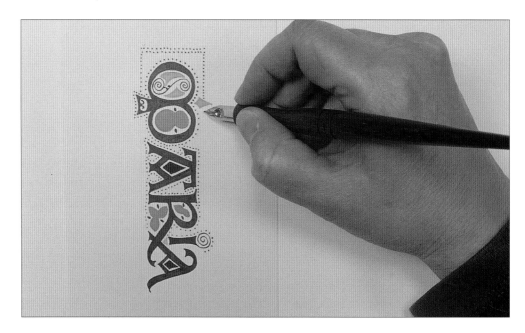

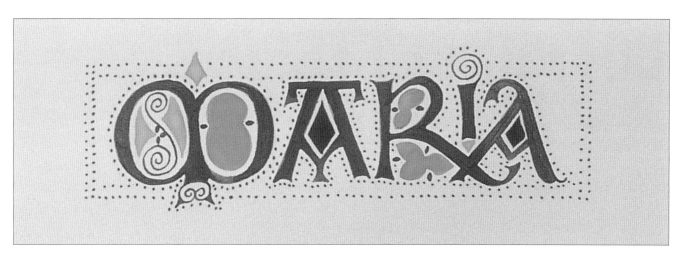

STEP 8 The completed project is based on ancient forms but has an eclectic look.

TIPS FOR ILLUMINATION

- Some of the earliest illumination was done by the Irish scribes who produced the Book of Kells and the Lindisfarne Gospels. Neither of these books used gold leaf, but instead used bright colors and rows of red dots to visually lift the letters off the page.

- A bright red accent adds a bit of magic to the page. Medieval illumination artists understood that red attracts the eye, so they often used red when decorating versals.

- The sequence in which you work is important. The traditional order is to do the lettering first, then the gilding, and the color painting last. Gold paint may be applied at the same time as the colors, but always do the lettering first. It's easier to hide mistakes in the borders than within the calligraphy.

- Gather visual reference materials from books or the Internet when planning a project. Experiment with different color combinations and decorative elements.

- Don't abandon your lettering practice once you start illuminating. Good calligraphy skills are essential to quality illumination.

- When working with color, keep your brushes very clean. Keep two water jars for consecutive rinsing. If possible, use separate brushes for different colors—particularly light and dark shades.

ILLUMINATED GOTHIC LETTERING

Book illumination rose to the height of intricacy and beauty during the medieval era. Artists often applied gold leaf to letters or to the backgrounds of versals and illustrations, which would catch the light as the page turned. Today gold paint offers a similar effect that artists can use to create historically inspired Gothic letters, such as the V below. The Latin word *viriditas* means "the greening power of life," so I infused the border with plenty of green vines. I created this image using a tracing method to transfer the design, which I explain on the next page.

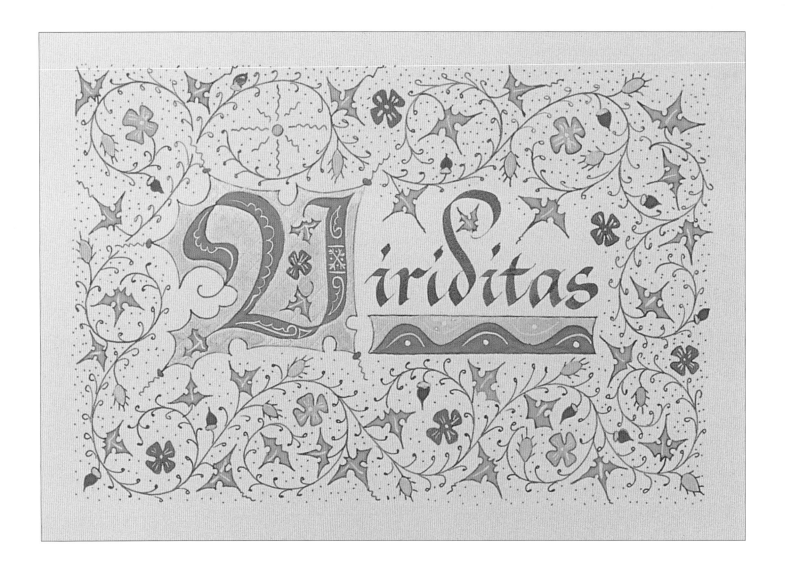

TRANSFERRING THE DESIGN

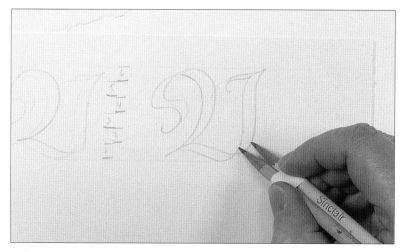

STEP 1 Tape two pencils together to create a tool for drawing large, unfilled letters. Make a pen-width scale, as you have with a nib, by using the width of the pencil tips. To achieve a desired width, adjust the angle of the pencil points to an imaginary horizontal baseline. Then outline your Gothic letter.

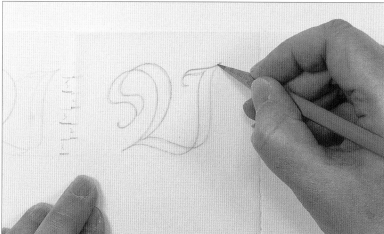

STEP 2 Tape tracing paper over the original letter, and trace it with an HB pencil, keeping the lines fluid. Draw the curves toward your drawing hand for a more natural line. Then turn over the traced letter and apply a thin layer of graphite over the back of the letter with a soft B pencil.

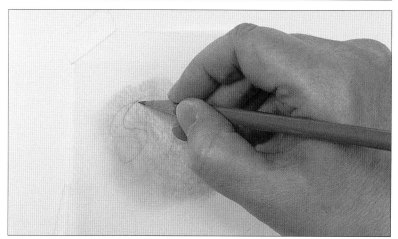

STEP 3 Now position the traced letter on the final art paper, graphite side down. Align the letter within the border of your paper using a triangle and a T-square. Then retrace the letter using an H pencil. The graphite on the back of the tracing paper will transfer the letter onto your paper.

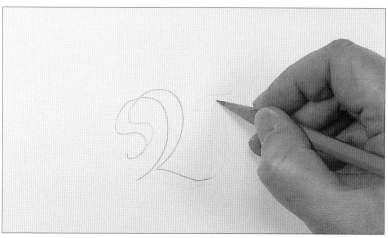

STEP 4 Remove the sheet of tracing paper to reveal the letter on your art paper. Then use a pencil to touch up the lines, as they may not transfer perfectly. Clean up any smudges with an eraser. Once you're happy with your final letter, you can add the decorative background around it.

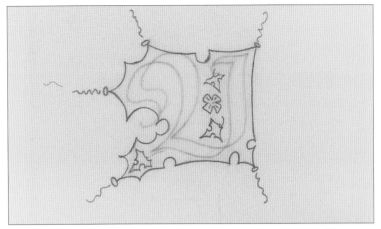

STEP 5 On a tracing paper overlay, draw the decorative shape around the V. Keep the lines close to the letter, creating a roughly square shape with medieval spikes. Add a few ivy leaves and a flower to fill awkward spaces. On the left side, away from where the letters will be, let the spikes flare out.

STEP 6 Turn the tracing paper over and use the side of a soft B pencil to apply a layer of graphite over the leaves, flower, and border. Follow the procedures you used in steps 2, 3, and 4 to transfer this background to your art paper.

CREATING THE ILLUMINATED LETTER

STEP 7 Use the drawing nib and thinned black paint to outline the letter, leaves, and flower. Keep the line weights consistent throughout the drawing.

STEP 8 Prepare dark green, light green, pink, golden yellow, blue, and gold in your palette. Use the smallest brush to carefully paint the letter, leaves, and flower. For tight corners, pull the brush toward the corner, lifting the bristles off the paper as you approach the corner.

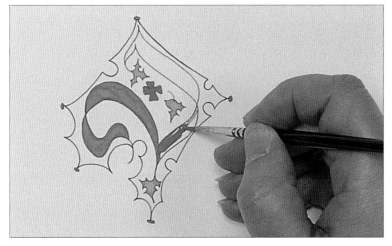

STEP 9 To get opaque coverage, first paint the area with thinned gouache; then flood it with thicker paint. Complete an entire area before moving to the next part of the letter. Gouache creates hard edges when it dries, so painting one area at a time keeps your strokes smooth.

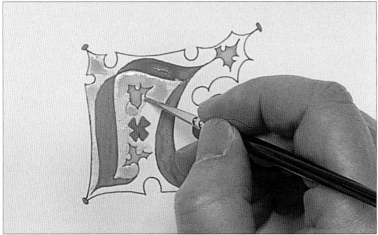

STEP 10 Use gold paint to fill in the background. The gold needs to be fairly thick to cover the area well, but thin enough so you can tease it into corners with the tip of the brush. Add some squiggles at the corners with black paint.

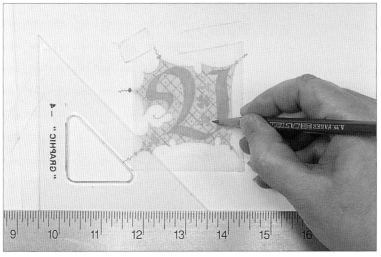

STEP 11 After the paint dries, place two layers of paper towel beneath your art paper. Place tracing paper over the letter, and use a straightedge and a sharp pencil to impress crisscrossing diagonal lines across the gold for a debossed look.

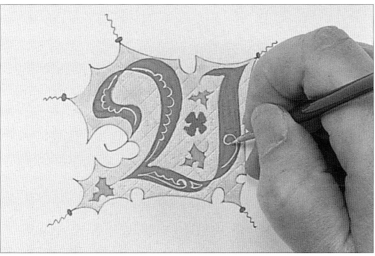

STEP 12 Use the small brush to paint white highlights on the letter, leaves, and flower. The white paint needs to be thicker than the mixture used for filling (such as the green), but thin enough to flow easily from the brush.

PAINTING THE MEDIEVAL BORDER

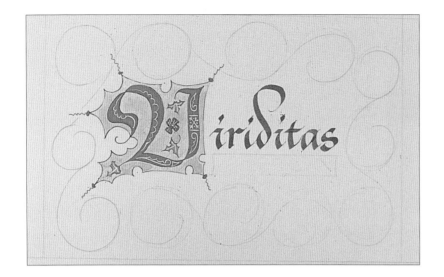

STEP 13 Use black paint to letter the rest of the word in a Batarde hand. Draw a border around the letters, and add the design under the word. Draw circles within the border. Add stems following the circles, alternating the direction of the vine around each circle.

STEP 14 Use the drawing nib to ink the outline of the vine. Allow this to dry and erase any pencil lines. Outline the small design beneath the bulk of the word, and add a wavy line across its center. Then draw some ivy and other elements with a pencil.

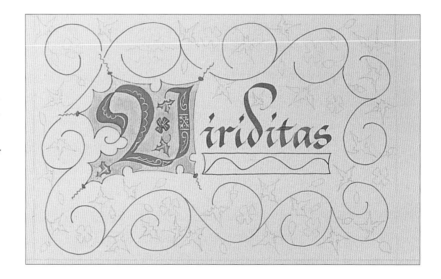

CREATING A DECORATIVE BORDER

- Remember to draw the curves of the vines toward your hand for a more natural line. This motion applies to calligraphy as well; in most cases, you will pull each stroke down and to the right, turning the paper as needed.

- Keep your gouache washes fresh on your palette by stirring them frequently with a clean, moist paintbrush. Then you can spontaneously switch between colors while painting the flowers and leaves.

- To add texture and interest to your border, contrast the thin, curving lines with small dots using your drawing nib. Called "stippling," this technique can also be performed using the tip of a round paintbrush.

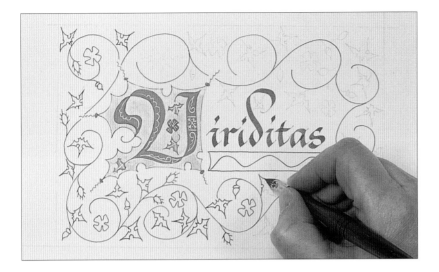

STEP 15 Now go over the leaves, stems, and flowers using the drawing nib filled with thin black paint. Keep your lines fine and consistent, so there aren't any gaps, wide lines, or dark spots to distract the eye.

STEP 16 Use the small brush to paint the leaves and flowers. Fill in the small border using the same colors as the V. Use the drawing nib to add buds on the stem lines in the outer border, keeping them within the rectangular shape.

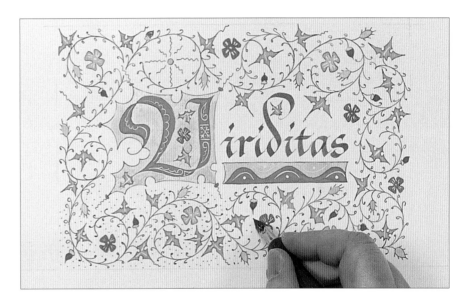

MODERNIZING ANCIENT STYLES

Today's scribes still use decorated letters to call attention to a special word or name. Although the letter R below is based on classic, calligraphic design principles, I've used a looser style for the painted background, resulting in an airy, lighthearted look that has moved away from the traditional Gothic style.

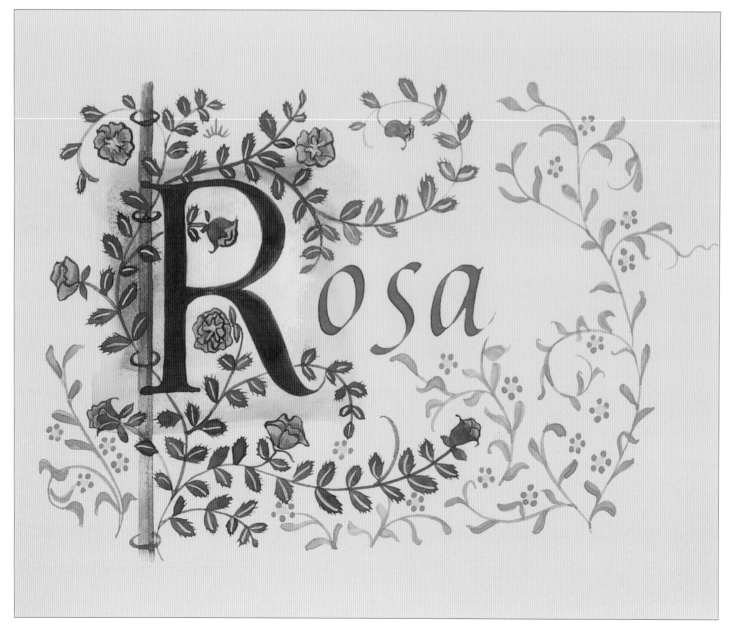

This border was inspired by William Morris's Book of Verse, written in 1870 at the start of the Arts and Crafts Movement in England.

PAINTING THE BACKGROUND

STEP 1 Lightly draw an outline for the background square. Prepare thinned yellow, red, and green gouache paint for the washes. Use a large brush dipped in clean water to loosely apply a square of water within the border.

STEP 2 Load the brush with the lightest color. Touch the brush to the wet paper to apply a little color at a time. Keep the yellow at the center, as shown; then you can frame the yellow by dabbing and dragging the red around it.

STEP 3 After adding the red, drop green into the edges. This will define the brush shapes you used to paint the square. If you like, "float" a brush full of thinned gold gouache into the wet paint. The gold gives a subtle shine to the background when it dries.

STEP 4 You may need to remove some of the extra water as you work. Take a piece of paper towel and roll it into a thin pencil shape. Touch it to the most puddled water to draw up the excess water, being careful not to absorb too much pigment.

WET-INTO-WET PAINTING

- To paint wet-into-wet, dampen the paper with a wet brush and then apply diluted color to the damp paper, as shown in steps 1, 2, and 3. The result is flowing colors that blend into one another, creating new colors where they meet.

- Tape the edges of your paper onto your work surface to prevent the paper from buckling as it dries.

- The heavier the paper, the less it will buckle. Always test your paper before starting.

- Experiment with color combinations on a piece of scrap paper first.

- This wet technique may take a couple of hours to thoroughly dry; don't move your paper while it's still wet, or the pooled color may run.

- The results of this technique may not be what you are expecting, but be open to surprises. The coloring that emerges when the background dries may help you decide which letter you will want to paint onto it.

ADDING THE VERSAL

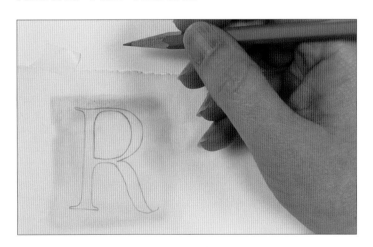

STEP 5 When the paint is completely dry, place a sheet of tracing paper over the painted square. Pencil the letter onto tracing paper and center it within the square, leaving a margin on all sides. Draw light marks on your art paper at the corners of the tracing paper, so you can replace it easily.

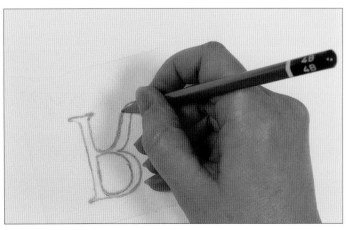

STEP 6 Turn the tracing paper over and use a soft B pencil to draw over the letter. Use an H pencil to transfer the letter to the painted square (as described on page 85). Touch up the resulting pencil lines as needed.

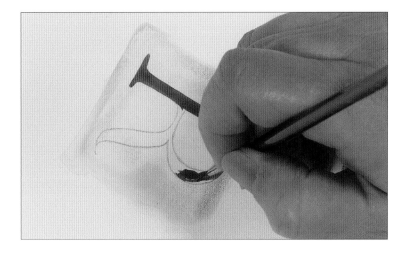

STEP 7 Mix dark pink by adding a small amount of white to red. Use the small brush to paint the letter. Load plenty of paint on the brush and keep a steady hand as you pull the brush toward you.

STEP 8 Clean up any rough edges of the letter by smoothing them with a layer of slightly thinner paint. Allow the letter to dry.

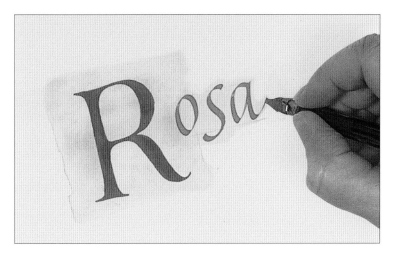

STEP 9 Rule the paper, positioning the baseline of the minuscules near the center of the large versal. This style of using an upright majuscule with an italic minuscule is a classic Renaissance combination. Load the #2½ italic nib with deep green gouache to letter the rest of the word.

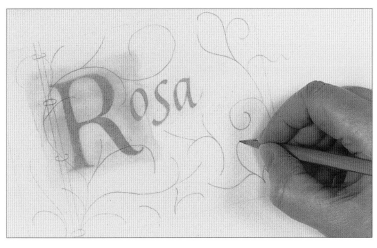

STEP 10 Use a pencil to lightly draw the vines of the border on tracing paper. Add leaves, roses, and forget-me-nots. Transfer the vines, large leaves, and flowers. Draw the remaining smaller leaves freehand.

PAINTING THE FLORAL BORDER

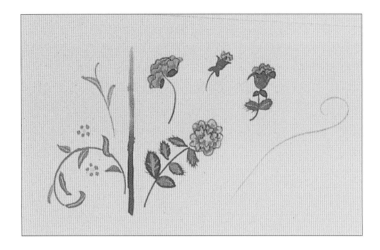

STEP 11 Mix medium and light pink; brown; blue-green and yellow-green; plus a few lighter and darker tints and shades of each. Test the colors on scrap paper. Use strips of paper to mask off the area not being painted on your art paper.

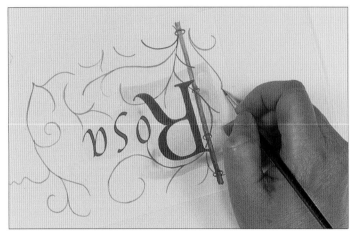

STEP 12 Use the drawing nib or the small brush to paint the vines, keeping the lines sinuous, even if it means straying from the pencil lines. Use thinned brown to paint the pole, and use thicker brown to paint the rose stems.

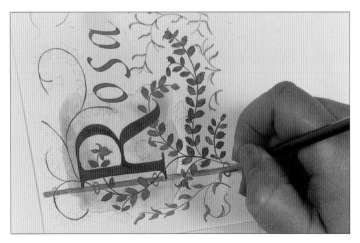

STEP 13 Use dark green to paint the rose leaves, giving the upper edges a serrated look. Paint the leaves of the forget-me-nots using two shades of yellow-green for added dimension.

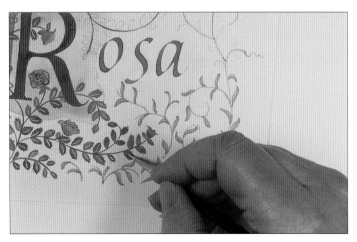

STEP 14 Use light pink to paint the shapes of the roses; then paint the edges of the petals with dark pink and shade the bottoms of the petals with medium pink. With a light tint of green, paint thin center lines on the rose leaves.

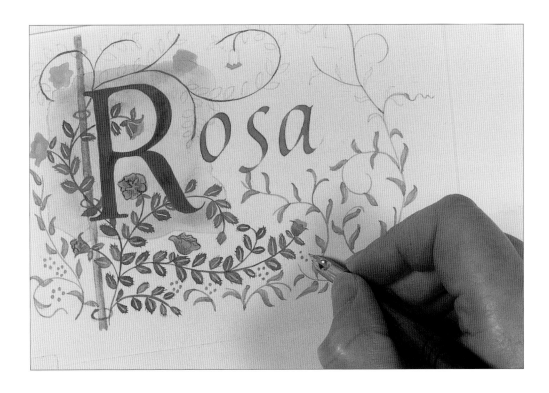

STEP 15 Use the small brush or drawing nib to add light blue forget-me-nots throughout the foliage. Add small yellow dots to the centers of the flowers.

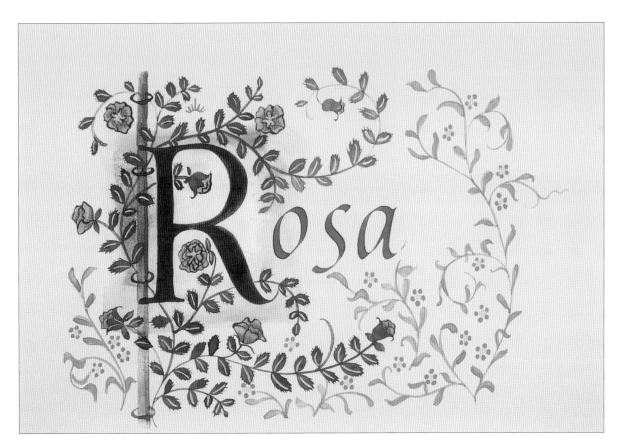

STEP 16 When the paint has dried thoroughly, erase any visible pencil lines.

DECORATIVE TECHNIQUES

As your calligraphic skills develop, you may enjoy adapting and inventing decorative techniques to use with your letters. Look to both ancient and modern illumination for inspiration. The resulting letters can serve as stand-alone monograms or as versals to begin a page of beautiful, handwritten text using your newly developed skills.

DIAMOND BACKGROUND DESIGN

STEP 1 Letter a majuscule with gouache using a wide nib.

STEP 2 Use a pencil to draw a diagonal grid pattern in the counters.

STEP 3 Paint alternating squares of gold and another bright color, such as blue.

STEP 4 Add a fine outline around the letter and a decorative border that echoes the shapes of the triangles and squares.

FILIGREE DESIGN

 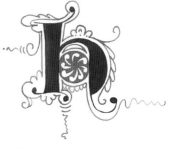

STEP 1 Draw and paint a Lombardic versal. Blue is the traditional color for this style.

STEP 2 Use pencil to draw a filigree design around the letter. This is simply advanced doodling, so there is no wrong way to do it.

STEP 3 Use a drawing nib to trace over the filigree design with red paint, the traditional color for this style. The center design is a series of comma shapes placed in a radial design.

STEP 4 When drawing the filigree, keep your lines fluid and graceful. You will probably not follow the pencil sketch exactly, and, with a little practice, you won't even need guidelines.

SPLIT-NIB EFFECT WITH BLACK AND GOLD

STEP 1 Use a #1 roundhand nib and black paint to write Gothic majuscules. You won't want to use a smaller nib than this; the lines have to be thick enough so that you can stroke within them using the small paintbrush.

STEP 2 When dry, use a small brush to add a center line of gold gouache, which creates a split-nib effect. You may need to go over the gold line two or three times to make it opaque. You can also touch up the black paint as needed.

CREATING DECORATIVE BORDERS

Part of the excitement of illumination comes from the creativity you express by adding elements to enhance your calligraphy. Decorative details need not be limited to letterforms. You can add borders, frames, and other colorful accents to your pages. Design elements can range from small flower and leaf shapes to geometric forms.

To begin your borders, draw the outlines, leaves, and shapes using the drawing nib and thinned black paint. After the paint or ink dries, use thinned gouache to paint the designs, so the lines show through. If you use white gouache, you may want to touch up the outlines. Use the small brush and gouache (but not ink) to touch up lines on top of painted areas.

Chapter 5

CONTEMPORARY CALLIGRAPHY

//

abcdefghijklmn
opqrstuvwxyz

ABCDEF
GHIJKLMNO
PQRSTUV
WXYZ

CONTEMPORARY LETTERING

Alphabets seem to attract us, even when they're not being used to form words. Their letterforms are an important graphic medium; they communicate and reinforce content. Each style represents a voice. In conservative typography, the voice is rather subtle, but in graphic and illustrative work, it is more prevalent and powerful. Like calligraphy, learning and mastering lettering takes practice. With practice and observation, your ability to add your own variations to the alphabets in this book will increase.

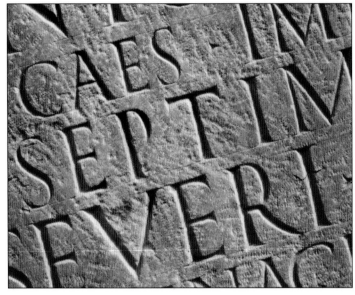

Roman letters

TELLING A STORY

Lines and shapes contain a content of their own. They speak with a language that we can use and manipulate to influence, alter, or reinforce a message. When applied to letterforms, these lines and shapes tell us a story before we even read the message. Our agreed social conventions have letter styles associated with them. When you see lettering that is fancy, grandiose, or elegant, you may think of a wedding or poetry. When you see blackletter, with its strong rhythms and angles, you may think of church, Europe, or even German beer. An old sign may contain a sans serif "Gothic" that evokes images of Grant Wood's painting *American Gothic* or a general store of the 19th century. When people started to work with letters in this illustrative manner, graphic design was born.

CONTEMPORARY LETTERING

Technically, the skills required to do this work have changed little until fairly recently. The way it has been done for thousands of years was by physically drawing, painting, or writing the alphabets. Only in the past 20 years have digital tools become a significant factor. Ironically, technology has given birth to some lettering that looks amateurishly hand done, which I call the "no skill, but great commitment look"—the human touch exaggerated. It reflects the individual's need to be different, nonconformist, and expressionistic. I like it, and it is one of many "voices" we can use. Oftentimes I think of my work in terms an actor might use. On some projects, it takes me a while to "find the character."

HOW TO USE THIS CHAPTER

This chapter features a range of styles that you can use as a source of inspiration or replicate in your personal lettering projects. The letterforms contained herein cover a range from classic and elegant to edgy and personal. You'll learn to exert control over nuances, creating variations on the fly—something that is not possible with computer fonts. Some styles are decorative; others derive their forms by being connected to the subject matter. You can even create variations of the featured letterforms by altering the underlying form, height, or weight, or by adding or removing serifs.

Some styles—like the classic form—are neutral. (You can use Roman capitals almost anywhere, for example.) Others have more specific uses. Some styles require more study and practice than others; however, if you study classic forms, you'll be able to render virtually any other style. Your personality will still show through in your letters, and your freestyle work will be more solid. It is important to remember that these are not fonts: You don't have just a few selections from a menu, but rather a continuum of lettering choices that are fluid and malleable. Once you master some basic techniques and principles, you will be ready to begin your own creative journey.

Take note of the relationships within each style and the key letter shapes. Anyone can make one impressive letter, but your new skills will come into play when you have to make the other 25 letters to match!

LETTERING ART

In my work, lettering is sometimes an independent image; other times it complements a photo or illustration. It may even contain qualities of the photo or illustration combined to look like one idea or thought. I design letterforms for a particular purpose, and this gives me control that one doesn't have when searching through a font menu. Lettering and calligraphy overlap in many areas, but they differ in a few important ways. Calligraphy has gone through many changes in the past two decades, and the lines between calligraphy and lettering have been fading. The difference is subtle, but it comes down to "writing art" vs. "lettering art." Each has a slightly different aesthetic and purpose. I like to think that "writing art" is more related to calligraphy with a performance element, whereas "lettering art" can be done by any means; however, each has borrowed from the other. Almost no one is a purist anymore.

IMMERSE YOURSELF

Become a collector of any lettering art that appeals to you, and try to discover what makes a particular piece work. Study from books and attend workshops.

Start looking at all the letterforms around you. You will find many sources on the web, in magazines, in bookstores, on the sides of classic cars, on food labels, and in movies—just look for them.

It's natural for people, whether practicing their signature, drawing comics, writing a letter, getting a tattoo, making art with words, or working on a business logo, to want to play with and discover what they can do with the shapes

of letters and their arrangement on a page. As long as expressing our individuality in words is important, there will continue to be uses for hand lettering. Once you get started, you may very well become addicted.

HONING YOUR SKILLS

Mastery is the same for everything in life: Plenty of practice is key.

Your first attempts at lettering will be focused on technique. But if you want to become a professional, you are better off with a recognizable style than with great technical ability. That is because *you* are the content, so a handwriting that has style and character is worth more than perfectly rendered Roman letters.

—John Stevens

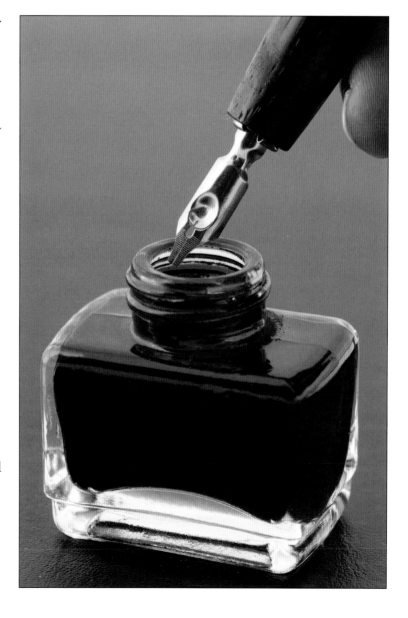

FUNDAMENTALS

The first important technical elements for a beginner of hand lettering to learn are hold, stroke, and rhythm. You must learn to do these things correctly before you will be able to write consistent letters. It takes practice in order to work with confidence. A stroke should not feel hesitant, and the shape the tool itself is prone to create should be understood and applied to the letterform that you are rendering.

HOLD

In general, brushes and pens should be held fairly vertically, with the back end of the writing instrument pointing toward the ceiling. Avoid pointing the handle toward the wall behind you (exceptions to this rule involve some ruling pen techniques). Most beginners hold the brush or pen too flat. The hold is a gentle grip between the thumb, index, and middle finger (for support). You can achieve great results no matter what technique you use; however, you must compensate for an incorrect hold with the way you move the brush or pen, which artists often do. Great art has been produced regardless of the technique. I like a vertical hold because it is the best starting point from which to move in any direction or flip to any side of the pen or brush. If your hold is flat with a locked grip, it will be hard to be fluid later, and you may have to unlearn some bad habits.

STROKE

Generally, stroke order should move from left to right, from top to bottom, and should attack vertical lines before horizontal lines. If you think a particular portion of a letter should be done in one stroke but it's just not working for you, try two strokes. Be careful and take your time.

The control of ink or pigment—getting the flow and the amount of ink correct—is a challenge for beginners. It's a combination of practice and knowing a few principles. It is a balance between having plenty of ink for flow and having a little bit for control (no blobbing, puddles, etc.). Because all inks are different, I usually have a palette or swatch of paper on which to test my pen or brush before I touch it to the page. With pen, I dip to load when the work is loose and free, and I load the pen using a brush when I must control the amount of ink on the nib to maintain consistency or to produce the hairlines on thin strokes. (See "Loading the Instruments," page 105.)

Dab a broad-edged brush on a palette after loading it with ink in order to shape its bristles and move the pigment to its tip. A pointed brush can be dipped and used for writing immediately, or dabbed on a palette first if the artist chooses to err on the side of caution.

RHYTHM

As you begin to create strokes and acquire a feel and confidence for making the most basic shapes (and doing so repeatedly), you will start to develop a rhythm. Rhythm is a natural process that helps unite the letters that are strung together. In lettering, our tasks start to become rhythmic, thereby gaining fluidity and momentum.

When we say we need to "warm up," we are referring to this natural phenomenon. Start with verticals; then move to horizontals, curves, and diagonals, and then try your hand at "key letters." (See "Key Letters," page 101.) Think about geometry and the quality of drawing. It might take some time to feel confident with the tools, but it will come together if you hang in there.

COMMON CHARACTERISTICS

Each tool has a unique technique associated with it, yet there are several aspects that overlap. Lettering, like calligraphy, has some characteristics common to most styles:

• Interesting line and characteristic shapes

• Proportions

• Variation in line

• Underlying structure

• Serif or sans serif
 (see box at right)

• Joints and connections

• Weight

SERIFS

Serifs are the details, or short lines, that stem at an angle from the ends of the strokes that form a letter. When an alphabet does not have serifs, it is known as "sans serif."

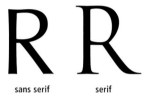

sans serif serif

KEY LETTERS

When you are learning a new style of alphabet, it's best to start with the "key letters." These letters will serve as your key to the straight and curved lines that are consistent throughout the other letters of the alphabet. For most alphabets, these letters are i and o. Next practice d, b, p, and q, and then progress from there. When you group letters by shape, it's easier to create unity. This methodical practice will help you to learn the inner relationships that make the letters in the alphabet go together, instead of seeing the letters as 26 different shapes. Key majuscules are H, O, N, and E. You can also organize letters into width groups. You will begin to see that the m and the n, as well as the P and the R, are made up of the same genes.

While learning a new alphabet, also take note of proportion. Classical letters have precise proportions, whereas unconventional letters usually do the opposite to create that "unskilled yet intentional" look.

KEY LETTER GROUPS

i m o

a e c

h n u r

b d p q g

k v w y z l

f t s j

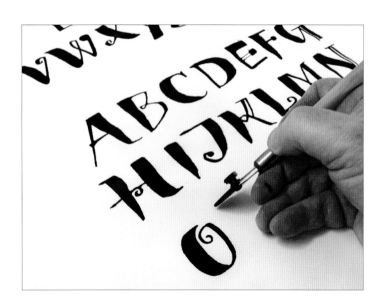

TECHNIQUES

The scribe of the past would cut a reed or quill pen, thus shaping the nib to his or her preference. You may find that you need to modify tools to your preference as well. For example, metal pens sometimes have a polished and slippery feel. When this occurs, roughen the tip with some very fine sandpaper. As you master the techniques in this section, you will discover ways of modifying your tools that will make them work to your advantage.

BROAD-EDGED TOOLS

With the broad-edged pen, start with simple, even strokes and hold a consistent pen angle. Most beginners start with a hold that is too tight and shallow, but then should develop a hold that is more vertical. Even though many of the alphabets in this section are informal, you will find that it is helpful to use a T-square to draw straight lines on your lettering surface.

CORNERING When cornering, use only the corner of the pen's nib to create a thin line or to fill in detail. This technique is often used for hairlines and sometimes for ending serifs.

BROAD-EDGED BRUSH

The broad-edged brush is somewhere between the broad pen and the pointed brush because you can borrow influences from both sides. Use it as a broad pen or use it as a "hybrid" brush.

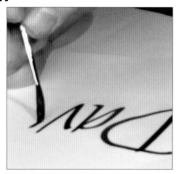

WAISTING

Waisting is accomplished with a slight quarter roll, or counterclockwise twist of the pen midstroke. This will give the line more visual interest by making it concave.

straight stroke waisted stroke

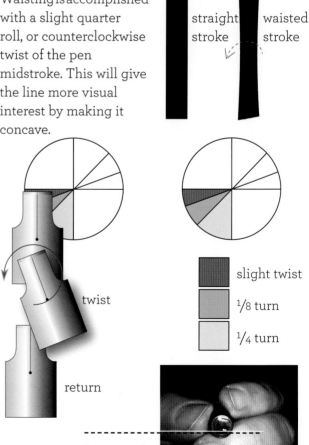

twist

return

slight twist

⅛ turn

¼ turn

horizontal baseline

BROAD-EDGED BRUSH HYBRID

This is an example of using a drybrush technique with a broad-edged brush to create an interesting effect. By doing this, the brush exhibits qualities of both a pointed brush and a broad-edged brush.

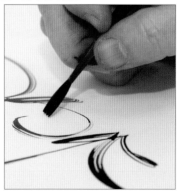

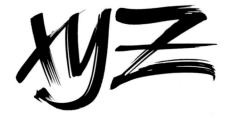

RULING PEN

The ruling pen is a play tool for many. Sometimes it seems as if you are violating the paper, as marks are forceful and the paper fibers can get roughed up. There is no right or wrong way to write with this useful tool.

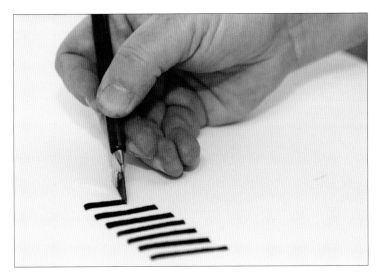

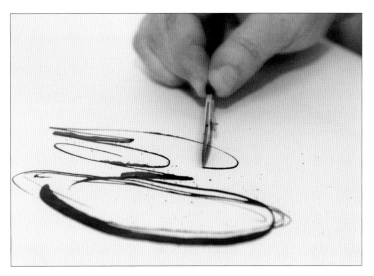

FOLDED RULING PEN The folded ruling pen creates a thin line when you work with just the tip, a thick line when you use its side, and every line variation in between as you move from one position to the other.

EXPERIMENTING WITH MARKS Here I am using what I call a flat hold, where I hold the pen as I would hold a knife at the dinner table. Although it is important to gain control of the ruling pen, the trick is to make the marks look slightly out of control.

POINTED PENS

This type of pen is associated with "copperplate" and Spencerian script, but it can be used for contemporary handwriting as well, especially when the tip has been modified. Putting a slight broad edge on a pointed pen is a modification I commonly make by sanding it down with an Arkansas stone. Another way to change the effect of a pointed pen is by using the pressure and release method (at bottom right).

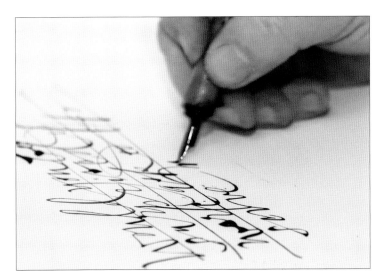

FLEXIBLE PEN Traditionally, most calligraphy was done with either a pointed pen or broad-edged pen. Both create "shaded" lines, but they achieve the shading in different ways: A pointed pen employs pressure, and a broad-edged pen changes in direction. Here I am adding pressure to a flexible pointed pen, which adds weight to the line.

PRESSURE AND RELEASE For this technique, add and release pressure applied to the point of your pen, which will spread and unspread the two blades. This motion controls the flow of ink onto the paper and allows you to create variations in line weight.

POINTED BRUSH

The pointed brush is full of variables and thus may be a little unnerving at first. I think it is the most valuable tool in many ways because you can draw, paint, and write in a variety of media and on almost any surface. Direction, pressure, and speed all affect the line you make with the pointed brush. The brush can be held upright or on its side; you can work with the point for thin lines or the broader base for thick lines. Develop a feel for this tool by practicing a variety of strokes.

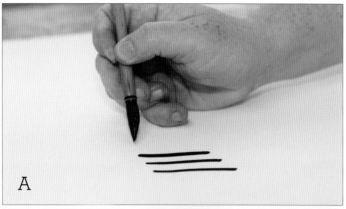

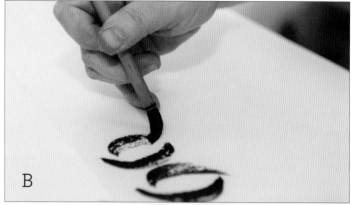

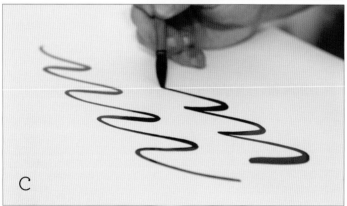

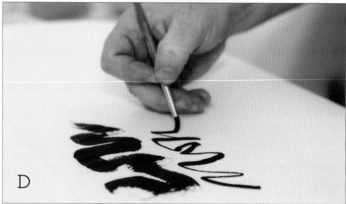

POINTED BRUSH HOLDS These photographs show the common approaches to handling the pointed brush. You can either work on the tip of the brush (A), work on the side of the brush (B), or use a combination of the side and tip of the brush (C). You can also create variation with pressure (D). There are different types of brushes, and the shapes, sizes, and bristles all make a difference. Both the paper you use and the method you employ to load ink into the brush will also impact the final result.

CHINESE BRUSH

The Chinese brush offers more variation in its stroke than other pointed brushes. Some Chinese brushes exert control and others are more like mops, dragging along the paper and leaving a brushy mark that gives (or reveals) character. Just like the pointed brush holds shown above, there are several holds for the Chinese brush: holding the brush handle vertically, holding the brush handle at an angle, working with just the tip, and working with splayed bristles.

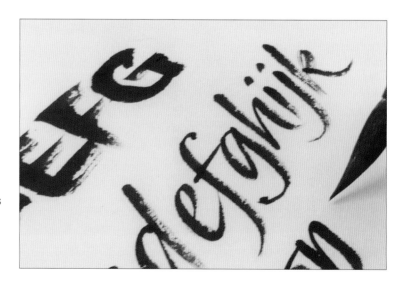

LOADING THE INSTRUMENTS

In fine writing, where precise control over the flow of ink is extremely important, use a paintbrush to load the pen with ink. To maximize consistency, I load the ink with a medium-sized brush. If I dip a pen, I almost always test it on a scrap of paper before committing to the final piece. In lettering, you must be able to predict what your tool will do—at least to some degree. Once you have established control, you can take more chances. Otherwise, it is simply a matter of personal preference.

Beginners have trouble judging ink dilution. If you are dipping and you load too much ink into the pen (in an attempt to extend the duration of your writing time without having to reload), you will end up with blobs. If you do not load enough ink, you will be reloading too frequently, which creates a break in rhythm. Practice is the key to fine-tuning your loading skills.

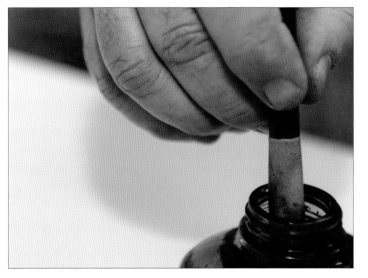

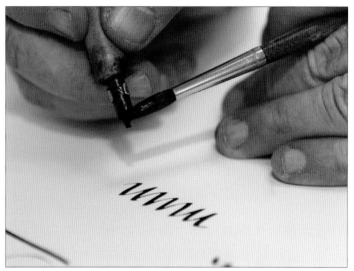

DIPPING For more spontaneous writing, you can get away with dipping the pen in the ink. Just be aware that the first stroke you make on the paper will release the most ink; subsequent strokes will release less and less ink.

USING A BRUSH Begin by taking the loaded brush in your left hand (if you are right-handed). If writing at a small size, carefully touch the tip of the pen with the brush and load a little ink into the reservoir. How much ink you load depends on how small the writing, how fine and absorbent the paper, and how fluid the pigment (ink).

LOADING COLORED INK & PAINT

When working with color, you will dilute your ink or paint with water to varying degrees depending on the effect you want to achieve. Very controlled (fine) writing cannot be expected with loose, watery ink. I often grind my own sumi ink for control. Higgins Eternal Ink has a controllable consistency, but you may want to dilute it if you are writing quickly. I find that an eyedropper is a handy tool for loading my pen when I want to create multicolored marks. The variables to consider any time you are diluting ink or paint and loading your writing instrument are the type of pen (or brush) you are using in relation to the size of the lettering, the density of the ink pigment, and the thickness and absorbency of the paper.

MASTERING THE ART

In music, you learn both the instrument and the notes at the same time. Lettering is similar in that you are learning the tool and the subject of lettering simultaneously. In order to become a master of both, there are a few things to keep in mind.

PRACTICE!

Above all, diligent practice will help your lettering skills flourish. As you get a feel for the tools you are using, you will gain confidence. Start by copying something carefully, such as an alphabet or a page of text. Observe the difference between your trials and the exemplar. Careful study of each letter is necessary. Practice with the exemplar right in front of you. Do not trust your memory at first. I recommend that you take plenty of breaks and even draw the letters so you are really "seeing" each shape, line, and curve. People often confuse "looking" with "seeing." Everyone looks, but not everyone sees. It takes time and effort to see, which is why drawing is so helpful. It slows you down, turns off your "naming" mind, and lets your eyes do all the work.

People often practice for hours at a time with days between sessions. Do the opposite: Hold short but frequent practice sessions. Learning is the result of observation, taking notes, and repetition at frequent intervals. Portable brushes and pens are available, so you can spend some of your free time practicing in a notebook. Simply having the tool in your hand and making marks will help. If you become bored or frustrated, play with the tools. Don't try to do anything specific; just see what happens. This is how you balance that desired look you may have in mind for your finished work with letting your creativity flow.

Having said that, you can check your own work in these ways: 1) Always have the model right in front of you for comparison. A common mistake students make is burying the exemplar as they concentrate on gaining control. This leads to practicing the wrong strokes over and over. 2) Create a map for yourself. Cut out your best efforts and place them next to the model. Draw or trace the model to make sure you are really "seeing." From time to time, be brave and hang what you have done on the wall to really "see" it. I guarantee you will view your work differently by doing so.

TIP

Remember to be methodical about your practice. Date your practice sheets and keep them—it's important that you notice your progress!

FINDING INSPIRATION

It's also a good idea to start a file of clippings that inspire you. This includes work you like, lettering in books and magazines, or fonts from the web that appeal to you. Old signage is disappearing, so get out that digital camera and snap as many photos as you can. Some sign shops still produce hand lettering. They are a friendly bunch, so call and see if you can stop by to see what they do. Be mindful not to interrupt working people; you will have to judge based on the friendliness of your host. But this might just be the last generation of sign painters, and they have a plethora of tips to share about drawing letters.

GETTING STARTED

As soon as you feel confident (don't wait too long), I recommend that you complete a project. Make something with what you have learned. There are many ways to apply your newfound skills: You can make an alphabet page, a poster, a book, a postcard, a logo, or a sign; letter your mailbox; draw your favorite quote; or design a program for school, church, your band, or other organization. Simple design (organizing lettering on a page) is more valuable than complex design in the beginning.

Not only will you then have a finished work of art, but your knowledge will be enhanced by completing a project. It is the secret of "anchoring" your skills and knowledge into your subconscious. Think of it like exercise: Your mind and vision will expand from creating and completing a work of art.

Whether the work is perfect is irrelevant; it is much more important that you finish and then move on to the next project. This is how you gather momentum. Over time, know that you will improve immensely through practice.

MASTERING THE ART OF LETTERING

Ask anybody who does lettering or plays an instrument and they will tell you that it is an ongoing process. You are never done learning. This is good news, as people as talented as Leonardo da Vinci have made it their life's mission to study and learn about infinite possibilities. Da Vinci believed that one's vision should be ahead of his or her ability. You should not strive for perfection; you should instead strive for excellence.

www.calligraphycentre.com

iPhone Wallpaper by John Stevens

"HAVE NO FEAR OF PERFECTION— YOU'LL NEVER REACH IT." —SALVADOR DALI

FURTHERING YOUR EDUCATION

If you are striving to become a professional lettering artist, additional education is recommended. A classroom setting will provide even more inspiration, and you will be able to see the process firsthand. More important, you will receive feedback from peers and see how other students progress.

The following pages feature a collection of models from which to work. After many years I have attained a level of excellence, but I too am still learning. Enjoy the journey!

CLASSIC WITH A TWIST

Classical lettering is refined and beautiful, and its letters have withstood the test of time. One of the most celebrated examples of this style can be found at the base of the triumphal Trajan Column in Rome. The Trajan Inscription contains the most elegant forms of Roman lettering, and it was written nearly 2,000 years ago. Imagine that. We still use the letters of the Roman Empire! This is because you cannot improve them— you can only alter them. They are considered to be the highest in the letterform pyramid. I recommend that any serious lettering artist do a thorough study of them. They are a fine balance of form and function. They are (unfortunately) also difficult to replicate well. In this section, I have included some personal variations that are not as difficult to create as the Trajan letters, but exhibit some of the same elegance. They are done with a broad-edged brush or pen. Variations can be found in history from 2,000 years ago until present. These letters were studied in the Middle Ages and during the Renaissance era, and they are still studied today.

There are several ways to approach Trajan variations: written, drawn, or built up with broad or pointed tools. In writing them, you will learn a few special techniques that will be useful for other hands as well. My purpose is to share methods that are not too demanding, with the assumption that you may not want to be purist, but rather that you will want to create beautiful letters that are placed well on a page.

TOOLBOX

Broad brush

Broad-edged pen

Modified pointed pen

Ruling pen

ZENFUL

The Roman Empire's monumental caps are still the standard of excellence today, and they require a great deal of effort to learn and replicate. This adaptation is an elegant and less difficult version of the Roman Imperial Capitals. Zenful is a narrow Roman alphabet without serifs, with highly modular shapes in its curves, and a soft triangular motif. I have been developing this alphabet into a typeface (font) for the last four years. This alphabet has strong links to classic function and form. I created these letters using a broad brush with a round ferrule.

ABCDEFG
HIJKLMN
OPQRSTU
VWXYZ&

LUX ET UMBRA VICISSIM
SED SEMPER AMOR

"Light and shadow by turns, but always love."

LATINA

Latina letters are playful as they bounce on the baseline, yet they contain the elegant lines of Roman capitals—delicate and airy. I created these letters with a broad-edged pen using a few techniques that will take some practice to perfect: twisting, cornering, and pressure and release. (See "Techniques," page 102.) You have the choice to work with any of these techniques once you are familiar with the forms. For me, my choice of technique depends on the size of the letterforms and the look that I want to achieve.

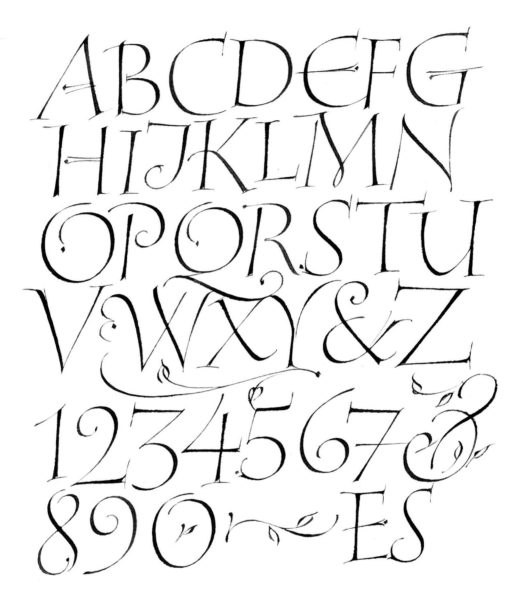

A LESS STRENUOUS METHOD

This Latin phrase was written with a pointed pen that I modified by shaping the point to a small, broad edge with an Arkansas stone. This helped the pen to function as both a pointed pen (flexible width) and broad pen. I created these lines by simultaneously building up the letters and using pressure and release.

PARVIS · IMBUTUS ·
TENTABIS · GRANDIA · TUTUS

"When you are steeped in little things, you shall safely attempt great things."

LIBRETTO

Libretto is a flowing script with strong calligraphic leanings, which serves as a basis for my other ruling pen alphabets and for gaining control of the ruling pen. Start by practicing the straight and curved lines that form this alphabet. Then move on to O, G, C, and Q. Once you've mastered those letters, move to B, R, and P, and then move on to the rest of the alphabet. In other words, you should warm up with families of letters, rather than start with A and work your way to Z. You want to feel the strokes by repeating them. Once you're warmed up, you can move to words and continue to work on individual letters that are giving you trouble.

ABCDEF
GHIJKLM
NOPQRST
UVWXYZ
abcdefghijk
lmnopqrstuv
wxyz Piano

BRUSHSTROKE

If an artist wants to make letters by hand, oftentimes they would like the lettering to have that "hand done" touch. With the brushstroke method, the letters display the characteristics and changes in transparency of the animated stroke.

The brush continues to be popular—partly because of its versatility and partly because it is a liberating and expressive tool. A brushstroke can communicate everything from power to delicacy and has a very long heritage—especially in the East. The Chinese and Japanese (along with other Asian cultures) have developed writing to a very high level, and the brushwork in the best of Asian art is deserving of study and admiration. Abstract expressionist painters were heavily influenced by the powerful brushstrokes of the East, where the way each stroke is executed is a high art. In the West, the brush is an experimental tool for creativity.

Even when not being wielded in a traditional manner, the brush is still a great mark-making tool. Simply by viewing its mark, one can see where the stroke started, its speed and direction, and where it ended.

TOOLBOX

Pointed brush

Broad brush

Large Chinese brush

The most challenging aspect of learning the brushstroke is becoming accustomed to what the stroke wants to do and absorbing this into your subconscious, which will allow you to create with its natural shape. When you pick up the brush, you will discover it is not the easiest tool to control—you must become familiar with its "inner rules." (See "Pointed Brush," page 104.)

ANIME

Written with ink and water to achieve a variety of tones, Anime is basically narrow and medium weight, with the occasional wider letter and heavier-weight stroke. If you are consistent with the basic rhythm, these two variations will go a long way to giving the feeling of variety and—depending on the quality of your strokes—a degree of individuality. Pressure and release in rapid movement is necessary to create variations in each stroke.

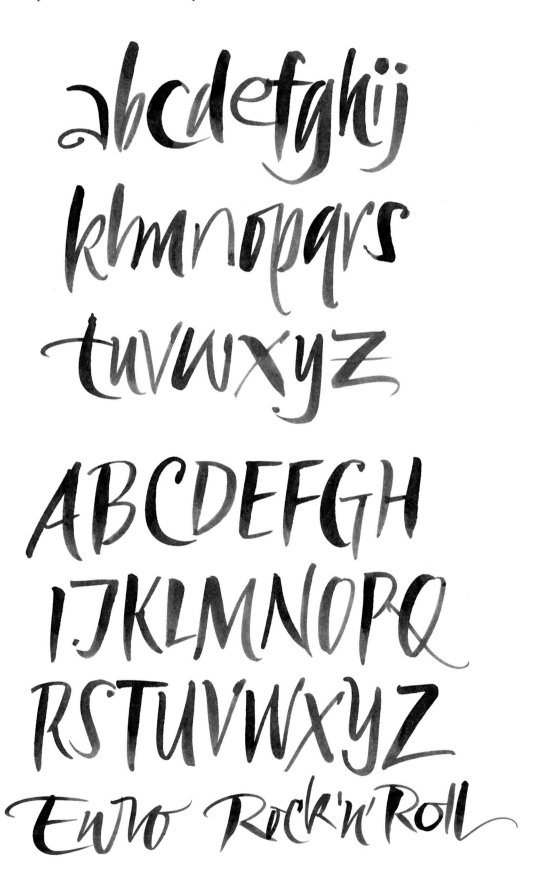

BEIJING

For this alphabet I used a large Chinese brush. Allow the bristles to make their characteristic marks by finding the right balance of ink loaded in the brush according to the paper's receptivity. Some papers absorb a lot of ink (Japanese papers are sensitive in this way and will help capture every nuance of stroke), but it is possible to get interesting effects on rough watercolor paper or Arches Text Wove as well. You should experiment on all types of paper.

The basic strokes are as follows: press, move, stop, then lift to make a bonelike stroke. Or you can press and move while lifting slightly to produce a stroke that tapers off. It will take some practice to feel free in your movements, but this type of brush makes very characteristic marks, so it should be fun. In this alphabet, the side of the brush is used more than the tip, occasionally "squashing" the hair when the ink is running out to create rough drybrush marks.

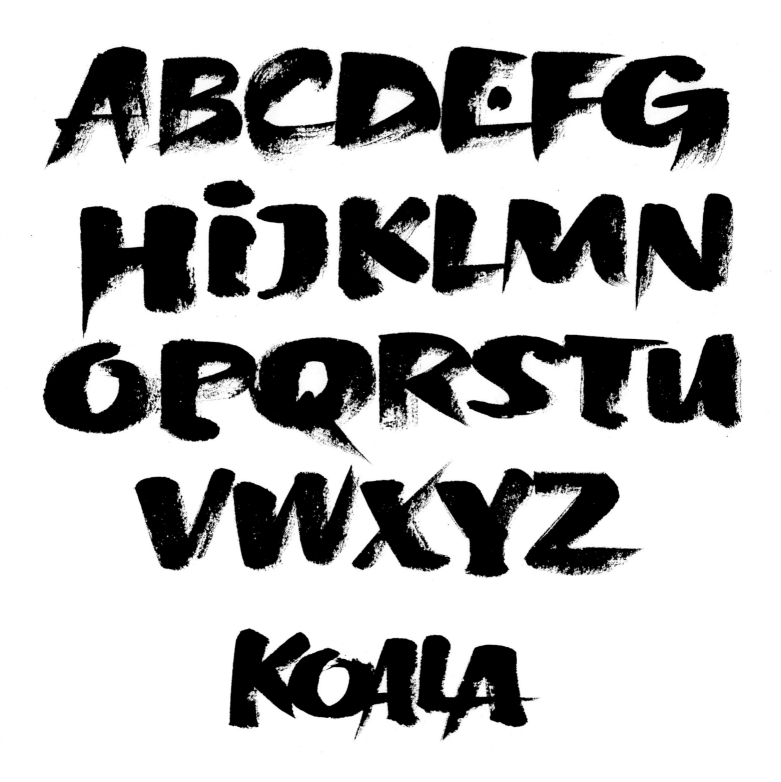

FRESH

This energetic alphabet, which I formed on Japanese paper, is all about finding a good match between ink and paper. Any pointed brush should work for you, but remember that every brush produces a different result. I like to collect brushes and learn the characteristic mark of each; then I choose based on my experiences. Write these letters quickly, keeping in mind that rhythm and energy are the important factors in this style. The strokes are a mix of the side and point of the brush, so practice several holds and stroke variations to learn what works for you.

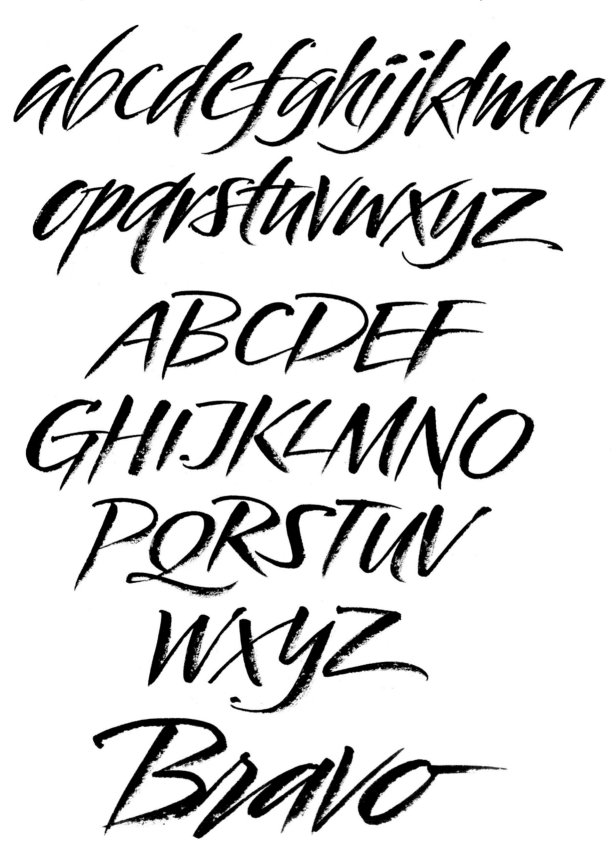

FUN & FUNKY

This lettering is unabashedly expressive. It is lettering that begs for attention. It is less disciplined than classic-inspired hands, and presently it's a bit trendy. You can use these styles in place of typography, where it complements the perfection of the computer with a human element. There is a culture to this type of work, and it is mostly associated with youth and creativity. (Picture your high school notebook.) You can draw or write these letters with any tool. I prefer the ruling pen, but you can use any instrument with which you are comfortable. Once you get the hang of the basic rhythm, you can invent your own alphabet. You do not need every letter to be crazy or different. In order for the variety to work, you must establish some order or unity to the letters. That might sound funny, but you get more "pop" on your creative play if you restrain in areas to provide the stage, or backdrop, for the drama.

TOOLBOX

Broad-edged pen

Pointed pen

Modified pointed pen

Ruling pen

Folded ruling pen

FUNK 49

I created Funk 49 with a folded ruling pen. The characteristic stroke has a taper, and the weight feels a little random. Despite this, notice that it still has a nice movement and rhythm. Using the side and tip of a ruling pen are the two basic moves you will employ. The advantage of the ruling pen is that it does not create fixed-width lines, thereby allowing you to create interesting shapes. Unfortunately, this "advantage" is also the downside, as you need to learn to control the pen before finding consistency.

ABCDEFG
HIJKLMN
OPQRSTU
VWXYZ&·
abcdefg
hijklmno
pqrstuv
vwxyyez
Super

SATURNIA

I created Saturnia with a ruling pen, but you could easily create these letters using the cornering technique with an automatic broad-edged pen. This is a mix-and-match alphabet hung on a structure of square-shaped, narrow letterforms, with the occasional wide letter thrown in. As in drawing, fantasy can be introduced at any time.

abcdefghijk
lmnopqrstu
vwxyz æs 123
4567890 ABCD
EFGHIJKLMNO
PQRSTUVUXYZ
& Taxi

POLYLINE PILE-UP

Polyline Pile-Up, which pairs a doodlelike quality with sophisticated play, is a good match for the ruling pen. Characterized by lots of movement and personality, these letters can also be created with a pointed pen or pencil. As in any other alphabet, one must grasp the idea of dynamic balance (the amount of black versus white that each letter contains) with a touch of uncomfortable variation. The lines dance around the narrow, squarelike structure that makes up each majuscule. This alphabet serves as a good way to both practice and play at the same time.

EDGY

Edgy styles are sophisticated yet a bit aggressive, or "forward." This lettering has beauty but does not fall into the "pretty" category that is normally associated with calligraphy. This group has calligraphic underpinnings but seeks to put more action and expression on the page. Many of these alphabets can be created with any writing instrument, with each tool producing different variations. Notice the weight placement: Broad tools will place the weight at a low-to-high axis, whereas the ruling pen and pointed brush will do the opposite. I prefer to combine the two influences to create "hybrid" type effects. I don't recommend that you do this at first, unless you have great visual judgment. It takes a while to learn the rules and know which ones to break. When you want to create lettering with a contemporary feel, this style is a good bet.

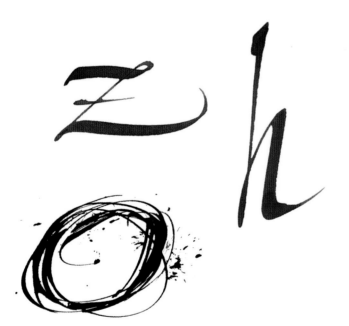

TOOLBOX

Brush

Broad pen

Modified pointed pen

Ruling pen

MANIC

You can replicate this alphabet using a pointed pen or a ruling pen. Focus on creating a balance between strokes that repeat and those that introduce variation. Also be mindful of the dynamic balance (amount of black versus white that each letter contains). The letters feel a bit unpredictable, yet they harmonize. Try using a flexible pointed pen with a broad edge to create an exciting stroke that will produce a bit of splatter. Broken pens work as well. Also, your first efforts are likely to be too busy—so think to yourself, "Less is more."

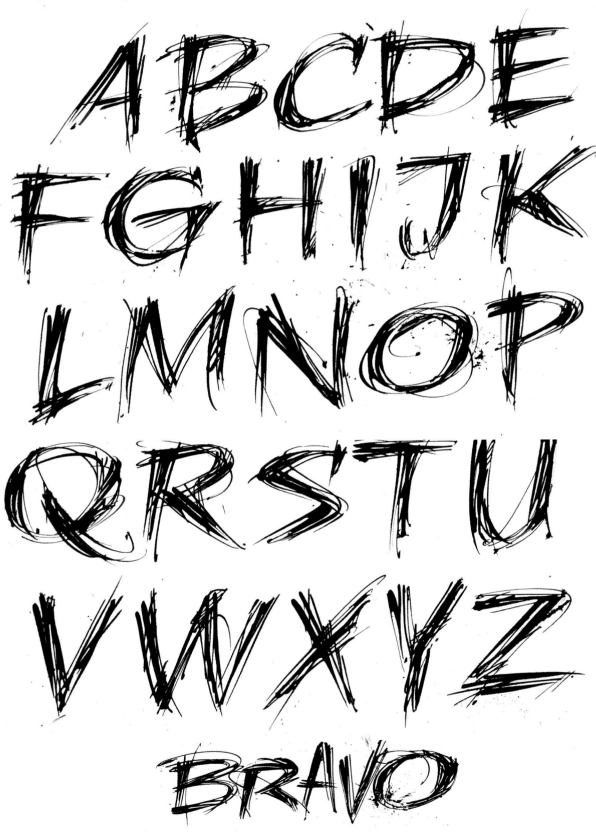

BOUNDARY

Boundary is a pen-written script in a contemporary, upright italic form. It is a cross between italic and an upright cursive, with more movement and a less predictable weighting pattern than straight italic. It is best to begin writing this alphabet with an automatic pen.

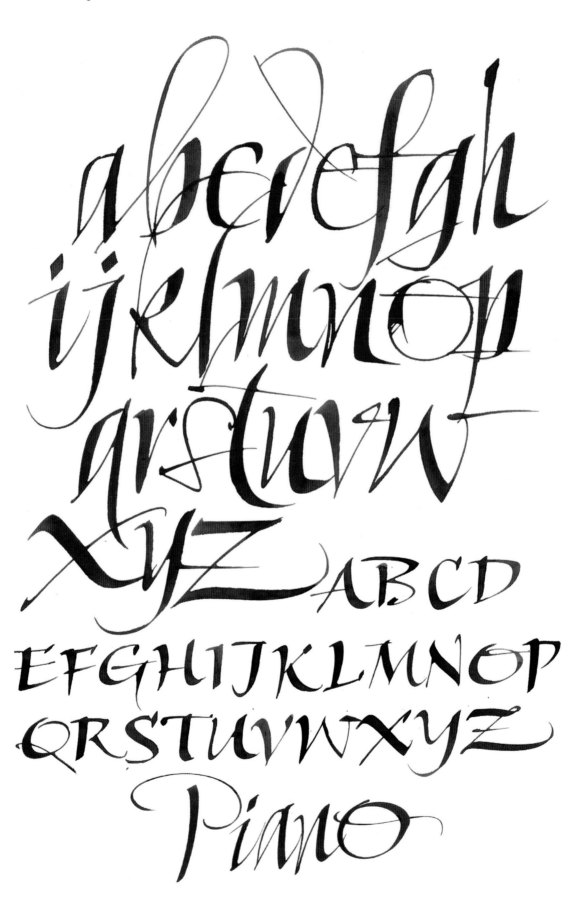

INTERTWINE

Intertwine is an alphabet of capitals with a fairly light weight (you can adapt them to be heavier or lighter), which I completed with a ruling pen. The appeal of these letters is that you can stack or arrange them in a "lock-up"—a composition that features an interesting form and pattern. In all lettering, the form, rhythm, and movement interact, and the aim is to create an overall pleasing pattern with cascades of movement.

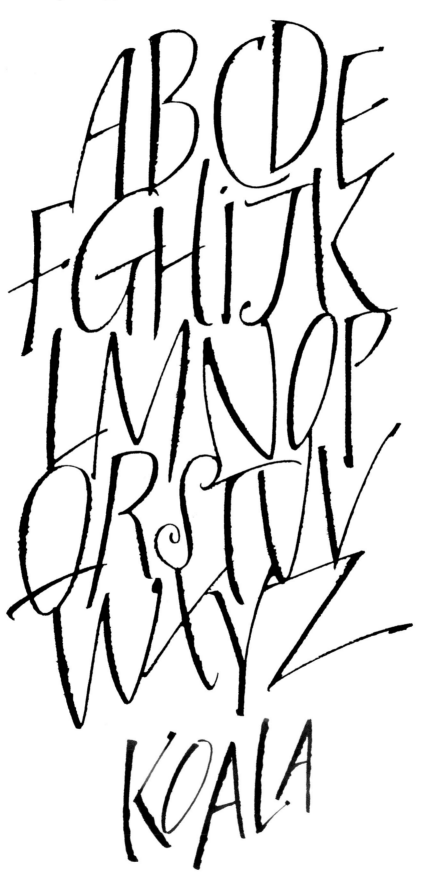

HANDWRITING STYLES

Handwriting is a system made unique by different habits and personalities. Whether loose, illegible, careful, or consistent, each handwriting style says something about its writer.

This section features alphabets that employ strokes similar to handwriting. These strokes have an abundance of movement, and the letters are often joined. Handwritten letters are informal, and no two are the same. There are variations in line weight that do not follow the regularity of formal calligraphy; however, form and rhythm are still important. Alphabets based on handwriting have a loose but controlled quality.

I often use a modified pointed pen for creating lines that are thick in some areas and thin in others, as I want a broad edge with pressure and release capabilities. This is a useful technique in many ways for other types of lettering too. You can create classic lettering styles with this technique as well.

TOOLBOX

Modified pointed pen

Pointed pen

Pointed brush

Square-cut round-ferrule brush

Felt-tip pen

CHIROGRAPHY

You can reproduce Chirography using a variety of tools. I used a pointed brush for this alphabet because I wanted a heavier weight than any other tool would have provided at this size. A bit of control is required when using a brush, so it's a good idea to warm up with pencil before beginning. You can also try creating this alphabet using a felt-tip pen on smooth or textured paper. Notice that this model is similar to the cursive taught in elementary school.

abcdefghij
klmnopqrst
wvwxyz

ABCDEF
GHIJKLMNO
PQRSTUV
WXYZ

Stop

SPIKE MILD

I created Spike Mild using the tip of a square-cut round-ferrule brush. It is a more formal but easily learned hand. Because this alphabet is narrow and has a straightforward rhythm, you can use almost any tool to create it.

abcdefgh
ijklmnopqrs
tuvwxyzAB
CDEFGHIJK
LMNOPQRS
TUVWXYZ
David

POSH

I produced this alphabet using a pointed pen. Posh has a strong calligraphic flair, but it also has a more contemporary form than the script our great-grandparents may have employed. It is useful for writing letters or quotes when you want freedom in your strokes and lightness of hand.

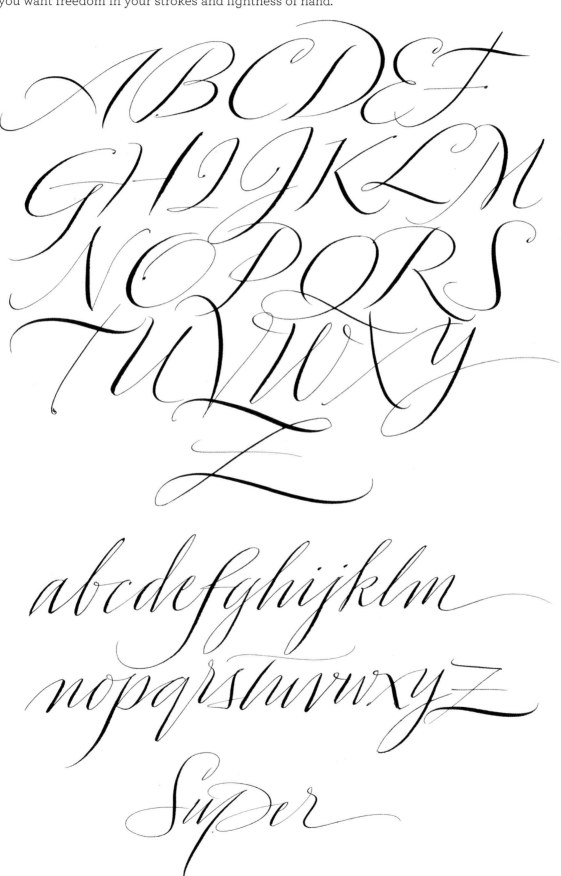

QUIRKY & CURLICUE

Lighthearted and related to the Fun & Funky style (see "Fun & Funky," page 116), this category is "innocent" and happy, and it may exude a bit of humor and character. These alphabets are preoccupied with self-expression. They say, "Look at me!" Borrowing on this style's narcissistic flair, try to make these lettering styles "all about me."

When drawing the alphabets in this section, think of both your audience and of what "voice" you imagine is behind the letters. Once you determine this, you can add or take away details to suit your tastes, and you will know that your work is communicating the tone that you intended. It's possible that you will create letters that stand alone as purely decorative works of art.

TOOLBOX

Pointed brush

Pointed pen

Ruling pen

BOING! REGULAR

This alphabet can go in several different directions, depending on attitude. It can be viny and au naturel, it can be busy and quirky, or the lines can be smooth or broken. I created this version with a pointed brush, adding pressure to produce the slight variations in line weight. The letterforms are on the narrow side to allow for the curlicues that encroach on their neighboring letters.

ABCDEFGHI
JKLMNOPQR
STUVWXYZ

abcdefghiijkl
mmnoparstuvw
xyz Anna

BOING! HEAVY

This version of the Boing! alphabet still displays details, such as the curlicues and the slightly broken curves, but it is bold and should be written with a pointed brush and a bit of self-involvement. You can create these busy letters in a painterly style, which will emit a look that is both fun and decorative. Your brush technique may vary depending on what paper you use, but you will employ the side and tip. Rough and absorbent papers will render attractive and slightly unpredictable results. Learn to differentiate between the character, the basic structure, and the details that can be changed to suit your taste. Some aspects must be copied, but others can be manipulated.

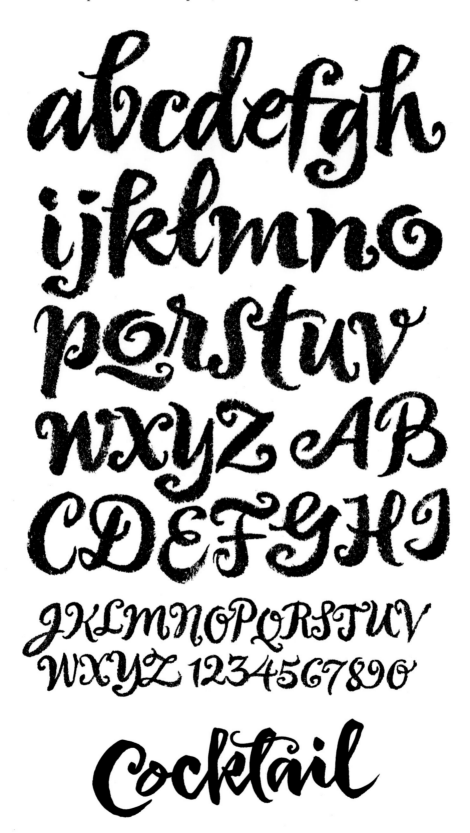

TING!

I created this alphabet using a ruling pen, but it can also be rendered with a pointed pen. The main features of the letters in the Ting! alphabet include curlicues, lots of bounce, and the strategic placement of dots at the end of strokes.

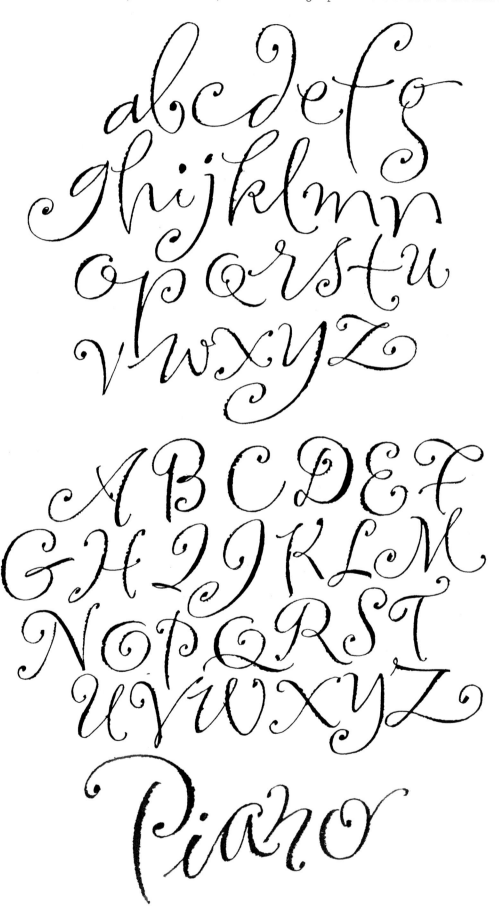

CHROMATIC

Once you are comfortable with your writing instruments and basic techniques—and after you have mastered the letters you intend to embellish—you will be ready to attempt color. I drew the alphabets in this section with a ruling pen and a broad-edged pen loaded with high-quality watercolor paints. When choosing the colors you are going to implement in your lettering art, keep in mind the basics of color theory (see "Color Theory," page 72), as well as the tone of the message you are trying to convey.

TOOL BOX

Folded ruling pen

Broad-edged pen

Eye dropper

CHEER

I wrote Cheer with a folded ruling pen on rough watercolor paper. This alphabet bears a resemblance to 19th-century scripts but involves taller minuscules. You can experiment with the height ratio of the majuscules and minuscules, but avoid making the minuscules exactly half the size of the majuscules (which I call "avoiding 50–50"). If you have the room, you can elaborate with ascenders, descenders, and the last strokes of a word or group of words. Symmetrical balance is old fashioned, but dynamic balance is full of tension and resolve, resulting in more interest.

KALEIDOSCOPE

Kaleidoscope is a mix of block letters and the occasional cursive letter. It appears to have more components because the block letters are different weights and sizes. Also, I make the letters very obviously hand-drawn, with no attempt at perfection. As you add color, keep in mind the amount of light and dark, which should balance out for the overall desired look. Otherwise, this alphabet can look too busy. Think 70–30, meaning 70 percent bold and 30 percent light—never 50–50.

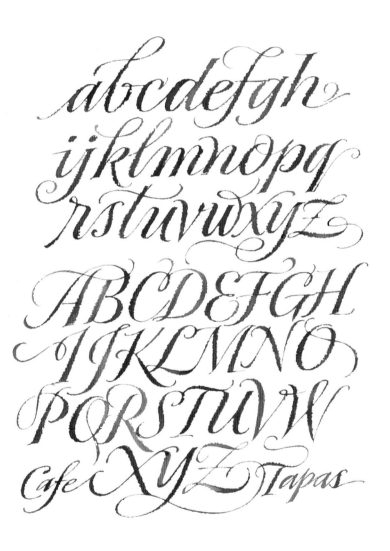

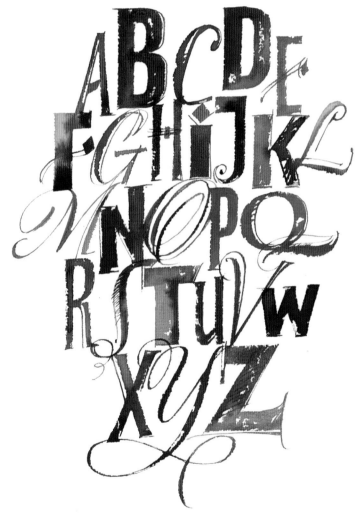

CONTEMPORARY ALPHABETS GALLERY

EXTRA ALPHABETS

Lettering possibilities are infinite. Below are some additional alphabets created by renowned lettering artist John Stevens. After you become comfortable with your writing instruments, experiment and see what kinds of letters and alphabets you can come up with on your own.

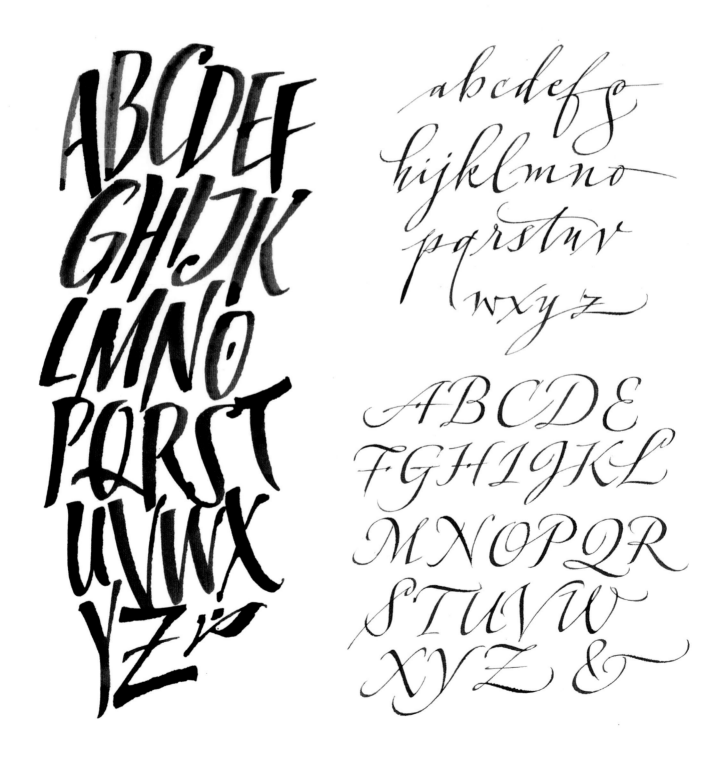

ABCDEFGHIJKLMN
OPQRSTUVWXYYZ

ABCDEFGHIJ
KLMNOPQRSTU
VWXYZ
abcdefghijkl
mnopqrstuvw
xyz

abcdefghij
klmnopqrstu
vwxyz
ABCDEFGHI
JKLMNNOPQ
RSTUVWXYZ

ABCDE
FGHIJK
LMNOP
QRSTU
VWXYZ

LATIN QUOTES

Half of a message can be conveyed through the letters used to create it. This final stage of the lettering process is also the most rewarding. John Stevens constructed the beautifully written Latin phrases shown here.

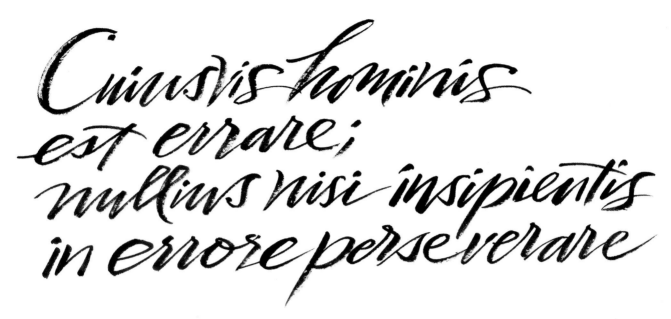

"Any man can make a mistake; only a fool keeps making the same one."

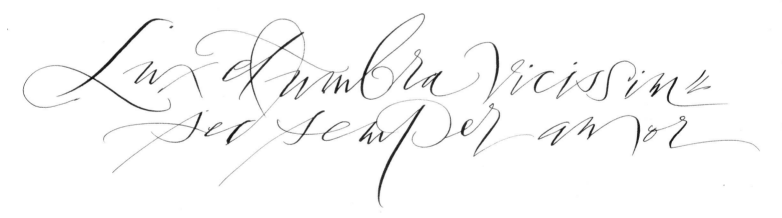

"Light and shadow by turns, but always love."

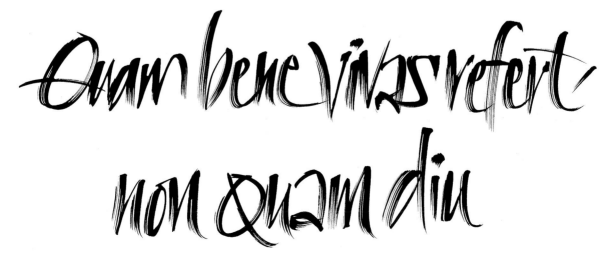

"It is how well you live that matters, not how long."

PART 2
MODERN
HAND
LETTERING

Chapter 6

FLOURISHES & EMBELLISHMENTS

TAKING IT UP A NOTCH

Yes—it's time to take your lettering to the next level! This upright script is loose and free—have fun with it! Notice that the letter shapes and strokes are drawn upright. As with slanted script, it's still very important to maintain even spacing between and inside the letters. Each letter should take up roughly the same amount of space. This script was written with a pointed pen.

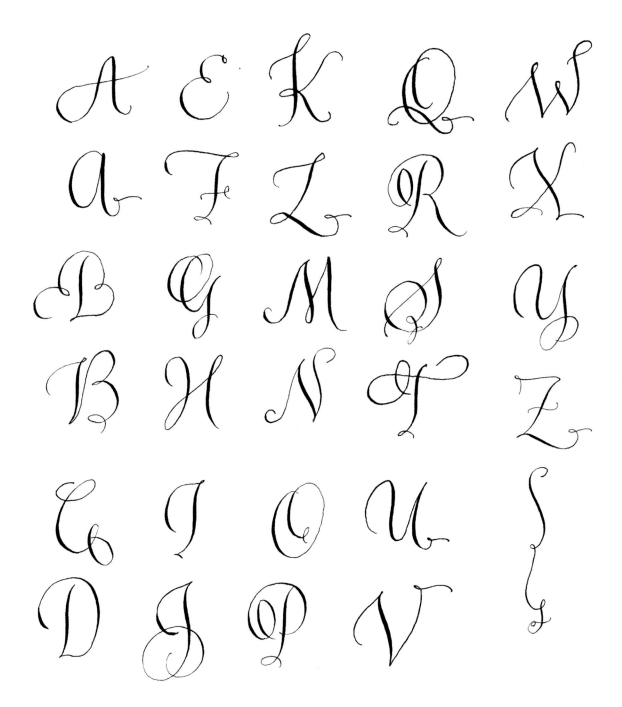

a b c d e

f g h i j

k l m n o

p q r s t

u v w x

𝒴 and 𝒵

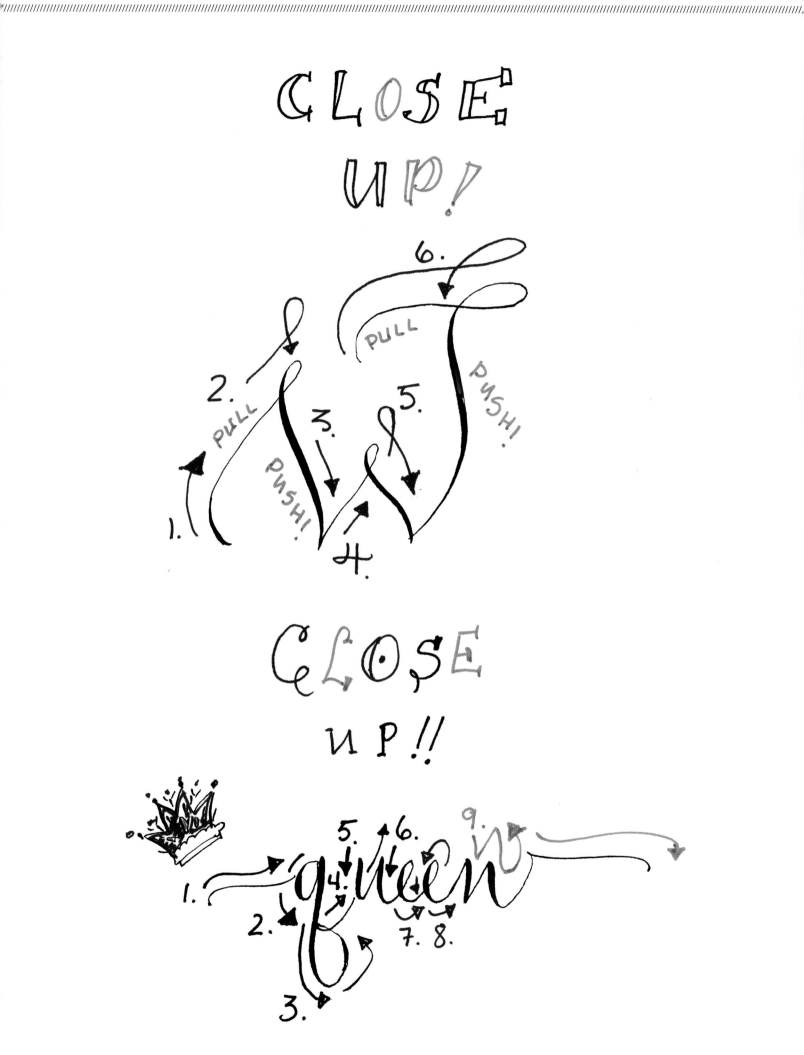

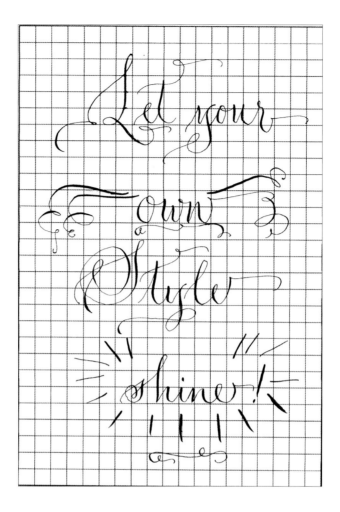

TIP

Graph paper is great for practicing upright script letters!

HOW TO LET YOUR LETTERING SHINE

With practice and over time your own unique calligraphy style will emerge. You will naturally discover certain letters, shapes, and strokes that are most comfortable for you. Perhaps you will find that you are drawn to ultra-flourished capitals and lots of swashes. Or maybe you will be most comfortable with a pared-down, loose, casual style. Whatever style you feel emerging, go with it! Here are some suggestions to help you get started.

- Study and master the basics. Practice the strokes that form basic letter shapes. Then practice some more! Don't skip this step; the only way to develop your own style is to master the basics first.

- Familiarize yourself with the traditional pointed-pen lettering hands. Experiment with creating the traditional letters of Copperplate/English Roundhand and Spencerian.

- Purchase a broad-edged pen nib, and try creating Italian letterforms. Many calligraphy teachers recommend learning Italian hand as a base for calligraphy studies.

- Join a local calligraphy club, or check out the calligraphy section at your local library or bookstore.

EMBELLISHING

And now...let's flourish! Follow the tips below to keep your flourishing and swashing natural looking, free flowing, and smooth!

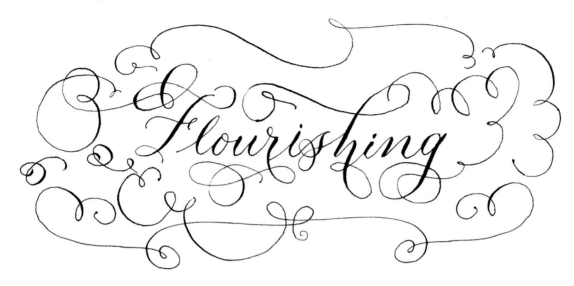

TIPS

- Give flourishes room to breathe.

- Return flourishes to where they began, trying to maintain a "sense" of a circular or oval shape in the flourish.

- Never cross thick flourish lines.

- Thin flourish lines can be crossed, but do so sparingly!

- Aim for delicate lines and smooth curls.

- Try to keep your movements smooth and natural, with lots of arm action—don't keep your hand planted on the table!

- Flourishes tend to flow either horizontally (from a letter or word) or vertically.

- Avoid abrupt endings, sharp corners, and hard angles.

- Create flourishes that extend from the beginning or end of words.

- Make sure your words are always readable. Avoid overly flourishing if it compromises readability.

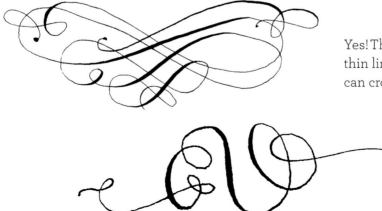

Yes! Thick lines can cross thin lines, and thin lines can cross thin lines.

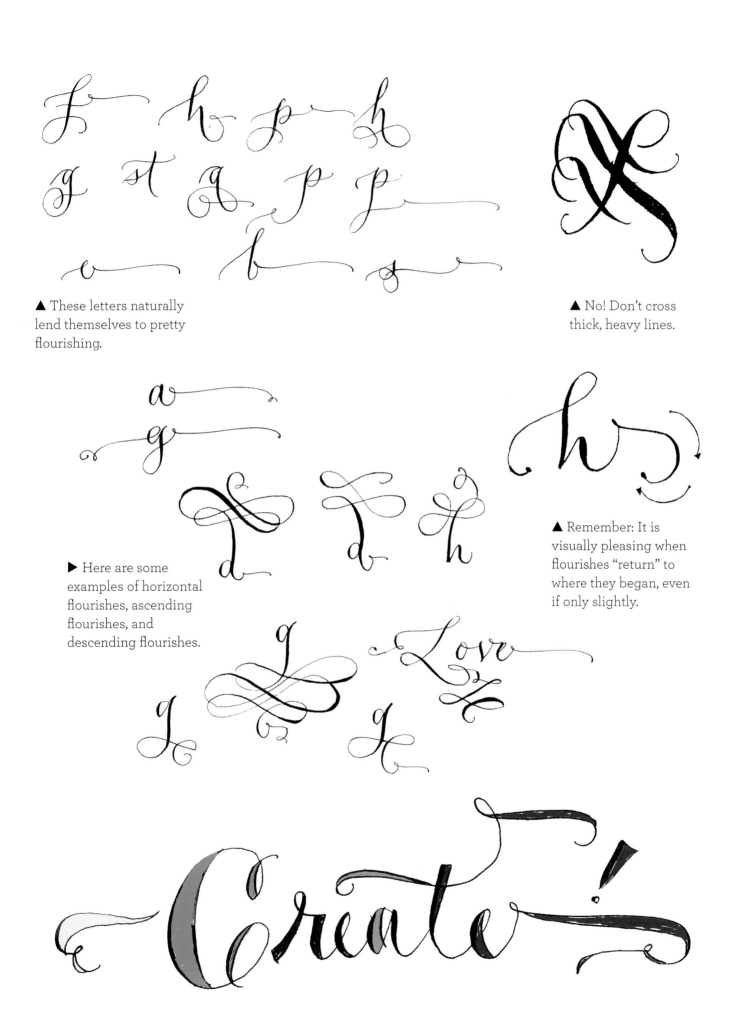

▲ These letters naturally lend themselves to pretty flourishing.

▲ No! Don't cross thick, heavy lines.

▶ Here are some examples of horizontal flourishes, ascending flourishes, and descending flourishes.

▲ Remember: It is visually pleasing when flourishes "return" to where they began, even if only slightly.

FLOURISHED CAPITALS

Give capital letters lots of space, and avoid squeezing the next letter of the word into the flourishes. Look for balance and composition, and remember to avoid crossing thick lines.

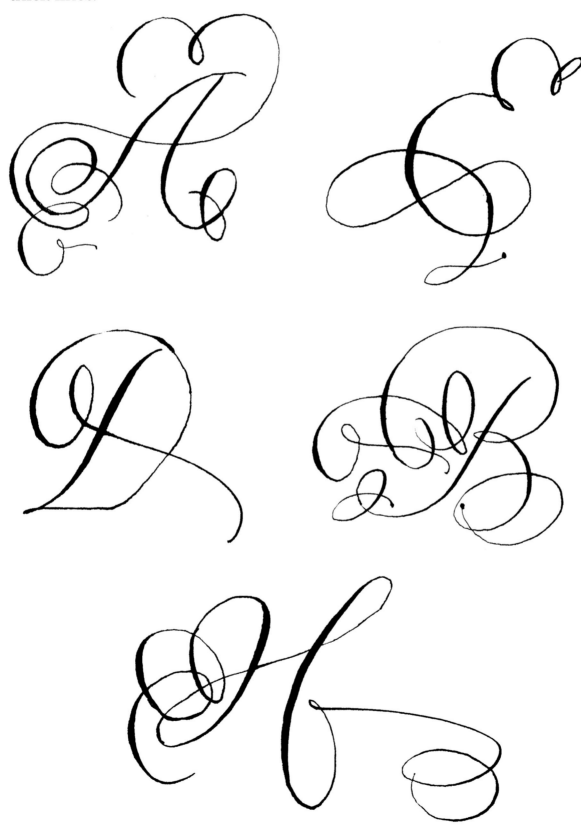

ONE LETTER, MANY FLOURISHES!

Here are a few ways to flourish a capital "S."
Can you think of more?

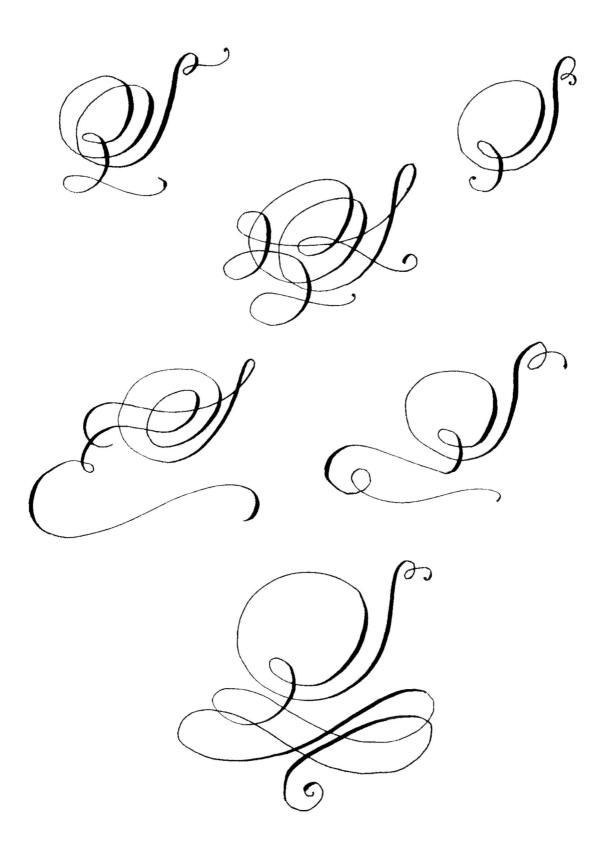

CREATING SWASHES

To create lovely swashes, start at the top and work slowly downward. Very gently pull the pen along the straighter parts of the flourishes, and apply a bit of pressure to create thick lines. The flourishes below were created with jelly pens—these pens are very fun to use and can create unique designs!

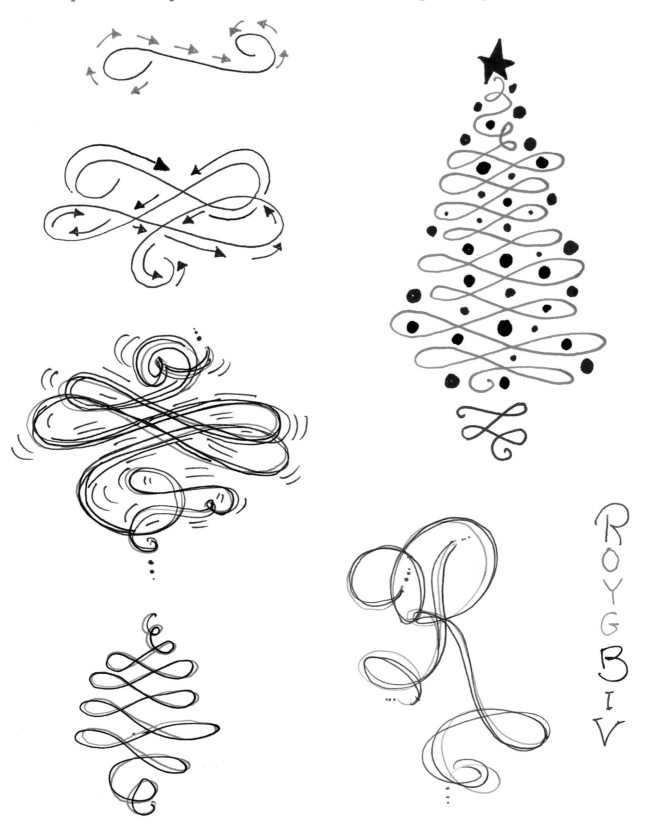

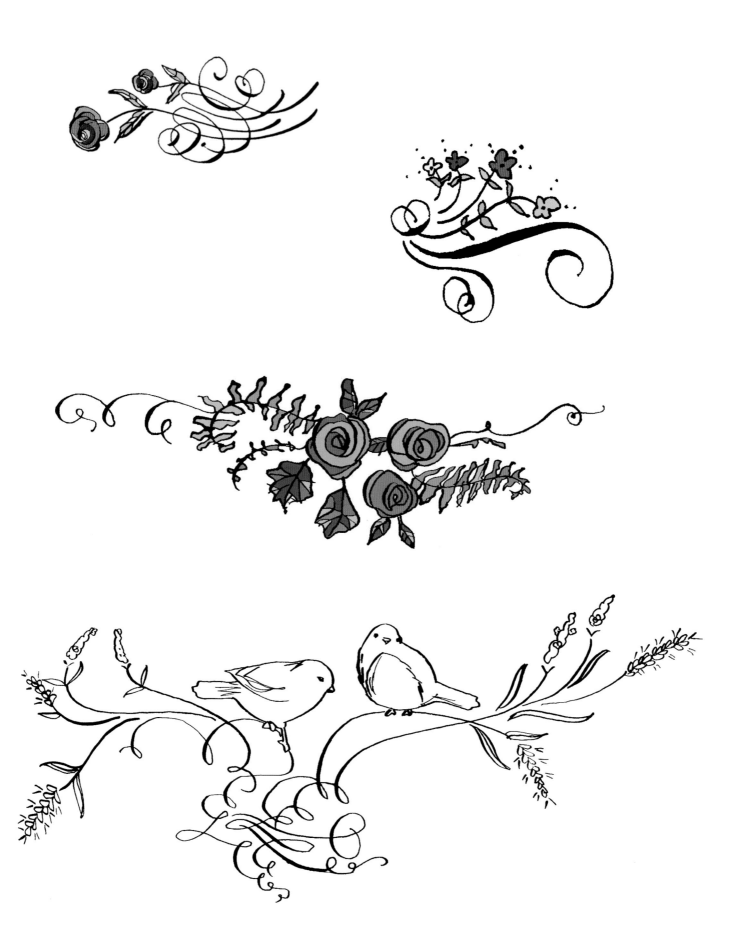

Butterfly

puzzle

Georgia

Happy Halloween

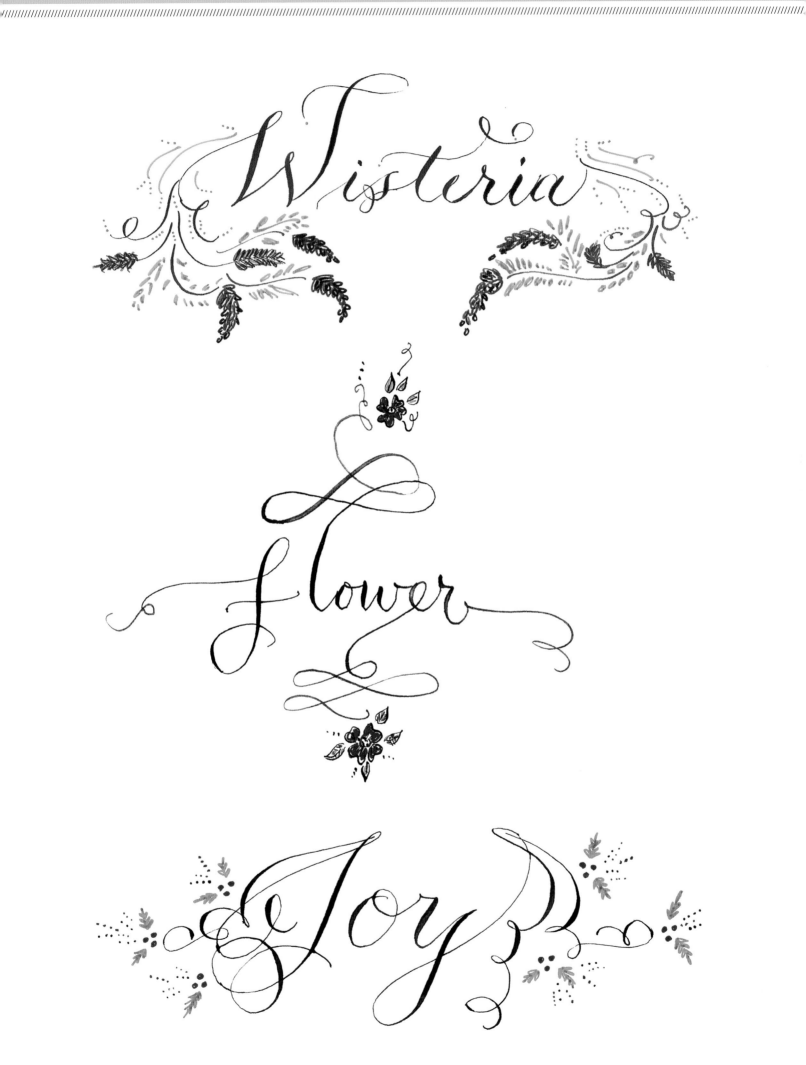

NUMBERS & BORDERS

Don't forget numbers and punctuation marks! These characters benefit from pretty flourishes and strokes too.

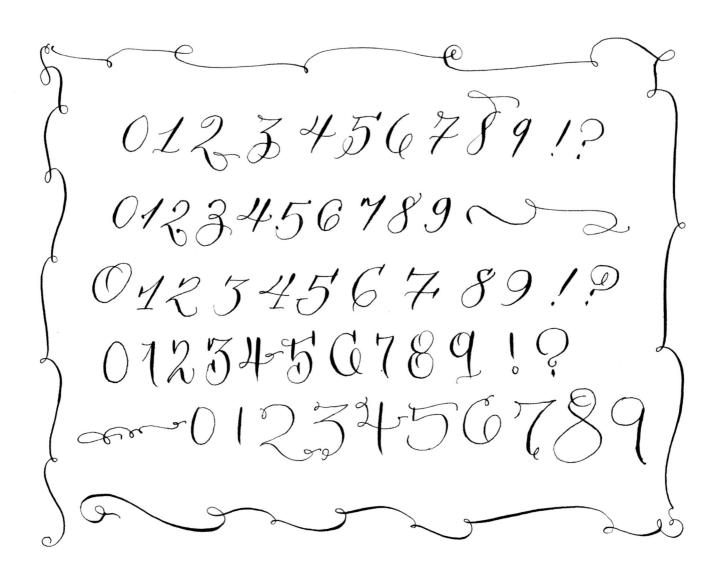

TIP

Keep your embellishments small, as these kinds of characters generally need to stay close to other letters and numbers.

You can craft pretty borders, boxes, and other small embellishments to bring even more dimension to your lettering. Here are just a few examples to inspire you.

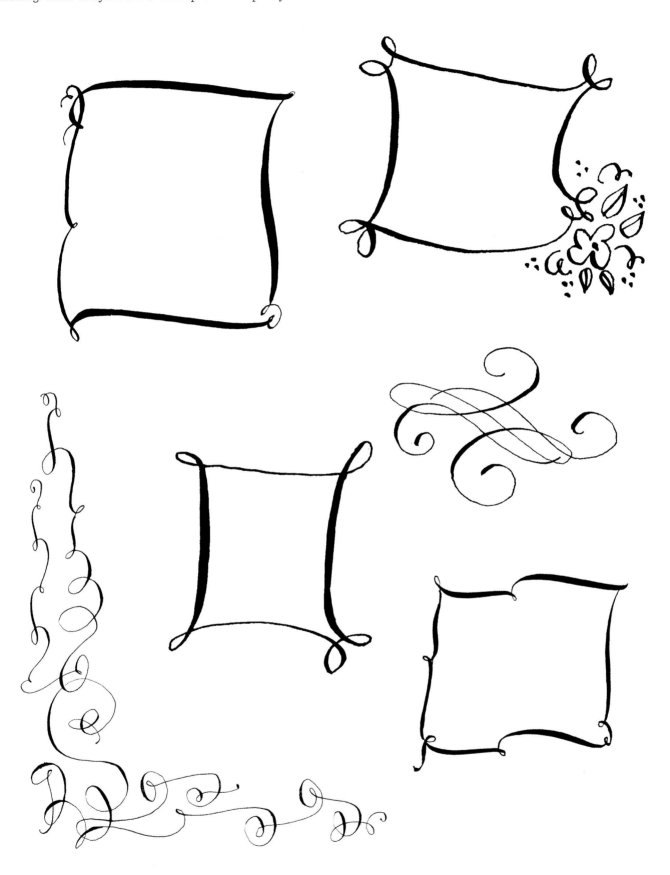

Chapter 7

ILLUSTRATED BY HAND

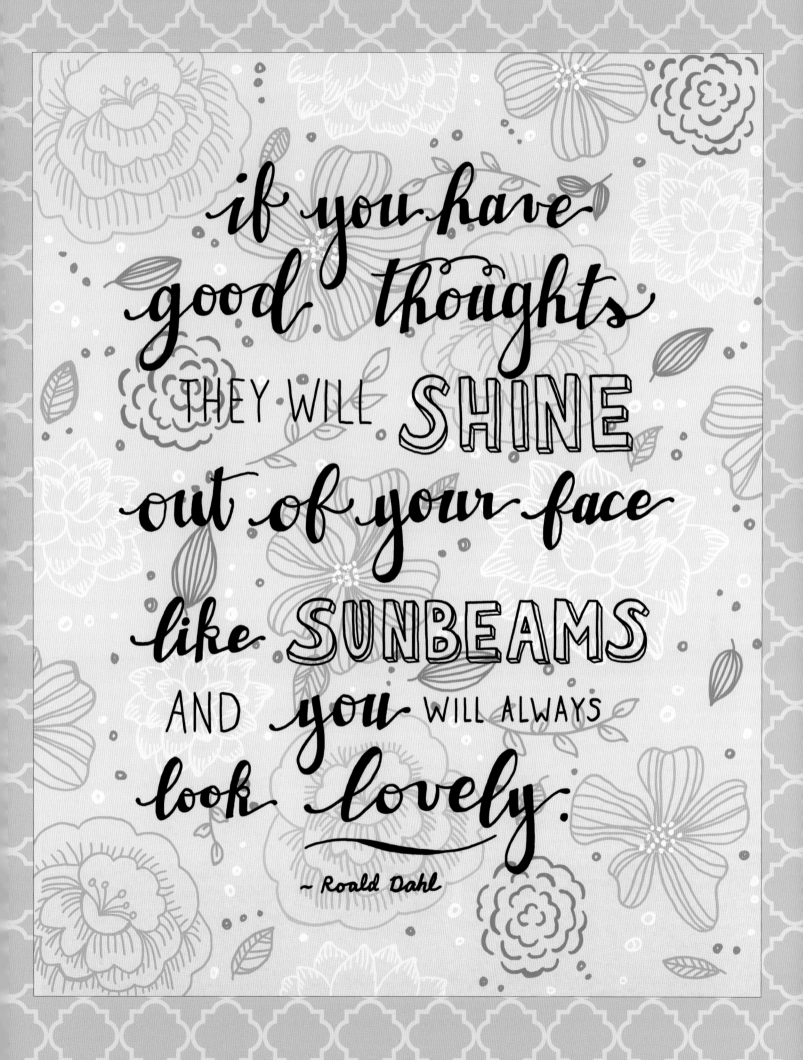

if you have good thoughts THEY WILL SHINE out of your face like SUNBEAMS AND *you* WILL ALWAYS look *lovely*.

~ Roald Dahl

GETTING STARTED

When it comes to beautiful, expressive lettering, the possibilities are endless. From pencils and markers to pens and paints, you can use just about any mark-making tool to craft pretty letters and words. On the following pages, I'll introduce you to some of my favorite lettering tools, techniques, and inspirations, including some of the fun materials you'll need to complete the step-by-step projects in this section!

THE BASICS FOR HAND LETTERING:

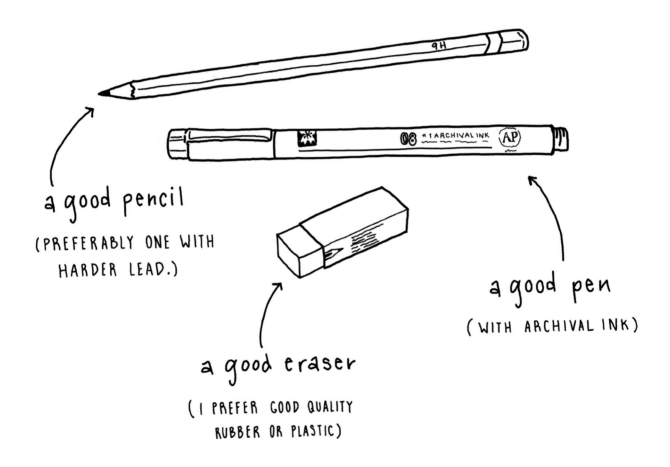

a good pencil

(PREFERABLY ONE WITH HARDER LEAD.)

a good eraser

(I PREFER GOOD QUALITY RUBBER OR PLASTIC)

a good pen

(WITH ARCHIVAL INK)

& dont forget your paper...

(I LIKE TO USE ARCHIVAL GRADE, ACID FREE 140-lb. OR 300-lb. PAPER.)

A GUIDE TO *pencil hardness*

2H

3H

5H

6H

8H

9H

PENCIL LEAD COMES IN A
RANGE OF HARDNESSES

9B = VERY SOFT
9H = VERY HARD

FOR HAND LETTERING
I LIKE TO USE HARDER
LEADS BECAUSE THEY
DON'T SMUDGE AS EASILY
AND THEY ARE EASY TO
ERASE WITHOUT A TRACE.

THESE are a few... of my favorites.

BEYOND THE BASICS

BRUSH PEN

-My favorite for expressive flourishes and **bold** script.

ERASER SHIELD

-In hand lettering you end up working with a lot of fine lines — so you need an eraser shield so you only have to erase what you need to.

WATERCOLOR BRUSH PENS

-These pens are so much fun! They allow you to create the look of watercolor without the mess of brushes & paint, and with more control — a beautiful way to add color to your work.

TO *serif*?
OR NOT TO *serif*?

WHAT IS A SERIF?

"Any of the short lines stemming from and at an angle to the upper and lower ends of the strokes of a letter."

– MERRIAM-WEBSTER

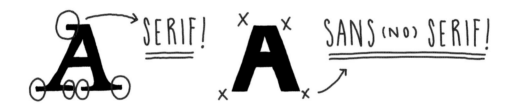

SERIF FONTS ARE...	SANS SERIF FONTS ARE...
– authoritative	– universal
– traditional	– modern
– respectable	– solid
– classic	– fashionable
– elegant	– clean

(STILL WONDERING? –just follow your mood.)

NEED A FUN WAY TO PRACTICE? TRY CREATING AN *alphabet sampler*

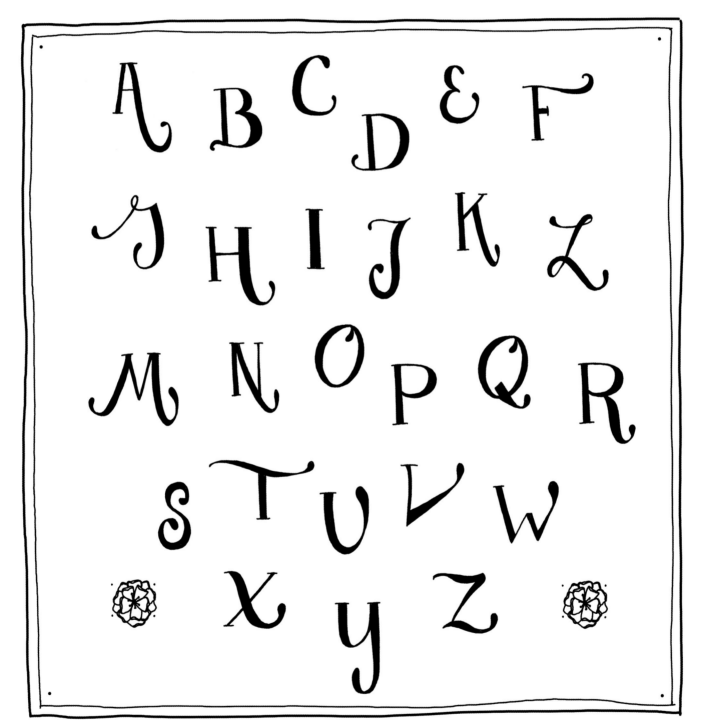

A B C D E F
G H I J K Z
M N O P Q R
S T U V W
X Y Z

how to

· MIX · FONTS · LIKE · A · PRO ·

Knowing how to skillfully and artistically mix fonts is intrinsic to becoming a great hand-lettering artist. Fonts can generally be divided into different groups depending on their aesthetic construction. The basic groups are: *serif*, *sans serif*, *script*, and *decorative*. There are no hard-and-fast rules on how to combine different fonts, and every artist has their own favorite combinations. Here are some examples of how fonts can be mixed.

BOLD & DEFINITE
— mixed with a fun cursive —

SLENDER AND WILLOWY
paired · with · something · bolder

a bit of formal fun
WITH JUST PLAIN FUN

& Remember
OPPOSITES → CAN → GO → TOGETHER

CREATE THE CALLIGRAPHY "LOOK"

Beautiful cursive script complements any hand-lettered piece. If you're still perfecting your calligraphy techniques, this simplified technique is a good alternative to achieve a similar effect. It does not replace or devalue calligraphic skill, but it can help create the look you desire as you develop your calligraphy skills.

we were together. i forget the rest.
—WALT WHITMAN—

STEP ONE
Sketch a simple outline with a pencil in basic, cursive script.

STEP TWO Sketch thicker lines that mimic the change in thickness seen in traditional calligraphy.

we were together. i forget the rest.
—WALT WHITMAN—

we were together. i forget the rest.

— WALT WHITMAN —

STEP THREE

Trace the sketch with a pen. Then fill in the thicker areas with ink.

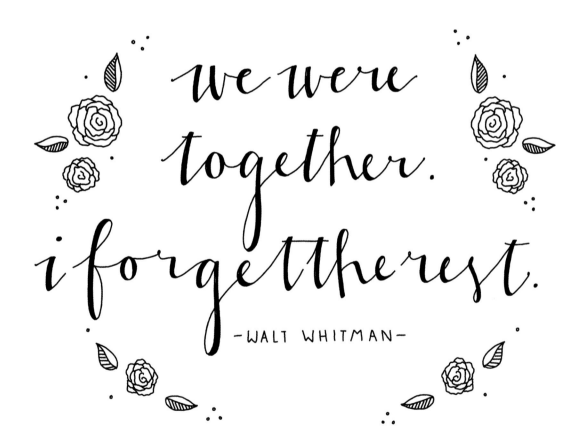

we were together. i forget the rest.

— WALT WHITMAN —

STEP FOUR Erase the pencil marks, and add any desired illustrative touches.

BLOCKING

Blocking is always my first step when I start a project. It allows you to visually plan the lettering before you begin inking.

STEP ONE Select a quote, and divide it into blocks of individual words or groups of words. Sketch a block or illustrative element for each word or group.

STEP TWO Choose your fonts, and sketch each word or word group in its corresponding block space.

STEP THREE You are now ready to ink! Carefully trace over your sketches with your choice of pen.

STEP FOUR

Once you are finished inking, erase your pencil marks. You can also add embellishments or final touches, like the arrows I added to fill in the silhouette.

WE -have-to-choose- JOY and Keep choosing it.

— HENRI J.M. NOWEN —

Experiment with different combinations of geometric shapes. Here is a more complicated example. Sketch out the blocks first and then the words. Once the words are sketched in, you can erase the blocks. For a different look, I used a colored background, and a white opaque ink pen to letter the words.

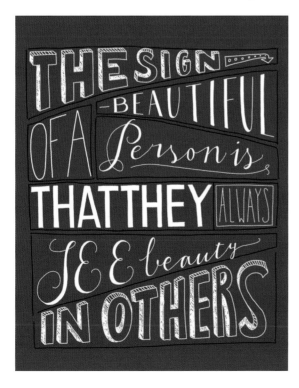

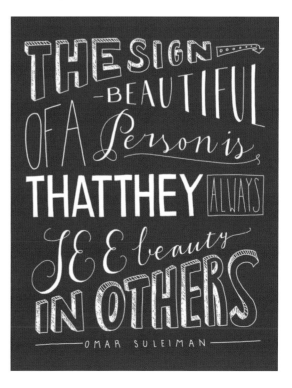

LETTERING IN SHAPES

One of my favorite hand-lettering skills is to letter in shapes. This technique is not only fun but also visually pleasing and great for creating graphic work that is ready to print on cards, T-shirts, or tattoos.

STEP ONE Pick a quote and shape. Sketch the shape, and then use the blocking technique to plan your word placement.

STEP TWO Sketch the words into their blocks, following the outline of the shape. Use embellishments to fill out the shape if necessary!

STEP THREE Trace the letters with a pen.

STEP FOUR Erase the pencil marks, including the outline of the shape, and enjoy the fun result!

NEGATIVE-SPACE LETTERING

Basic hand lettering is typically practiced with black or colored pens or pencils on white paper. To create a striking piece, try using *negative space*. Negative space is the area around an object or word. With this technique, make white letters against a dark background. The effect creates powerful works of art that stand out with shapes and geometric profiles.

STEP ONE Sketch a shape or silhouette. I used a silhouette of a couple hugging because it reflects the subject of my chosen quote perfectly.

STEP TWO Sketch the outlines of the letters. Try to use simple fonts with bold profiles. Consider how the letters will stand out against a dark background, and sketch the outlines slightly larger than normal. Some of the size will be lost as you fill in the background.

STEP THREE Fill in the background, carefully following the outlines of your letters. I like to first outline the silhouette and the words with a pen to help me stay in line. As you fill in the shape, watch how the words begin to stand out from the dark background.

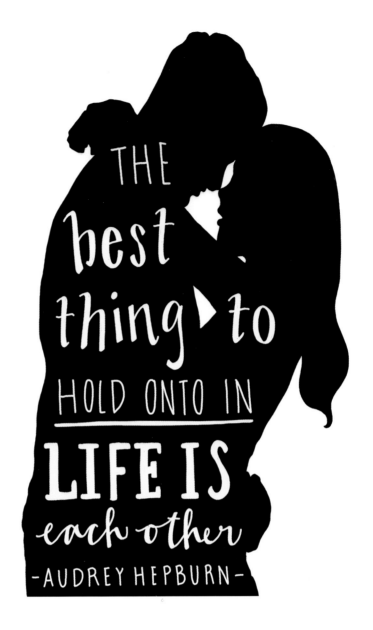

Playing with negative space can be addicting, thanks to the amazing black-and-white contrast that creates striking works of art. Here is another more advanced use of these techniques. As you get more confident, play around with more complicated fonts and illustrative elements. This technique is very effective in creating brand logos or custom stamps!

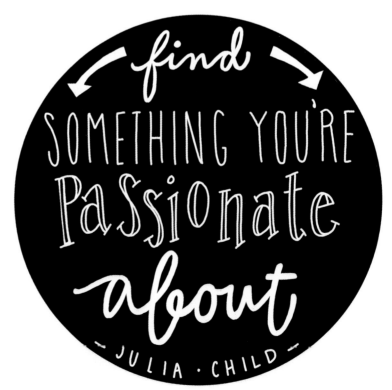

NEGATIVE ILLUMINATION

Illumination is a beautiful technique. To put a twist on it, flip it to create a negative image!

STEP ONE Choose a quote, and sketch the outlines of the letters. When you are satisfied with the sketch, ink the outlines of the letters and erase the pencil marks.

STEP TWO Sketch out the illustrations, this time around the letters and not inside them. Take your time. Once you're happy with the look, ink the illustrations and erase the pencil marks.

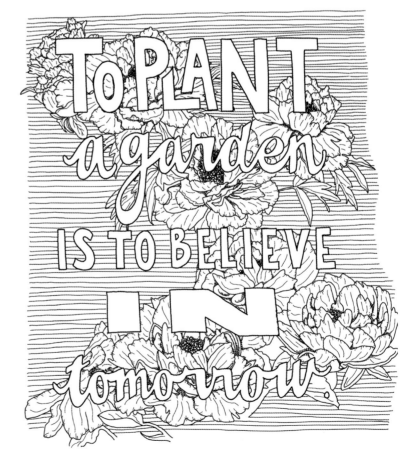

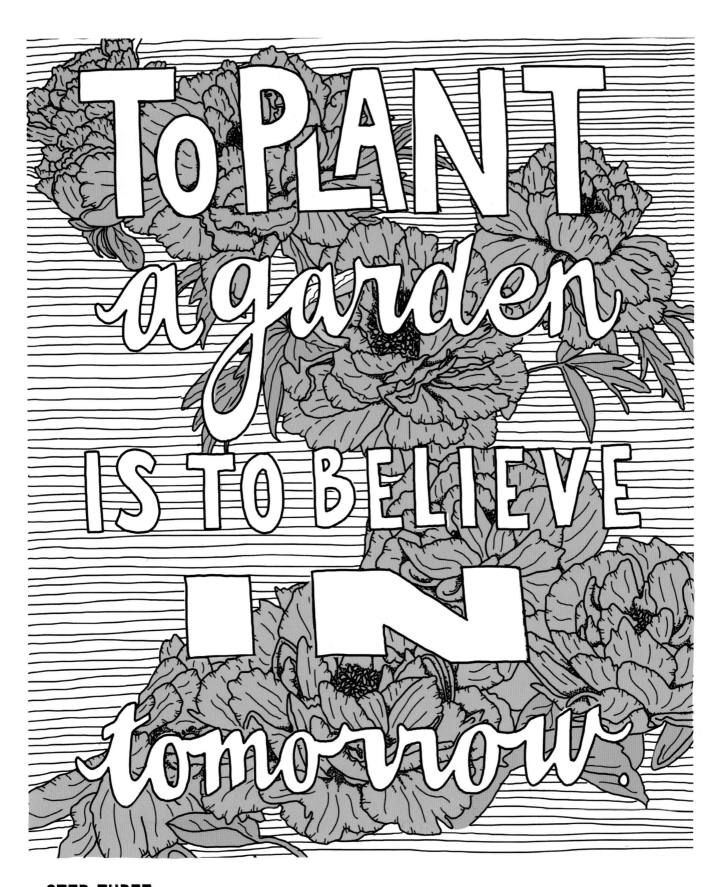

STEP THREE You can add color to your design digitally or with markers or watercolor paint! I chose to crop the edges of my piece to give it a clean look.

STIPPLING LETTERING

Stippling is a technique that involves drawing or painting small dots to create detail and depth. I love to use stippling as a technique for pen-and-ink drawing, but it is just as fun to use in hand lettering for a really cool effect.

STEP ONE Trace or sketch the outlines of your letters.

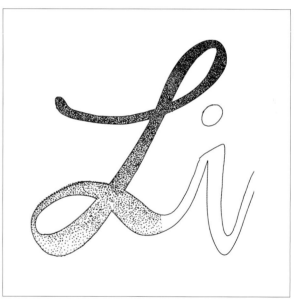

STEP TWO Begin to stipple. Stippling can be a long process, so choose a pen that has lots of ink left in it. I like to start at the top with more dots closer together and fewer dots further and further apart as I work down to create an ombré look. Make sure that the dots at the bottom are still numerous enough to maintain the integrity of the letter's outline.

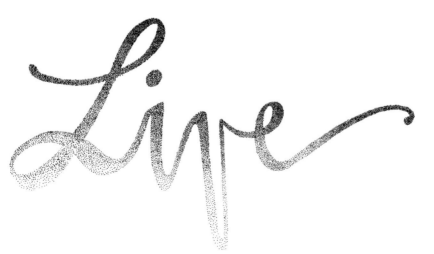

STEP THREE Apply the stippling technique to the rest of the letters. Step back and survey your work from a distance to see if there are any inconsistencies in the stippling gradient. Add more dots as needed, and then erase your pencil lines.

Love stippling? Try it in reverse to create a cool negative effect!

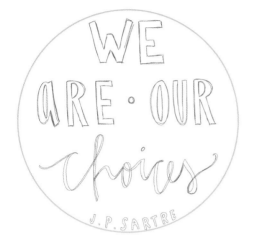

STEP ONE Choose a quote, and sketch the outlines of the letters. For this technique, I find it easiest to draw an outline of a shape around the letters, such as a circle.

STEP TWO Start stippling, but this time stipple only in the background—around the letters, not in them. You can stipple in a gradient or ombré, or in any number of patterns. For example, you could draw stripes and stipple some stripes darker than others.

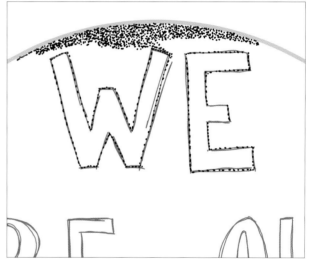

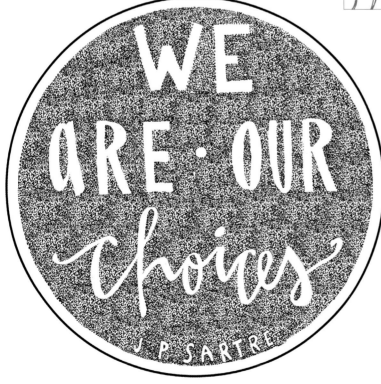

STEP THREE Once you are done stippling, erase the pencil marks! Add any other decorative details at this time. I added another circle to frame the design.

PLAYING WITH WORDS

A beautifully painted phrase or illustrated word can have a powerful, inspiring impact. Elements such as shapes and silhouettes, scale and proportion, and texture and dimension add interest to any word picture. Try flourishes and twirls for a fancy look, or bring your own personality to any snapshot, page, document, or chart with a custom font. Using the illustrations below as inspiration, practice creating your own word illustrations.

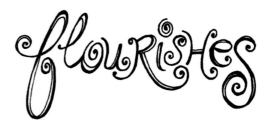

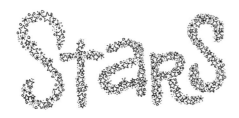

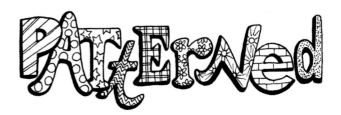

REVERSE

SKINNY

SERIF

OUTLINE

Embroidered

METALLIC

Fuzzy

dotted

Doodly

Childish

ETCHED

BEVELED

BLOCK

Calligraphy

SHAPE UP

Many graphics and logos contain letters that are drawn to form the shape of an object or an idea. There is freedom to drawing these types of words because there are no rules—the letters can simply morph into whatever you want them to be. Follow the steps below to try your hand at drawing an object-shaped word.

STEP ONE Draw a faint, simple outline of your object.

STEP TWO Draw the middle letter(s) of the word in the center of the outline to establish spacing.

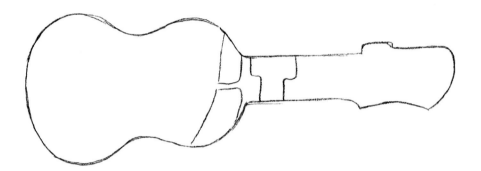

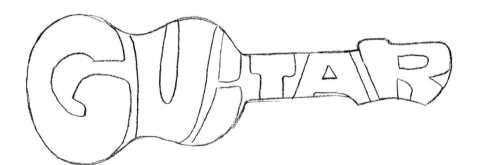

STEP THREE Add the rest of the letters.

STEP FOUR Erase your pencil outline and ink the letters.

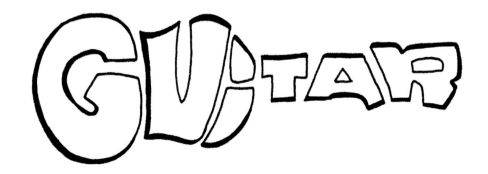

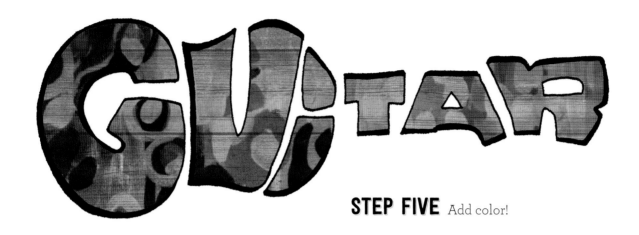

STEP FIVE Add color!

MORE EXAMPLES:

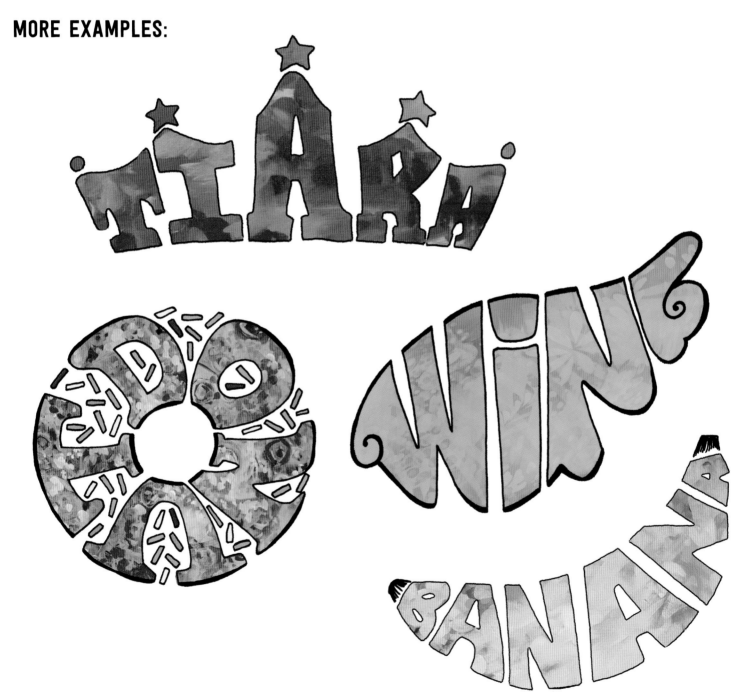

RIBBON LETTERING

Ribbon lettering is a fun way to add personality and a unique look to your lettering. Practice this basic tutorial to get the hang of it, and then take it to the next level with the example on page 181.

STEP ONE Trace or sketch the word in cursive, adding any desired twists and flourishes.

STEP TWO Think about how a ribbon would twist and overlap as it forms the letters. Trace this second set of lines.

STEP THREE To create the illusion of ribbon, carefully erase lines where one part overlaps another.

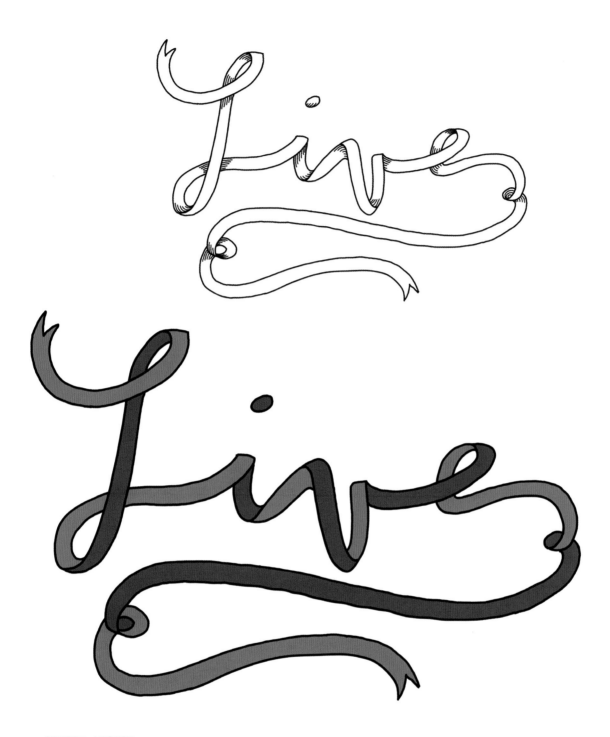

STEP FOUR There are several ways to add depth to ribbon lettering. I have demonstrated two ways here. The first is to use simple line shading to show shadows where one part of the ribbon overlaps another. The second is to color the ribbon with two shades of the same color, using the darker shade on the underside to create the illusion of depth. You can also use two different colors, one on each side of the ribbon. Practice several ways and with different colors!

CONVERTING TO A DIGITAL FORMAT

Now that you're getting the hang of hand lettering and loving your results, it's time to open yourself up to a whole new realm of opportunity. All you need is a camera, a computer, and Adobe® Photoshop® or similar photo-editing software. Once you learn to convert your work to a digital format, you can create any number of projects, from printed fabric to temporary tattoos and so much more!

what you need to get started

DIGITAL CAMERA

WHITE DOUBLE FOAM CORE BOARD

TRIPOD

art

STEP ONE The first step is to photograph your work. You need a few basic supplies: white double foam core board, a digital camera (preferably a DSLR), a tripod (optional if you have a steady hand), and a piece of your art!

how to set up your photoshoot

LIGHT
SOURCE

(WINDOW
OR LAMP)

STEP TWO Use the illustration above as a guide to set up your photo shoot. Choosing a light source is the most important thing. If it's available, natural light, such as near an open window, is always best. Position the light source to the side so that it can reflect off your foam board and properly light up your subject. If you can't use natural light don't worry! You can either buy a full-spectrum light bulb or play with the white balance on your camera.

STEP THREE Once you have snapped a couple of good photos and loaded them onto your computer, you are ready to start editing. First select your favorite file and open it in Photoshop or your photo-editing software of choice.

STEP FOUR Next create a new layer. Go to the Photoshop menu and click on "Layer," "New," and then "Layer."

STEP FIVE Move to the layers palette on the right, and click on the small lock symbol to the right of the original image layer to unlock it (A). Then click on the new layer and drag it down below the original image layer (B).

STEP SIX On the top menu, click on "Select" and then "Color Range" (A). This opens the "Color Range" window (B). Use the eyedropper tool to click on the background of the picture.

A

B

C

STEP SEVEN Once the background is selected, you can use the fuzziness slider to increase or decrease the contrast and the number of pixels selected (A). This determines how sharp your letters will be (B) once you delete the background. When you are satisfied hit the delete button on your keyboard, and the background will disappear (C). Then go back up to "Select" and click "Deselect."

STEP EIGHT Now go down to the color selector, and click on the top box. The color selector will open and you can choose a background color (A). Then click on the second layer (Layer 1). Using the paint bucket tool, click on any part of the background to insert the new background color (B).

STEP NINE If you want to insert or drop your lettering over a different background, just click on the small eye icon next to Layer 1 to make the white background invisible. Then you are ready to save your work.

HOW TO PLACE ART ON A NEW BACKGROUND

To place your digitized artwork on another background, open the background image (in this case, a pretty floral design) in Photoshop. Then drag and drop your lettering onto the open file. This automatically creates a new layer. You can customize the size and placement before fully placing it on the page by double-clicking. Then save your work!

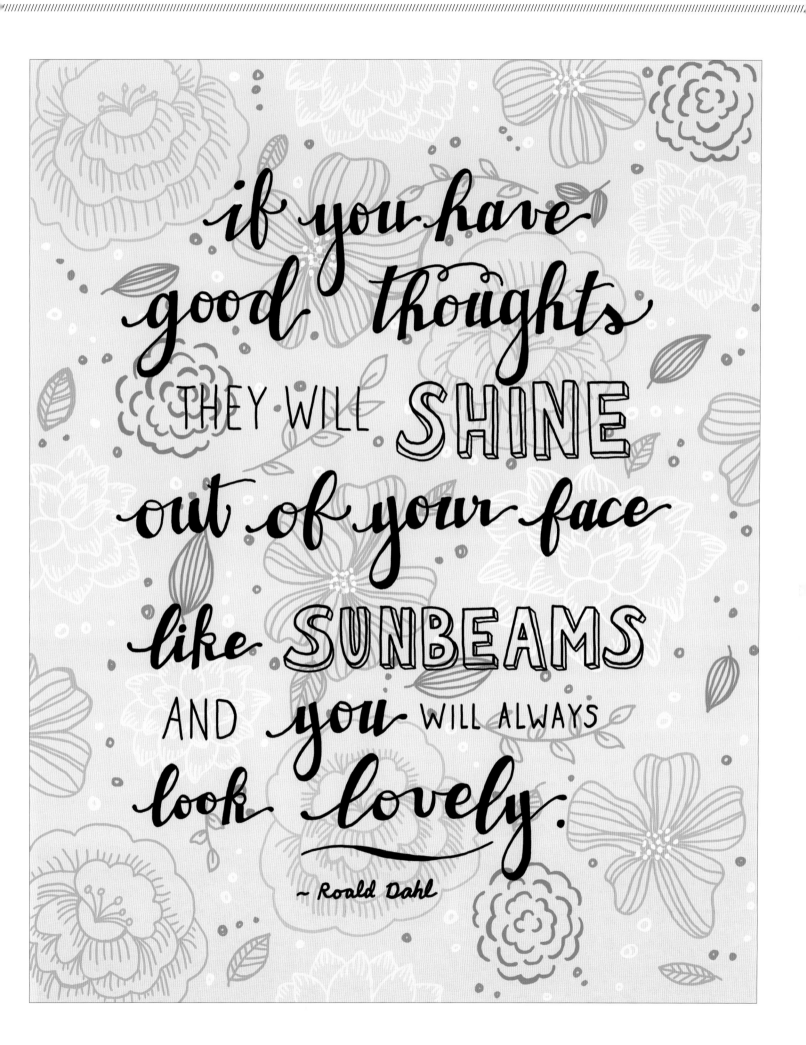

if you have good thoughts THEY WILL SHINE out of your face like SUNBEAMS AND you WILL ALWAYS look lovely.

~ Roald Dahl

Chapter 8

CHALK LETTERING

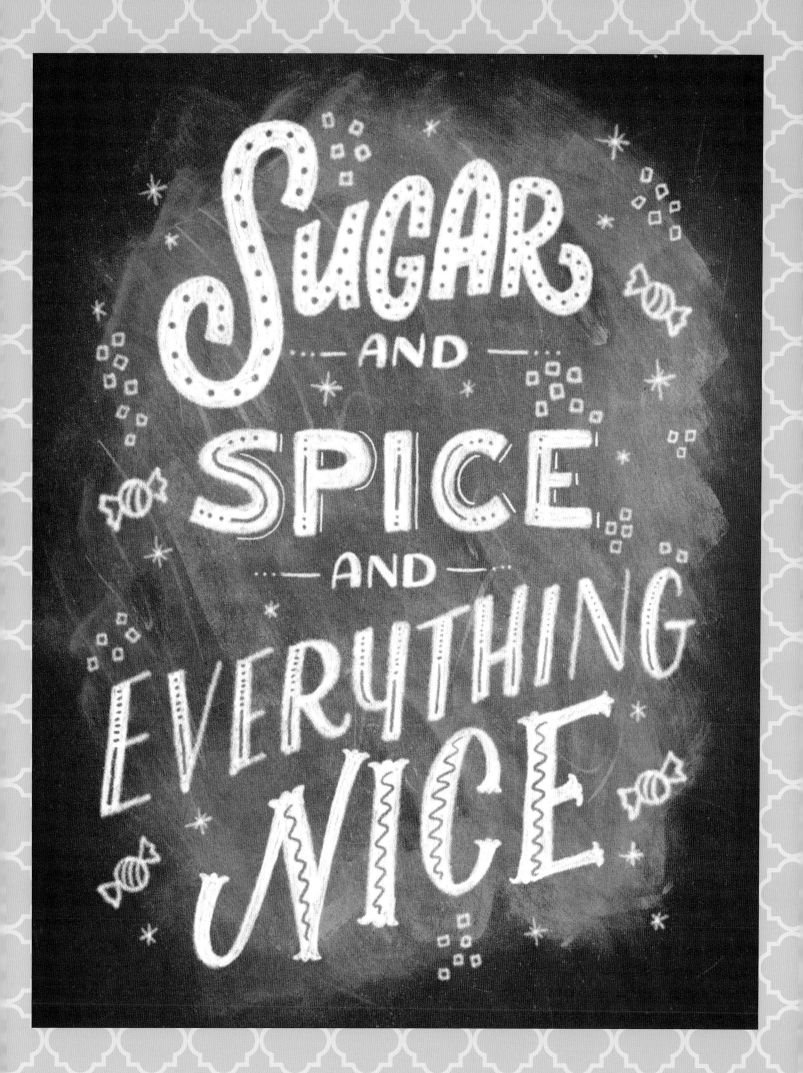

CHALK LETTERING TOOLS

It doesn't take much to create beautiful chalk lettering and artwork. All you truly need is a chalkboard and a piece of chalk! There are, however, a few more tools you might find helpful as you dive into this fun art form.

CHALKBOARD

A 16" x 20" chalkboard is a good, manageable size for chalk-lettering practice and artwork. You can find chalkboards at some art & craft stores and online retailers. You can also make your own chalkboards (see pages 194-195).

CHALK

You don't need fancy chalk—the kind you find in the school-supplies aisle will do the trick! Try to find anti-dust chalk, which creates less of a mess. You'll need plenty of white chalk, but consider investing in a package of colored chalk as well for embellishing your artwork with bursts of color.

CHARCOAL PENCIL

A white charcoal pencil is perfect for detail work and fine lines.

ERASER

One of the best things about chalk lettering is the ability to erase mistakes—or almost instantly have a clean slate on which to work! There are myriad erasers available for chalkboards. Choose the kind you prefer to work with.

CLOTHS

You can also erase chalk from your board with a damp cloth. Keep a stash of microfiber cloths on hand for erasing and cleaning up small areas of the board between and around letters.

SHARPENER

You can sharpen chalk with a large pencil sharpener (or even an eyeliner sharpener). The larger opening is just the right size for a piece of chalk. Sharpening your chalk will allow you to be more precise when creating detailed designs.

SOFT PASTELS

Soft pastels are another way to bring vivid color to your chalkboard art. Soft pastels are available in sticks or as pencils, with a protective coating to keep your fingers clean. If you decide to experiment with pastels, just be sure to use soft pastels—not oil pastels.

DIY CHALKBOARD

In my hunt for good chalkboards, I have found that they're becoming increasingly difficult to find. In this tutorial, I'll show you how to create your own out of just about anything!

MATERIALS

Chalkboard paint
(available at hardware stores)

Paint primer
(Optional: only necessary for
plywood or other unprimed surface)

Sandpaper, coarse and fine

Chalk

Towel or small rag

Foam brush

Clayboard*

*Note: Other hard surfaces also work, but I prefer
clayboard because it's solid and smooth.

STEP ONE Prep your workspace on newspaper or a large piece of cardboard.

STEP TWO Stir the chalkboard paint until it is thoroughly mixed. If you are painting on plywood or glass, mix your primer first and use the foam brush to apply it to the whole surface. Let dry before moving on. If your surface is already primed, proceed to step 3.

STEP THREE Use the foam brush to apply chalkboard paint to the surface of your board.

STEP FOUR Let the first coat dry, and then apply another coat.

STEP FIVE Once dry, smooth the surface of your new chalkboard with coarse sandpaper, followed by fine sandpaper to eliminate any bumps the brush may have left behind. This also helps prime the surface for use!

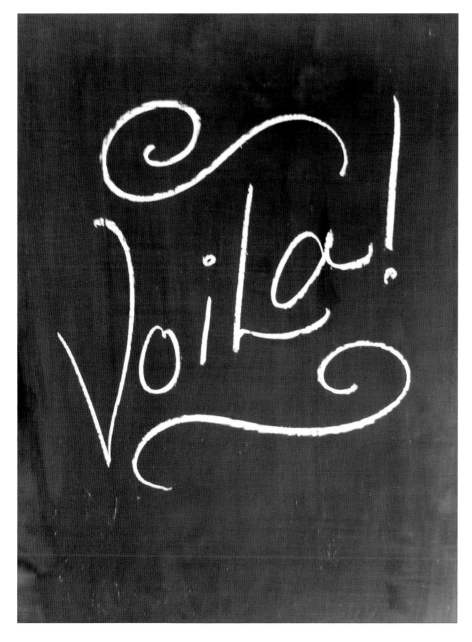

STEP SIX Wipe the chalkboard with a damp cloth to remove the dust. Your new chalkboard is ready to use!

PERPETUAL CHALKBOARD CALENDAR

Make this chalkboard calendar for a cute addition to any wall in your home. There's no need to replace it each year. The grid and days of the week always stay in place. Just erase and update the month and day numbers each month.

MATERIALS

White charcoal pencil

Ruler

12" x 18" chalkboard

STEP ONE Start by using your white charcoal pencil and ruler to section the chalkboard into a grid for the calendar days. Draw seven rows across the board, starting at the bottom. I like to make marks on the bottom row for where my next set of grid lines will go. Use the ruler to draw straight lines for seven columns. Make sure you leave room at the top to write the days of the week and the name of the month.

STEP TWO Write the days of the week across the top of your grid. Each day should fit over a single square and should read graphically. For my weekday lettering, I used an easy, legible hand. You can experiment with styles of writing.

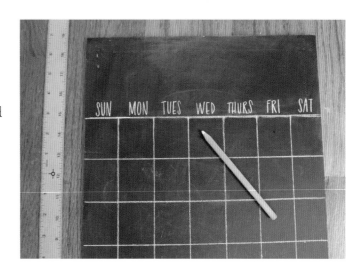

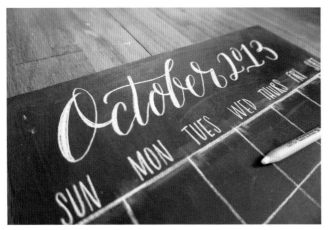

STEP THREE Write the name of the month and the year at the top of the chalkboard. I used a script font to contrast with the lettering I used to write the days of the week. You can imitate my writing here, or you can explore other styles and create something of your own!

STEP FOUR Next fill in the dates with the charcoal pencil, writing each number in the upper left-hand corner of each grid square. Be sure to refer to a finished calendar for reference!

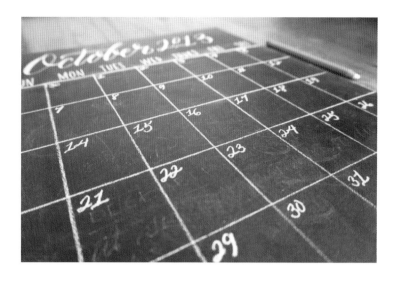

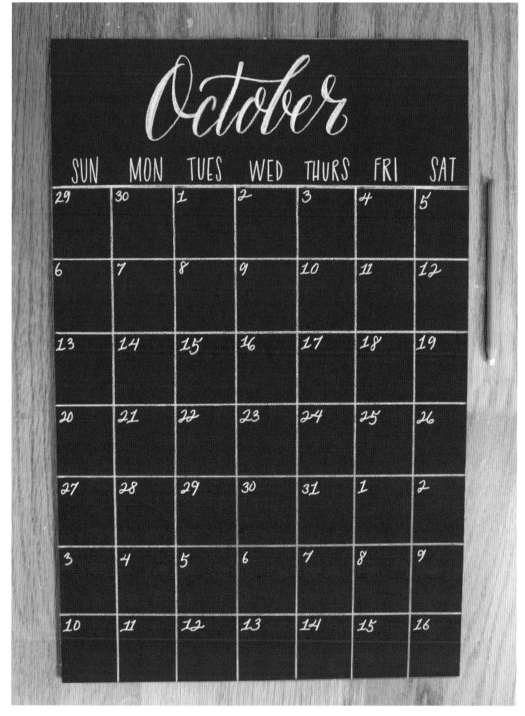

STEP FIVE Your calendar is finished! Find a spot to display it in your home and show off your hard work. Use your charcoal pencil to add appointments or special events.

TIP

When the new month arrives, simply erase the month and the numbered days with a soft cloth. Then add the new details. Try mixing up your lettering styles. You can even add little embellishments, such as swirls, stars, and snowflakes.

DROP CAPS

Drop caps are the large letters often found at the beginning of a book chapter. Traditional drop caps are ornate and flourished. However, modern drop caps can be stylized any way you like, as long as the letter is recognizable. Take the first letter of your first or last name—or your favorite letter (I enjoy drawing Q's)—and create your own personal drop cap. Get as ornate as you like, and reference other styles for inspiration!

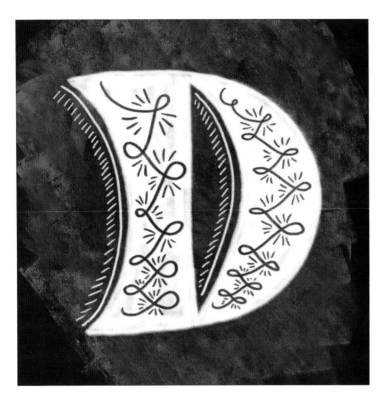
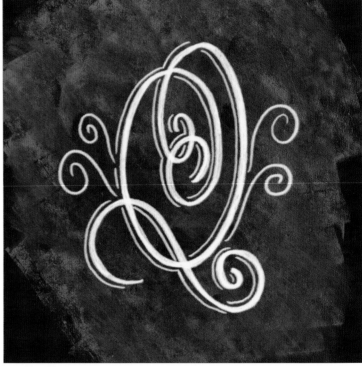

DROP CAP EXAMPLES

Need some inspiration to get started? Try practicing these letters to get your chalk moving and creative juices flowing!

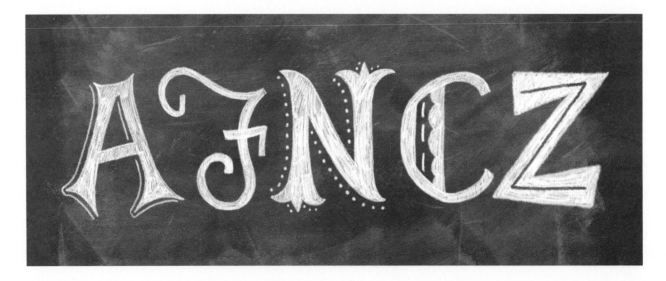

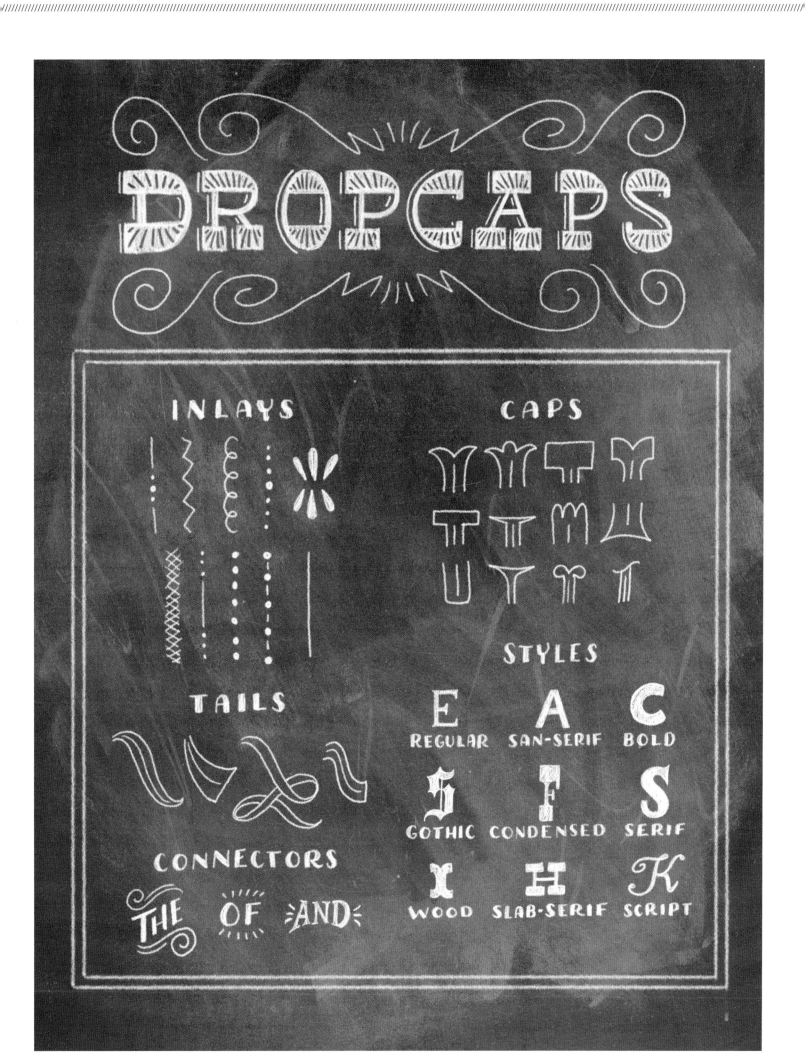

DROPCAPS

INLAYS

CAPS

TAILS

STYLES

E REGULAR A SAN-SERIF C BOLD

S GOTHIC F CONDENSED S SERIF

I WOOD H SLAB-SERIF K SCRIPT

CONNECTORS

THE OF AND

WHAT'S IN A NAME?

Practice lettering your name in contrasting styles. Search books, magazines, and websites like Pinterest to find contrasting lettering styles (e.g. blackletter, script, and retro). Draw your name in each style. Notice how each style varies from the others, and incorporate those differences into your piece.

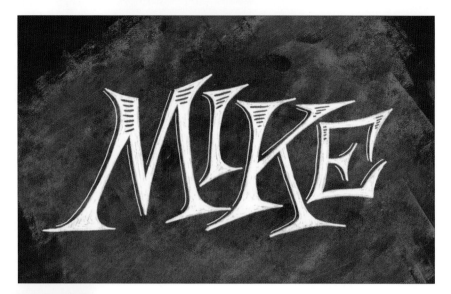

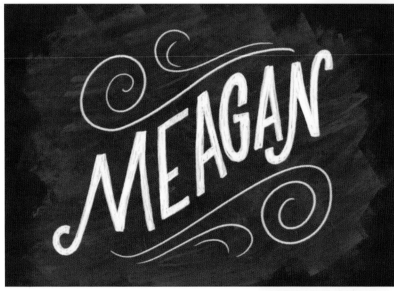

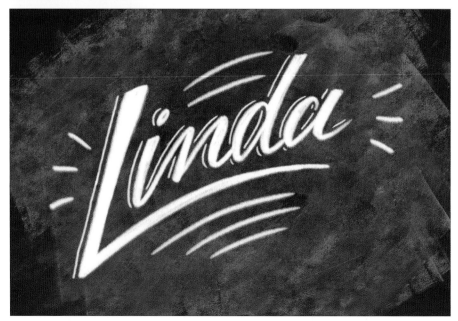

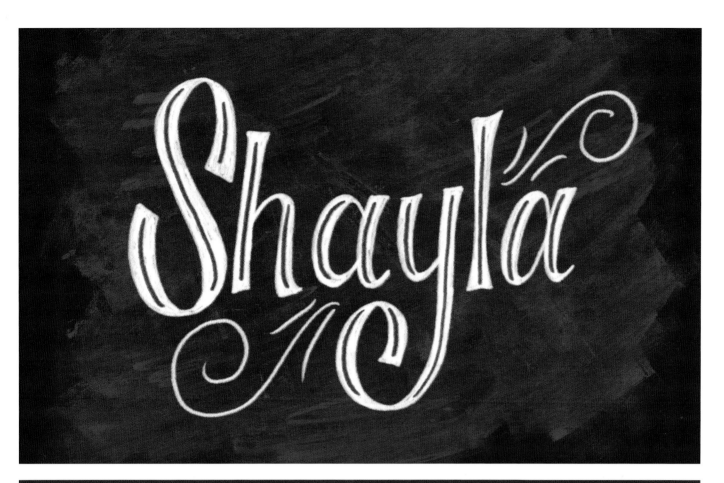

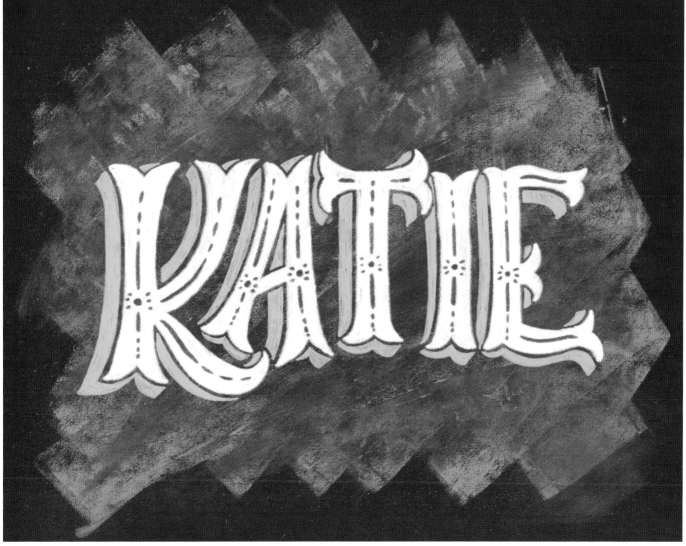

BANNERS & BORDERS

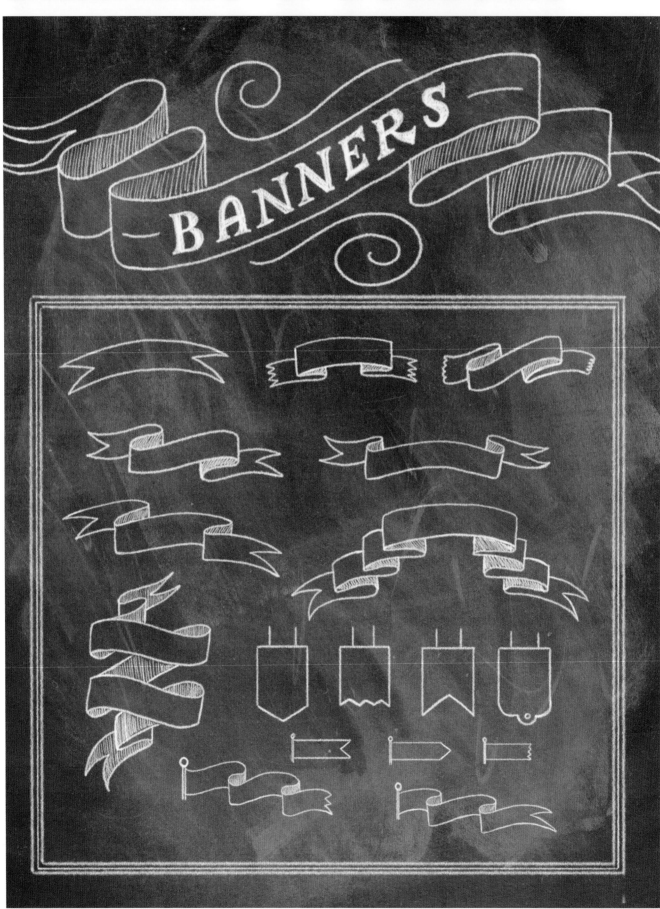

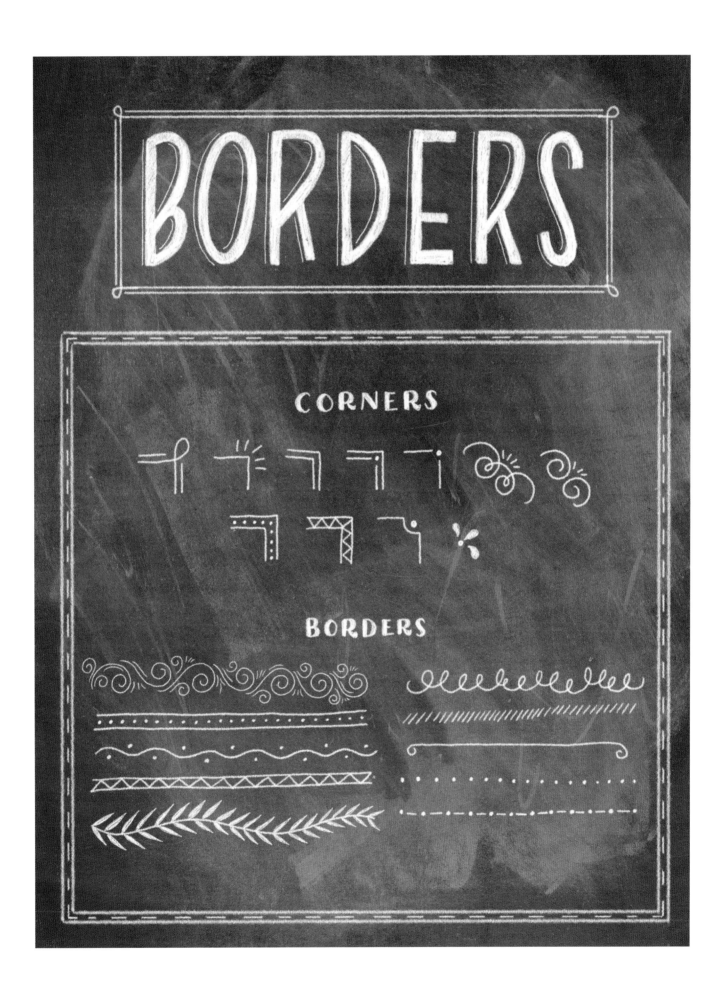

BORDERS

CORNERS

BORDERS

FLORALS & FILIGREE

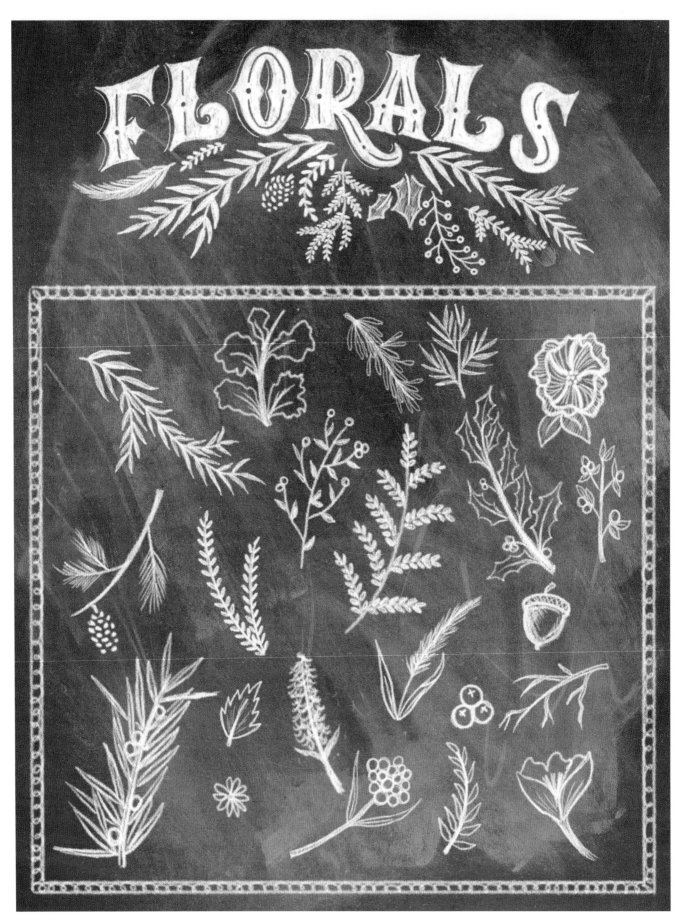

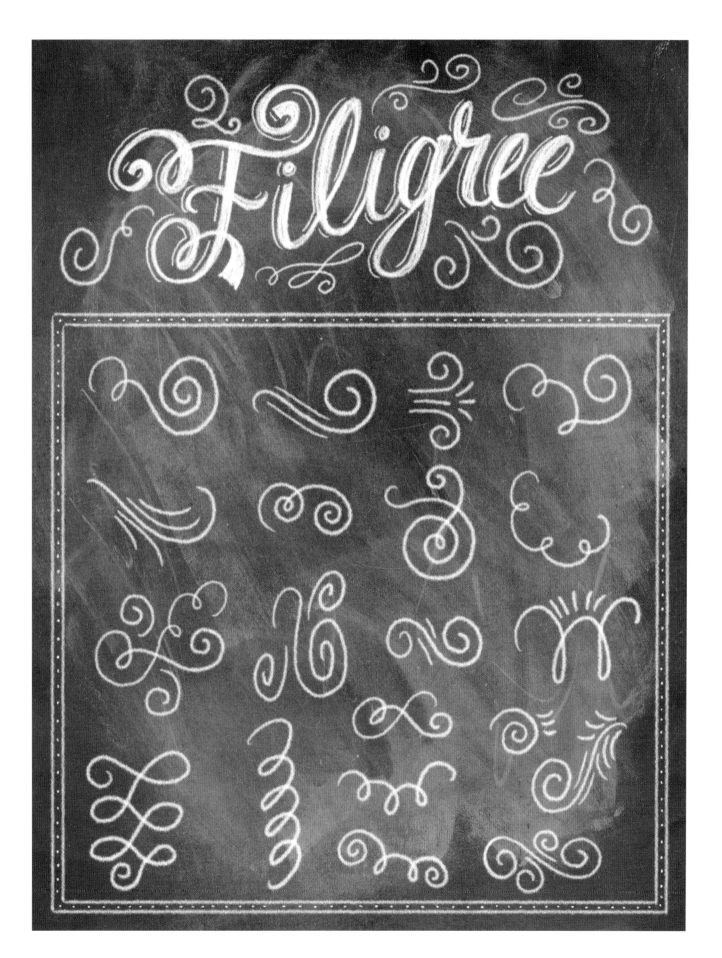

ACCESSORIZE & DECORATE

Now that you have a brand-new, blank chalkboard, just imagine all of the creative possibilities! A chalkboard can be used just about anywhere for just about anything. The sky is the limit!

TO-DO LIST OR MENU

Create a to-do list board for your office or a menu board for your kitchen. Pick some fun phrases, and have fun lettering them. Don't forget to add simple embellishments for extra pizzazz!

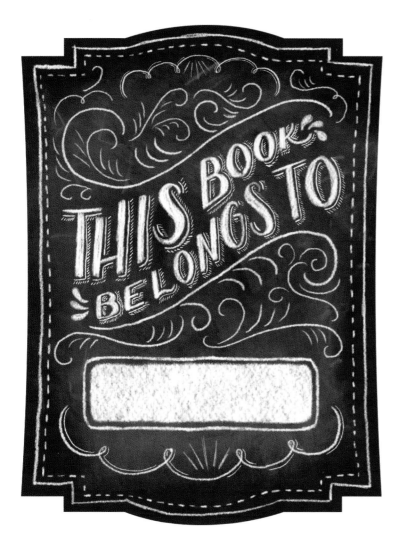

TIP
Break up black-and-white chalk art by using colored chalk to add details, embellishments, and pops of color!

LABELS
Everything in our world is labeled: coffee cans, wine bottles, even office supplies! Design a label to fit on a can or in a book. I've created a coffee can label and a book sticker as examples.

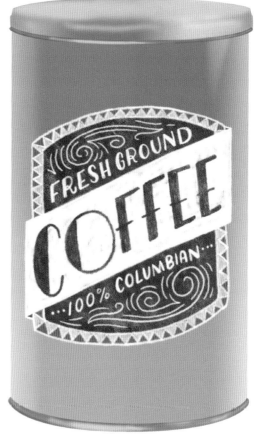

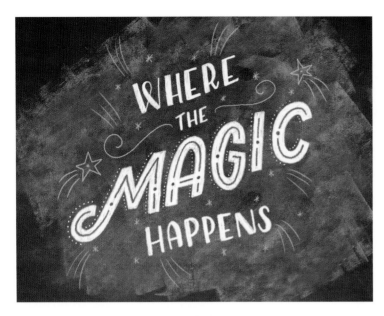

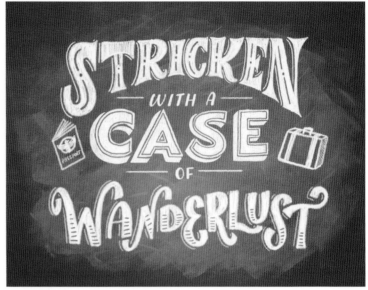

ART ABOVE MY COUCH

Create a lettered piece of art from a phrase or song you love to hang in your living room. The phrase can be anything that brings a smile to your face.

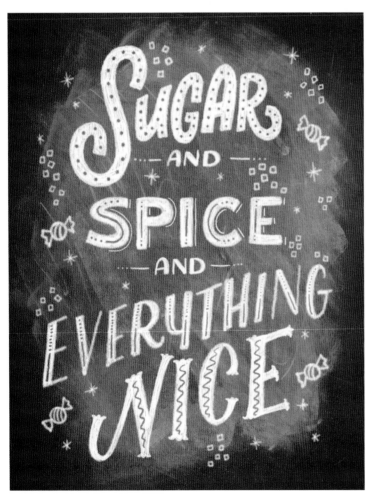

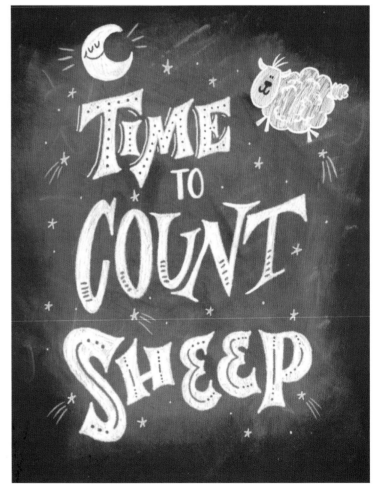

CHILDREN'S ROOM POSTER

Kids need art too! Design a chalk poster for a child's room. If you don't have kids of your own, imagine designing a poster for a high-end children's store or for a friend's baby shower. Make it fun, and explore some new styles!

POSITIVE IS AS POSITIVE DOES

There is nothing like staying positive, even in the hardest of times. Take one of your favorite phrases and letter it as a motivational poster. Keep the work happy and bright!

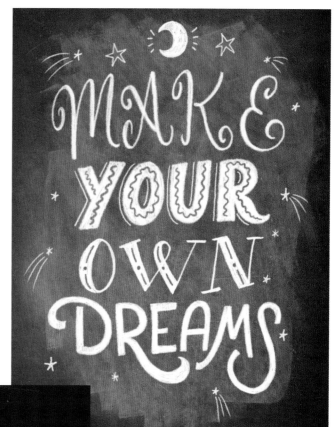

TIP

Chalkboard paint is available in myriad colors, not just black. Try creating a teal, pink, or purple chalkboard!

KITCHEN CHALKBOARD

Design a fun and kitschy chalkboard work of art for your kitchen! You can use anything, from a silly phrase to a recipe to a simple illustration.

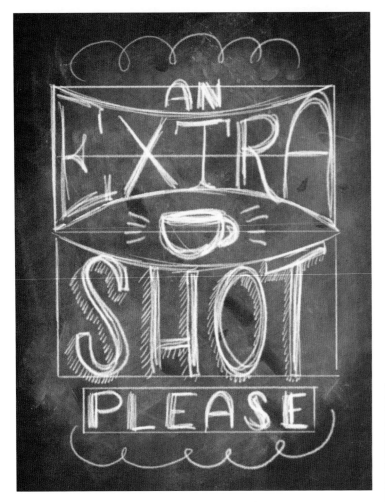

STEP ONE Brainstorm ideas and phrases for your kitschy kitchen art. Since I am a coffee lover, I chose the phrase, "An extra shot please." Sketch some different layouts, and pick the one you like the best. Then roughly sketch it on your blank board. Don't be afraid to make mistakes—that's what your wet cloth is for!

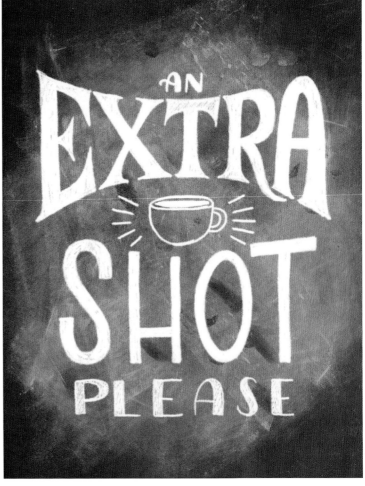

STEP TWO Block in the letterforms. Look at various items or advertisements for font styles and treatment. I like to draw inspiration from vintage labels—in this case, coffee labels. Experiment with the style of the lettering until you are happy with the look.

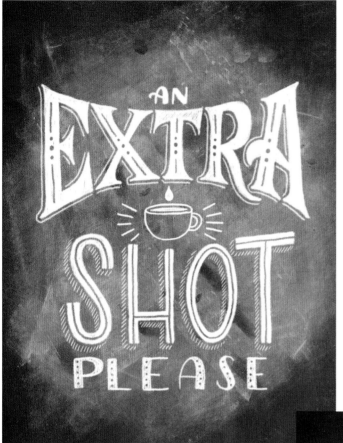

Simple lines can add a great deal of depth and dimension to your letters. Notice how both a solid line and a series of dashed lines make the letters appear to pop out from the board.

STEP THREE Now it's time to add details to your lettering. I added a simple line shadow to "Extra" and another shadow detail to "Shot." I also added some inline details (inside the letters) for an extra punch.

STEP FOUR Finalize your piece by cleaning up your letters, removing any stray marks, and adding in flourishes and extra details. Display your new illustration proudly for all to see!

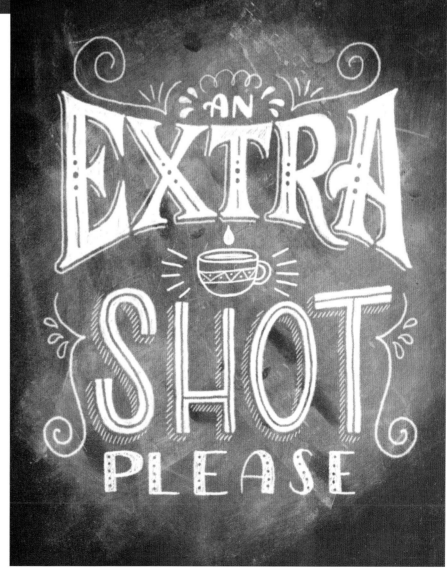

CHALKBOARD SIGNS

In this exercise, we'll experiment with chalk realism, as well as creating gradients. I'm drawing floral elements, but you can choose to include anything you like! To get inspiration for flowers and greenery, take a look at some Victorian references and seed packets.

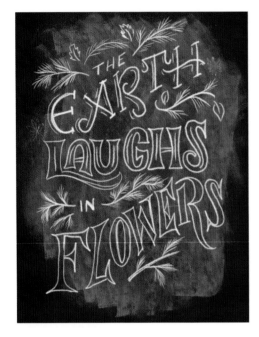

STEP ONE After looking at some reference images for inspiration, lay out a rough sketch on your blank board.

STEP TWO Next block in the letterforms and work on defining the style of the entire piece. To keep the piece feeling Victorian, I kept my letterforms in a serif style and added curves.

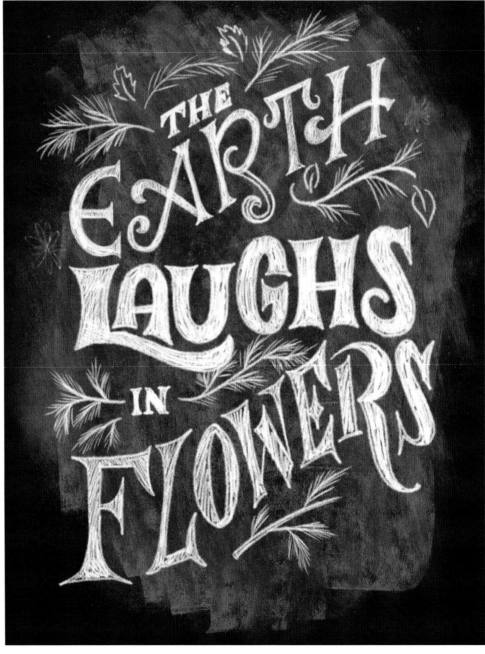

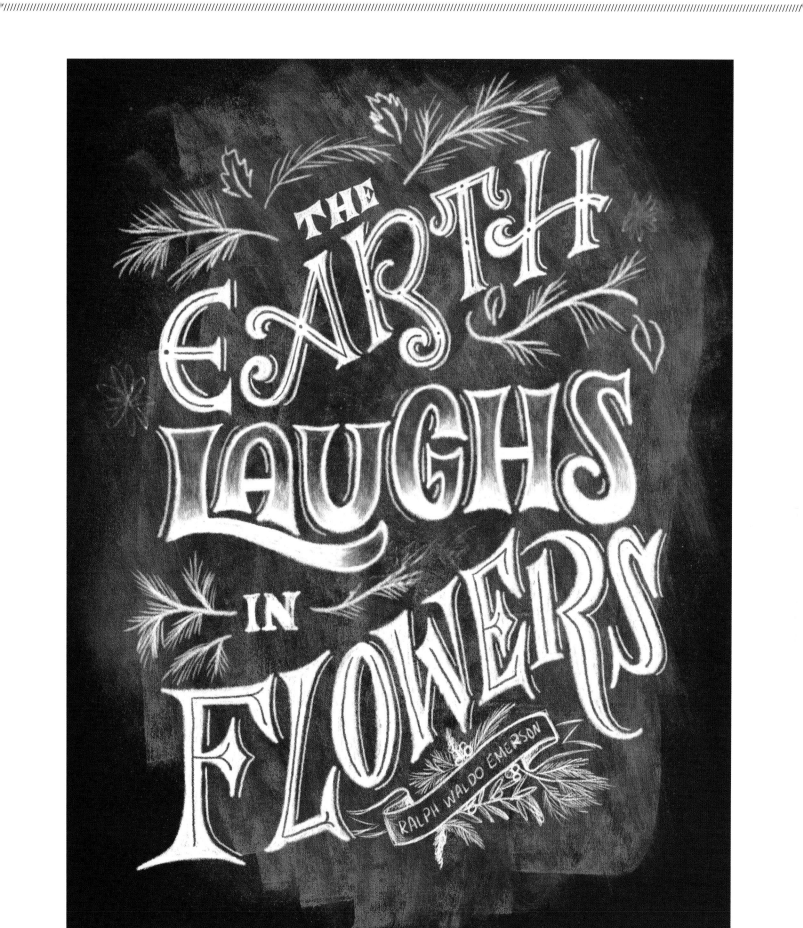

STEP THREE Time to add detail to the lettering. I had a lot of fun in this step by experimenting with gradients in the word "laughs"—something I'd never done before! To achieve a gradient look, wipe away a section of the word and slowly shade in the area with chalk to create a gradual, soft gradient. I also added inline details to "earth" and "flowers" and a line shadow to all the big words. Have fun with this step, and experiment with gradients or other line details!

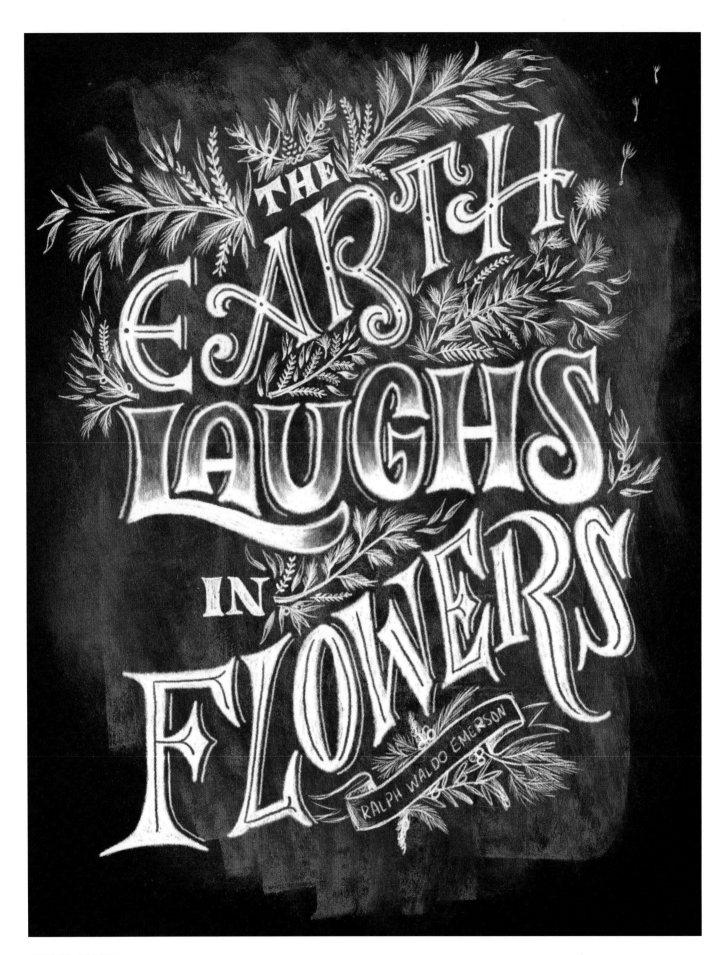

STEP FOUR Once the letterforms are essentially complete, focus on the elements that will tie your piece together. I pulled inspiration from fields of flowers and used various branch and leaf details to highlight the lettering and fill in the negative space. It's very easy to overdo it, so be mindful of what you draw and how much to include.

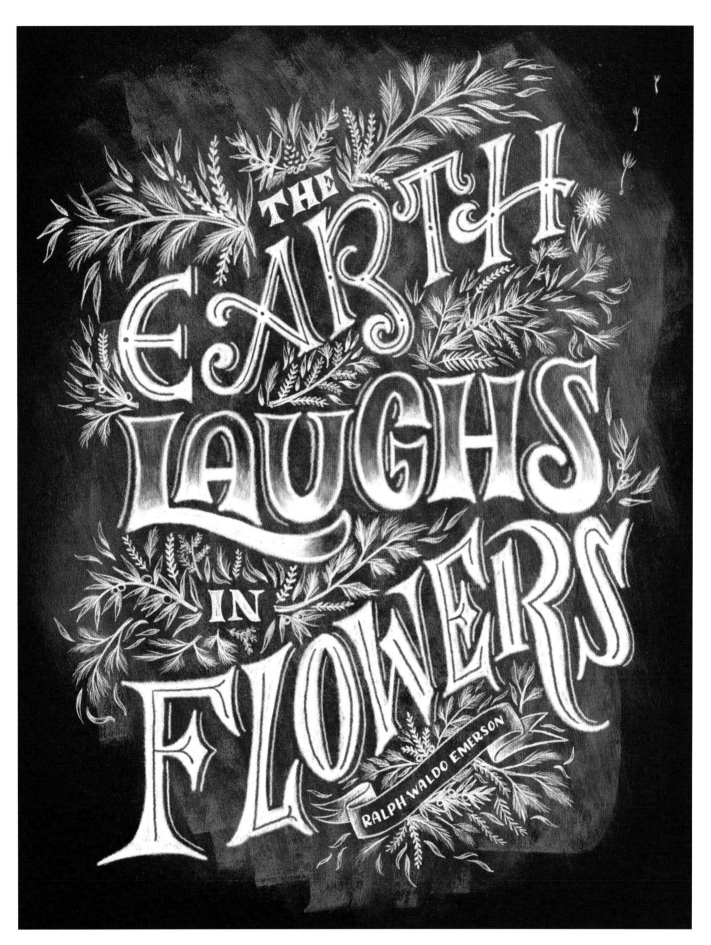

STEP FIVE Finalize your piece by cleaning up any stray marks and adding in any last details. I finished off the branches and added random long leaves to give the illustration some whimsical fancy.

DREAMS

Sometimes I feel like a five-year-old trapped in an adult's body—and as such, I love fairy tales and dreaming. For this project, let's dive into our childhood fantasies and create a really whimsical piece.

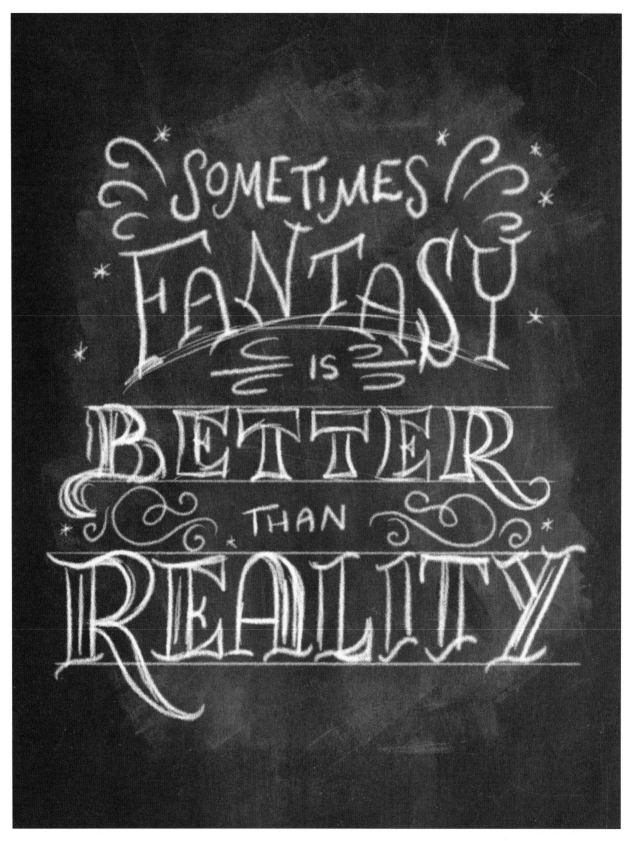

STEP ONE I chose the phrase, "Sometimes fantasy is better than reality." Feel free to come up with your own phrase or use one from your favorite fairy tale! Begin by making a few rough, quick sketches on paper. Then pick your favorite layout, and sketch it onto your board.

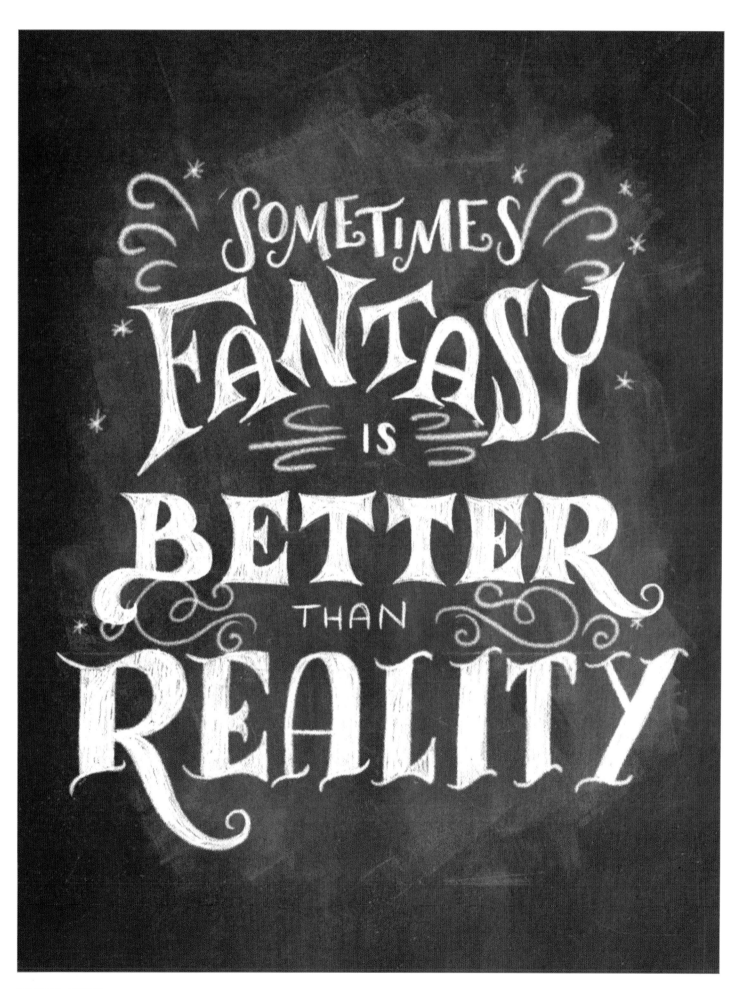

STEP TWO Next block out the letterforms. I used the artwork of Mary Blair and older fairy-tale movies for inspiration. Keep your piece loose and happy!

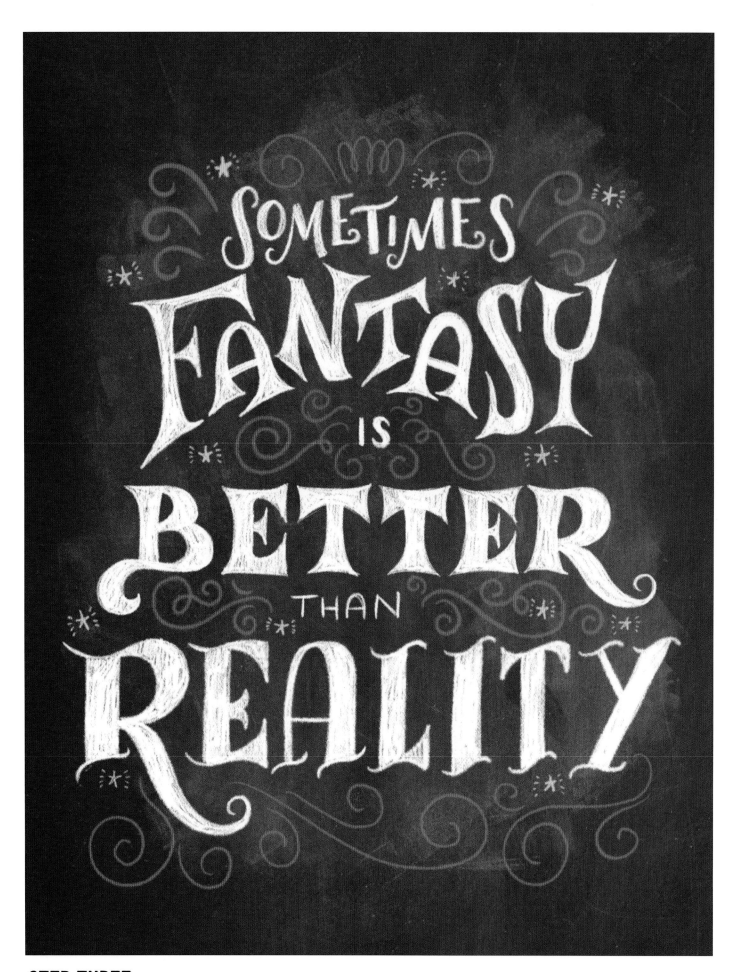

STEP THREE Add in some fun filigree details. Using colored chalk can take a piece from "Eh" to "Oh, wow!" in a heartbeat.

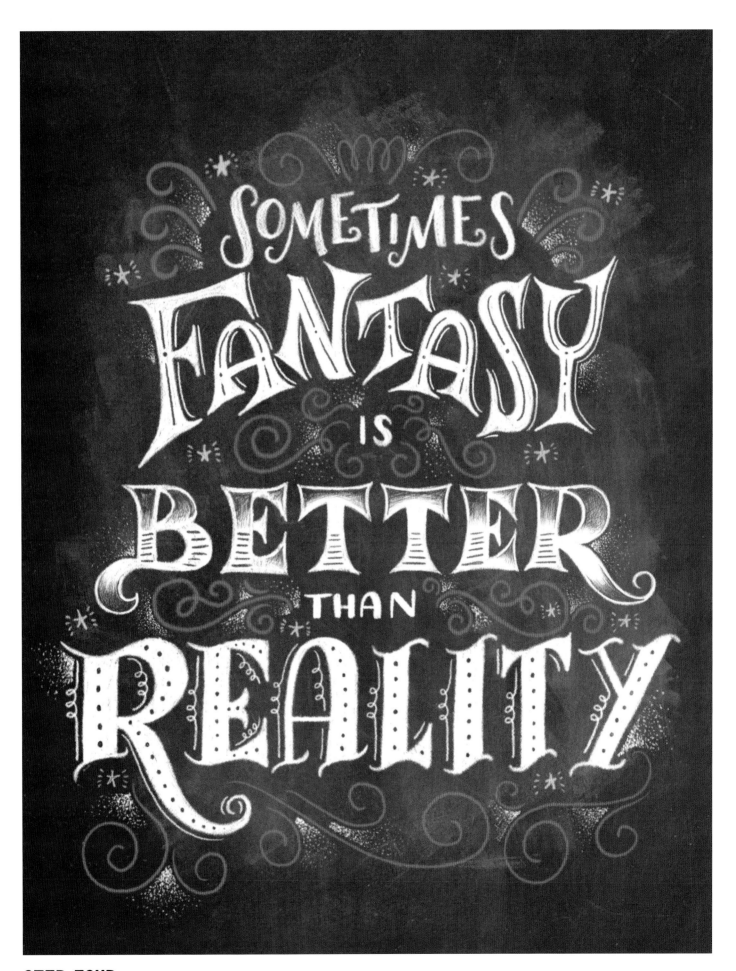

STEP FOUR Start adding details to your lettering. There are no rules in this step! I added swirls and gradients, as well "pixie dust" to the curves and filigree. Just experiment, and have fun! If you add something and it doesn't work, simply erase it and try again.

PART 3
CREATIVE LETTERING PROJECTS

Chapter 9

LETTERING ARTS & CRAFTS

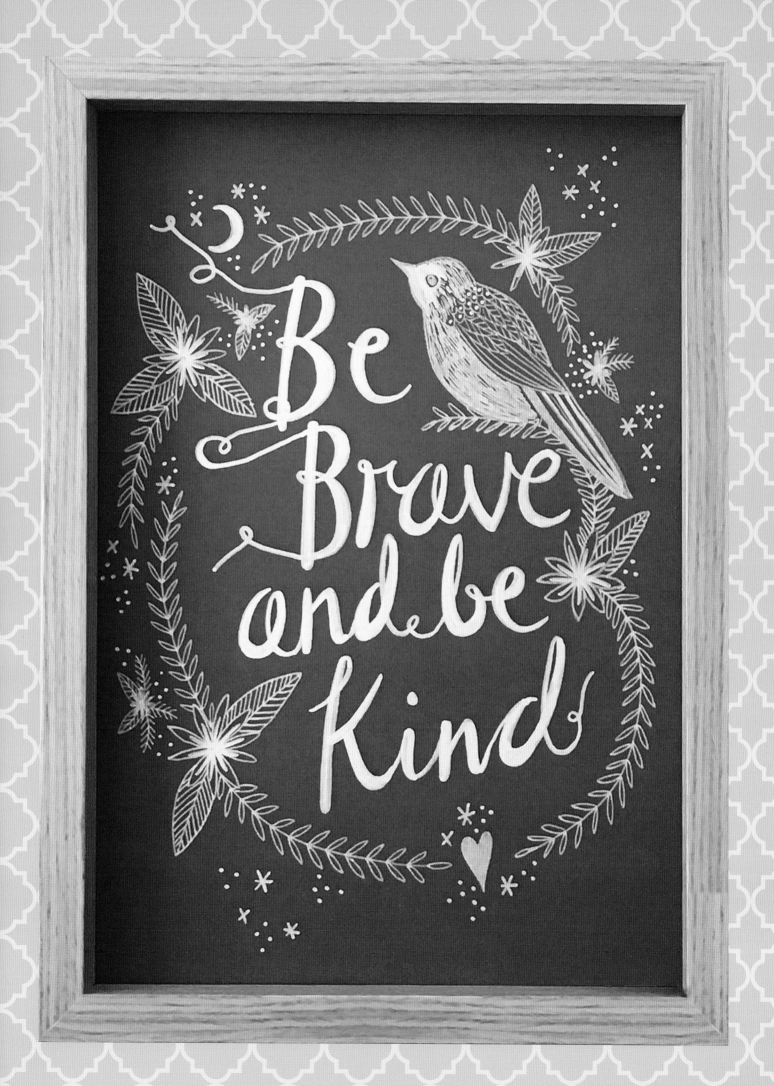

PERSONALIZED JOURNAL COVER

Whether you're an artist, a student, or a working professional, a notebook or journal can help you stay organized. It's also a great place to doodle and brainstorm creative new ideas. A journal with a personalized cover created by you makes a great gift as well. Here you'll learn how to make your own little work of art using a journal cover.

MATERIALS

Pencil

Scratch paper

Permanent markers with different nib widths and in different colors, including white

Tracing paper

A journal with a cover you can draw on

STEP ONE Think about the person for whom you're creating this journal. How do you want to write his or her name, and what is this person interested in?

Sketch your ideas on a sheet of scratch paper. Try embellishing the person's name with flourishes and details from his or her hobbies.

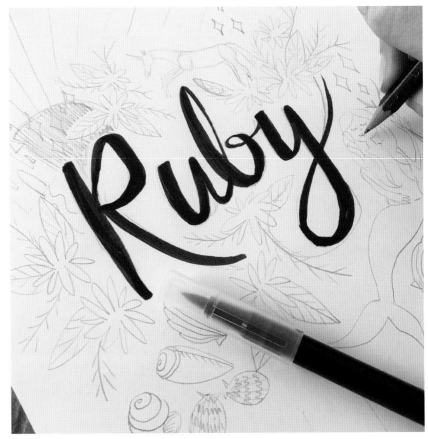

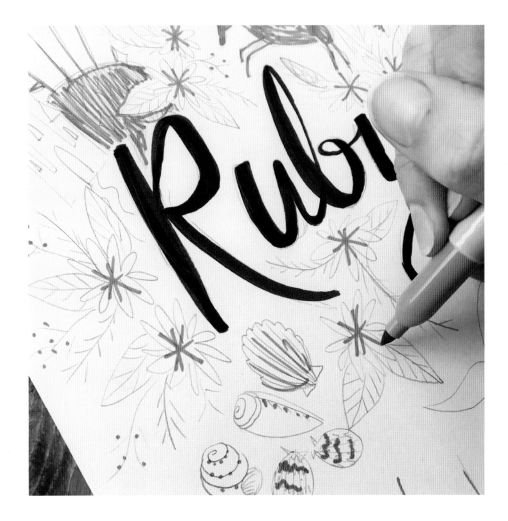

STEP TWO Now think about where you might want to add color and further details. I like to use a limited color palette, so I've chosen pink and black to add contrast to the journal's cover. When I'm almost finished, I'll use a white marker to add highlights.

STEP THREE If you're confident about your drawing skills, go ahead and copy your hand-lettered art directly onto the journal cover using a pencil.

Or, on a sheet of tracing paper, trace over your sketch with a pencil. Then turn over the tracing paper, and draw over the sketch again on the back side. By turning the tracing paper right-side up again and pressing on it using a bone folder or a pencil, you will create a faint print on the journal cover. Use this as a guide.

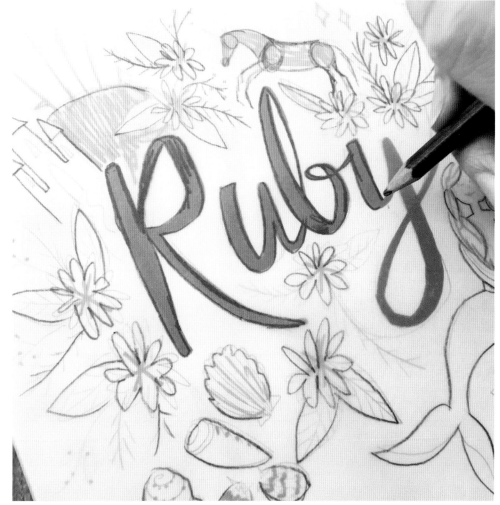

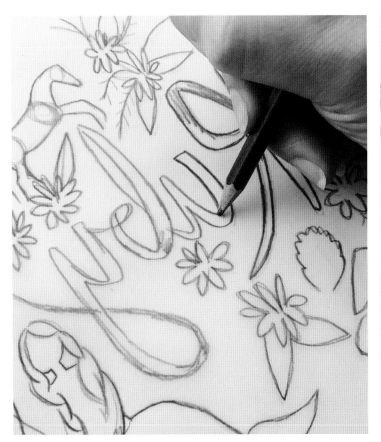

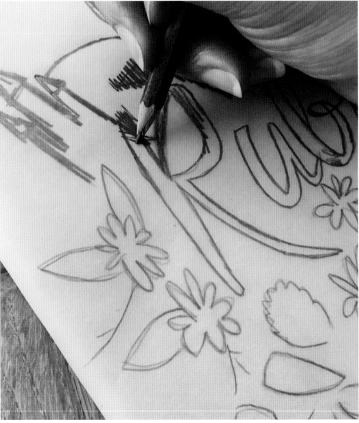

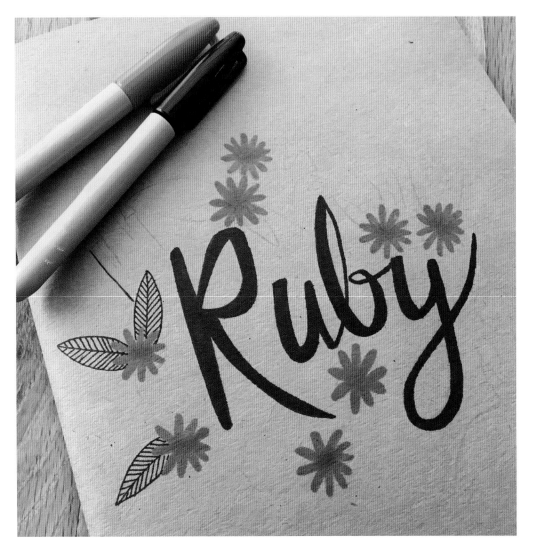

STEP FOUR When you're ready to add color, start with the name. Work outward from there, adding any larger design elements. Use markers of different thicknesses to create a variety of lines.

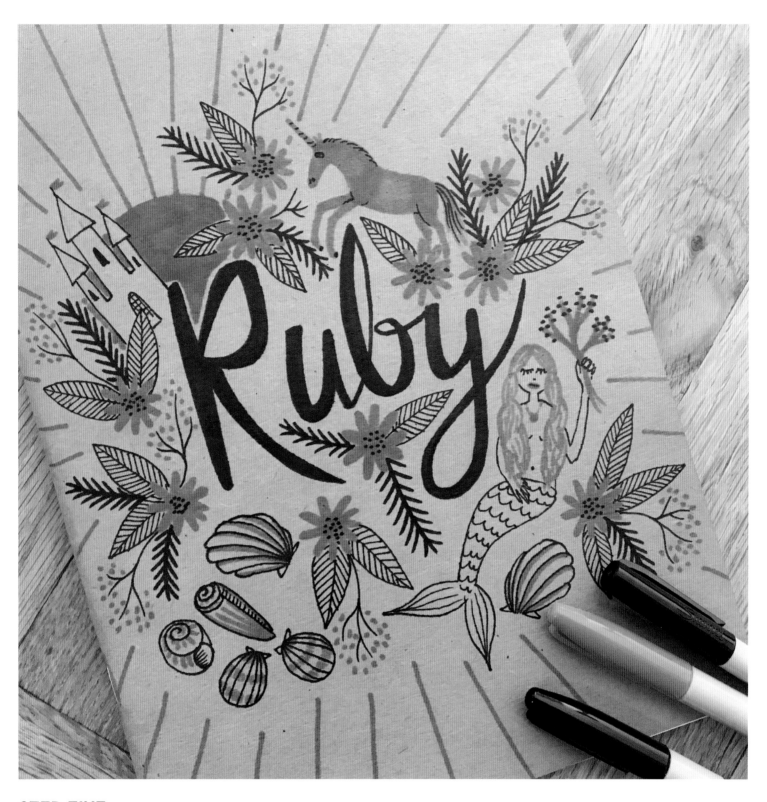

STEP FIVE Once you have the larger parts of the design in place, add your details. Your hand-lettered art will really start to come together now!

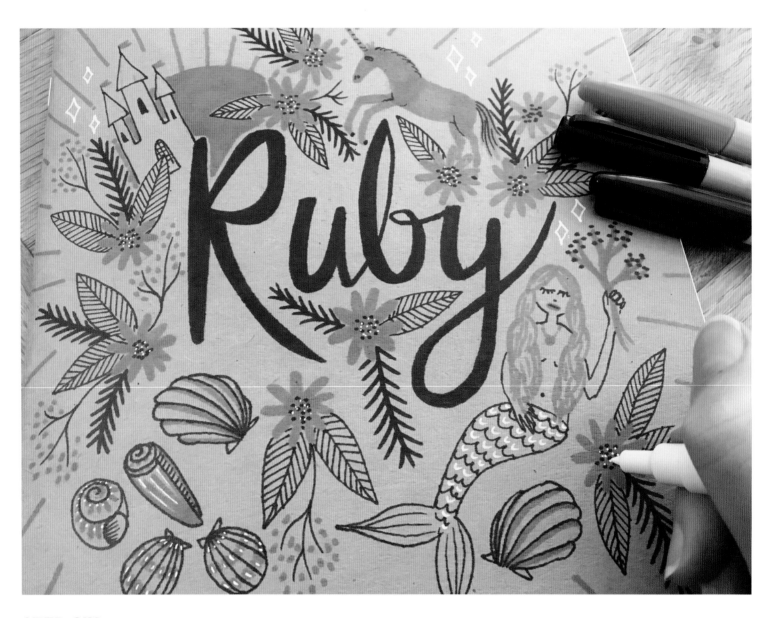

STEP SIX Use a white pen to add a few highlights and details, and then fill your personalized journal with your own hand-lettered art!

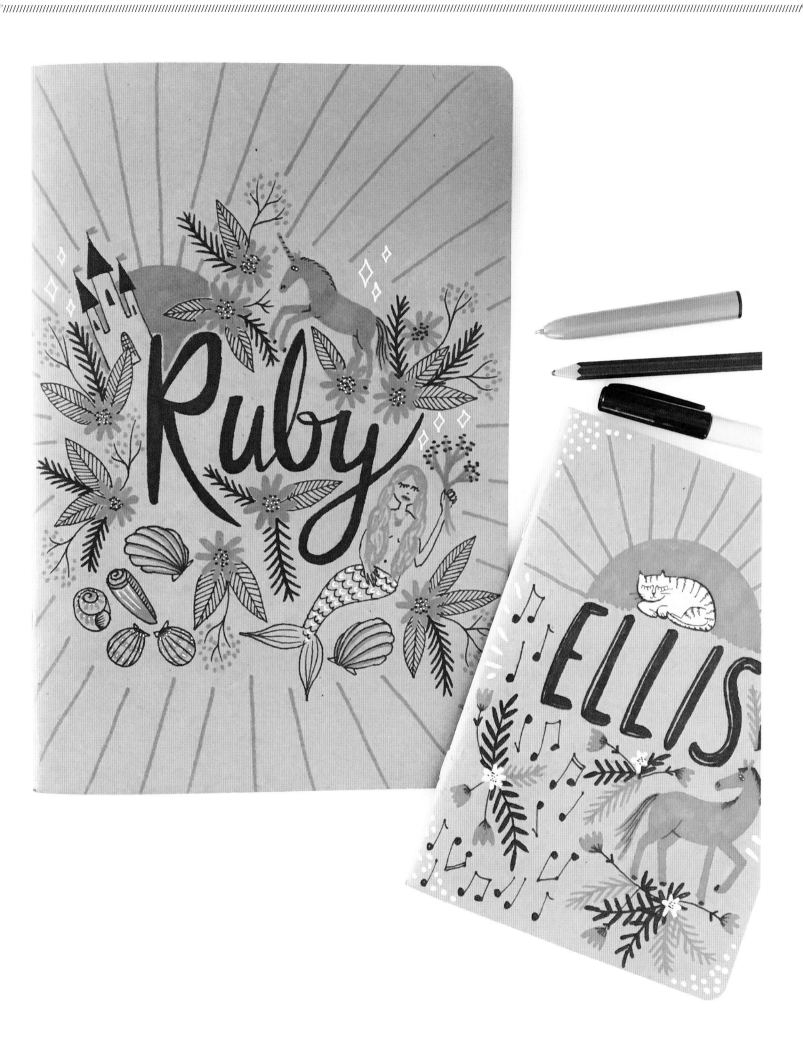

QUOTABLE ART

Hand-lettered art featuring an inspirational quote makes for a beautiful wall hanging, and if the quote inspires viewers, that's even better. Think of it as a pep talk every time you pass your handcrafted artwork!

MATERIALS

Sheets of scratch paper

Pencil

Tracing paper

Sheet of dark blue paper

Gold and silver markers

Jewel-toned sheets of paper look beautiful with gold and silver markers.

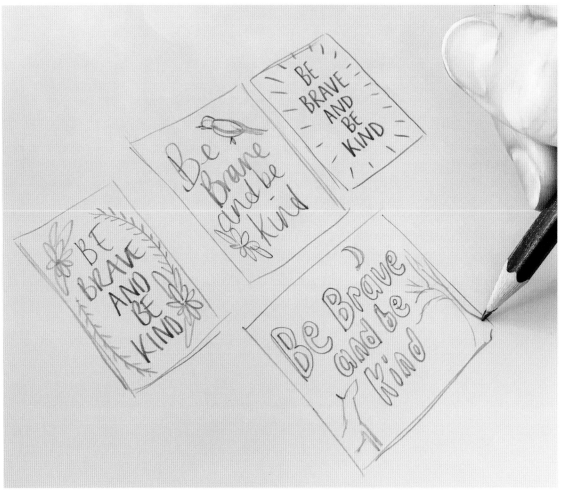

STEP ONE Do a bit of research, and find a quote that means something to you. Maybe you'd like a little motivation or a motto for your everyday routine? Using various lettering styles, do some thumbnail-sized sketches of the quote you've chosen, and see which lettering style best suits the piece you want to create. Try laying out the quote in different ways.

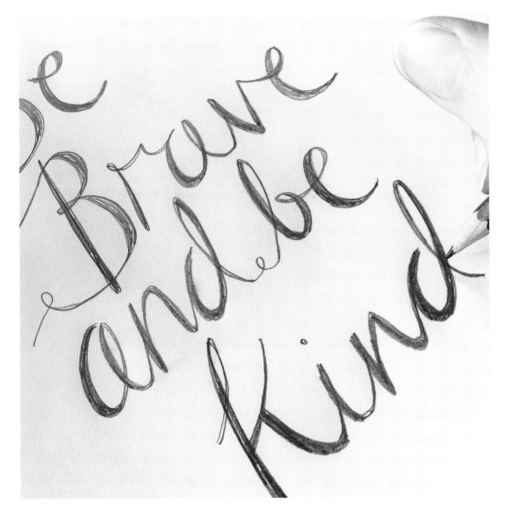

STEP TWO Once you've designed a layout that you like, create a more finalized sketch in the size that you want your final artwork to be. Take your time; you want your quote to be legible as well as artistic, and it can take some practice to increase a sketch from thumbnail to full-size.

STEP THREE Create a border around the letters in your sketch. You want the words to stand out, so keep the border fairly simple and decorative. I drew shapes inspired by nature, including a simple bird, and then added stars and a moon for a little touch of magic!

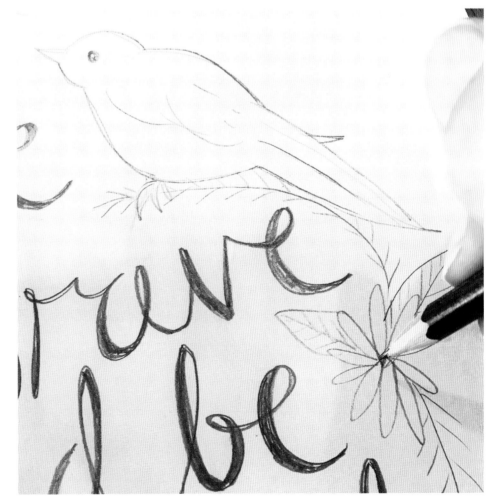

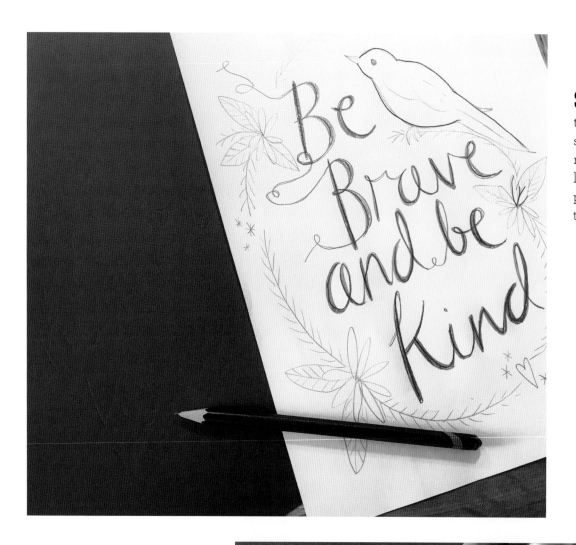

STEP FOUR You can now transfer your drawing onto a sheet of colored paper. If you need guidelines, make some light sketches, or use tracing paper. (For a refresher on using tracing paper, see page 225.)

STEP FIVE Use one of your metallic markers to hand letter the quote.

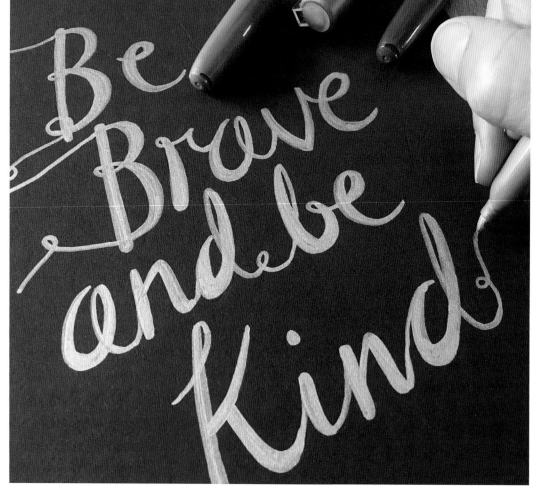

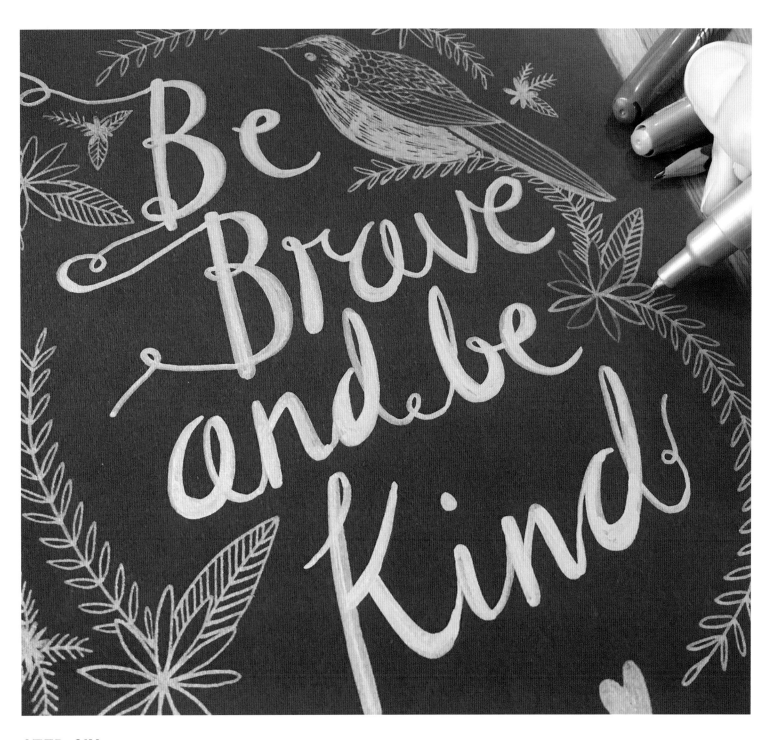

STEP SIX Add the decorative border using the other metallic marker. Skip some of the finer details, such as the stars and floral elements.

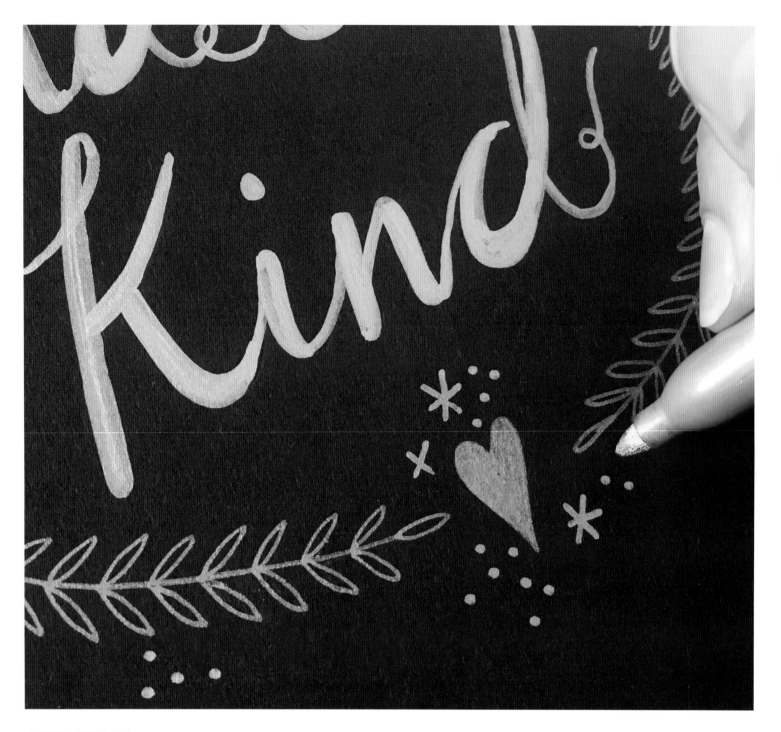

STEP SEVEN Using the same marker that you used to hand letter the quote, add the final details to delicately tie in the color of the quote with the border.

STEP EIGHT Frame your art piece, and feel inspired every day!

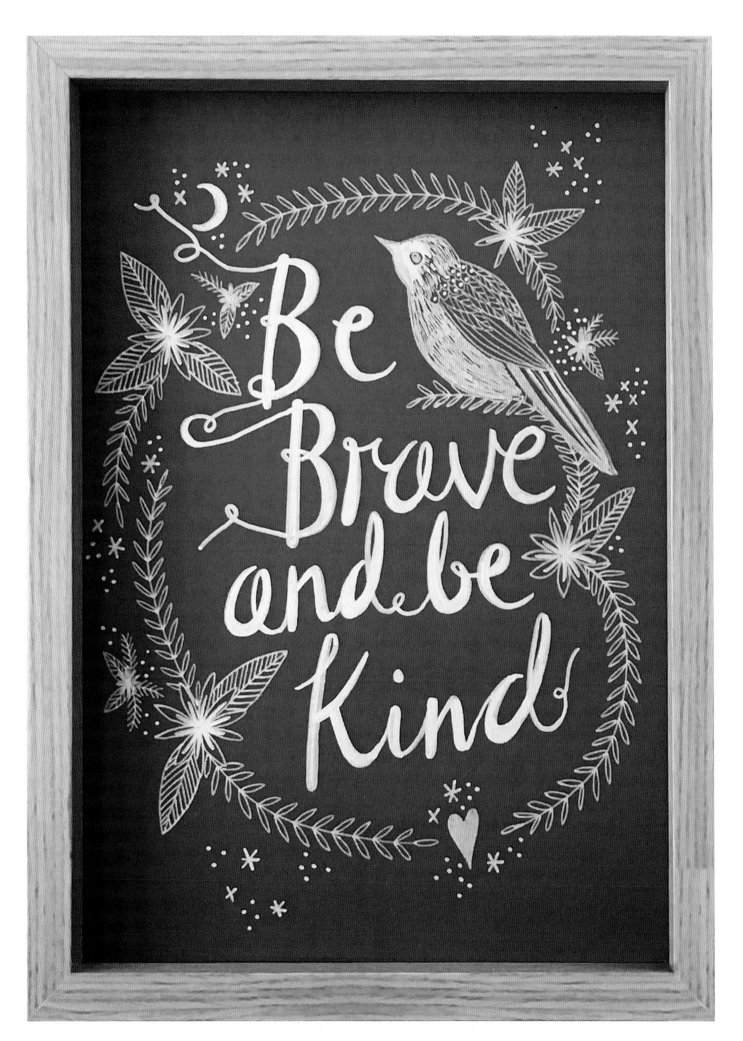

CALLIGRAPHED PLACE SETTINGS

Using kraft paper as a tablecloth, create a whimsical and fun alternative to boring ol' place cards. Unique, beautiful, and cheap, try this out the next time you host a party or gathering!

MATERIALS

Kraft paper*

Pencil

Ruler

Scissors

Paintbrush

Black acrylic paint

Black marker

White fine-point paint marker

White broad-point paint marker

Dinner plate

*Note: Select the width of your kraft paper according to your table's dimensions and your chosen design (e.g. full tablecloth or runner).

STEP ONE Unroll the kraft paper and cut to your desired length. Map the location of each place setting, and measure and mark where the plate will sit. Then, using a dinner plate as a template, trace the circle in black marker at each place setting.

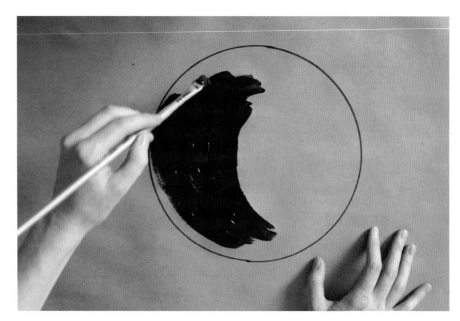

STEP TWO Carefully paint the circle with black acrylic paint, and allow the paint to dry completely.

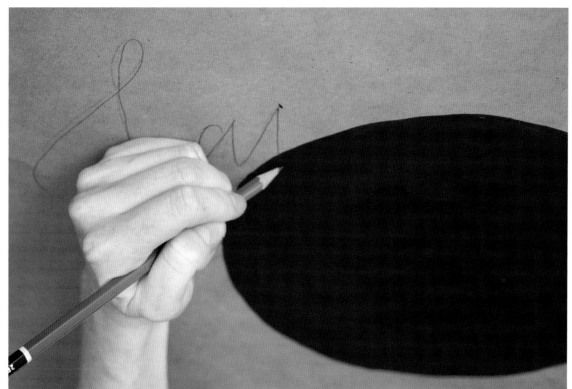

STEP THREE
Using a soft pencil (such as a 2B), lightly draw in the name of a guest above each painted circle.

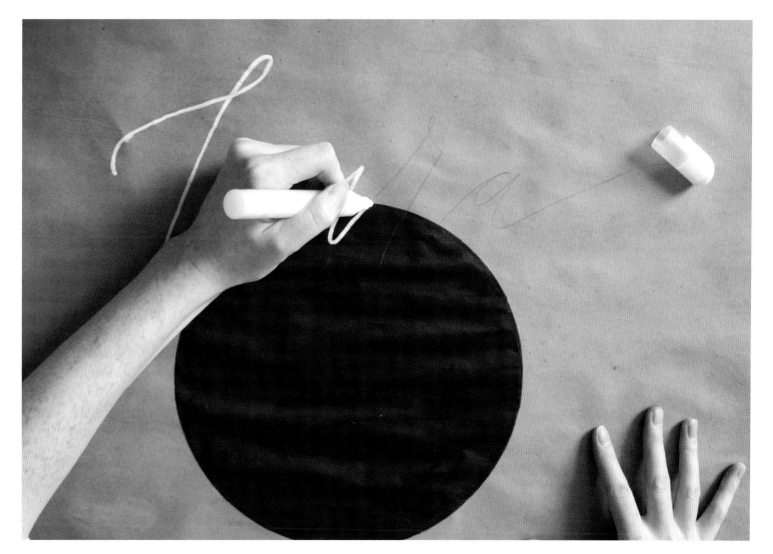

STEP FOUR Use a white fine-point paint marker to trace over the pencil lines.

TIP

Determine the placement of each downward stroke by looking at the letter and noting each place where you would pull your pen down if you were using a traditional calligraphy pen and nib.

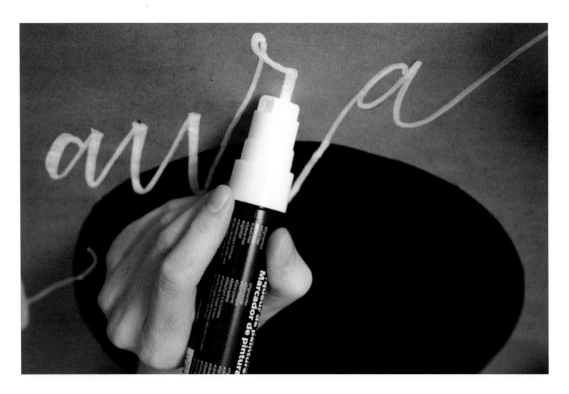

STEP FIVE To create a calligraphy look, use a white broad-point paint marker to go over each letter's downward stroke to make a thicker line weight.

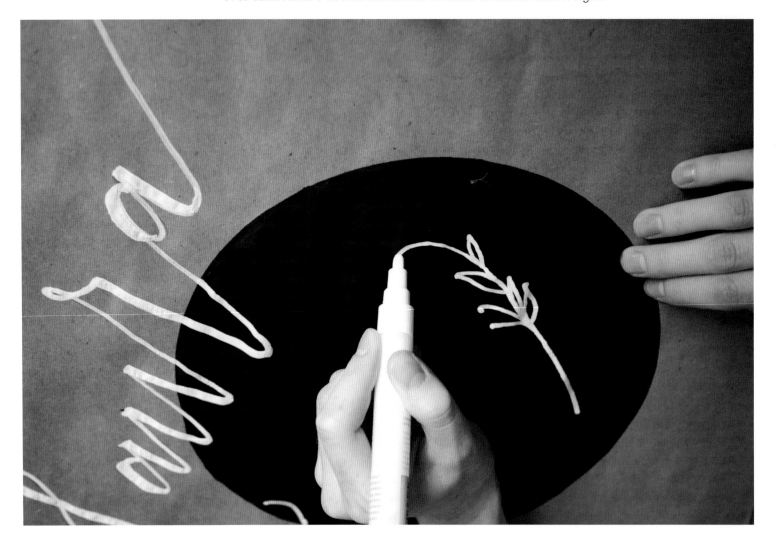

STEP SIX Design a graphic illustration or whimsical flourish, and add it to each painted plate with a white paint marker.

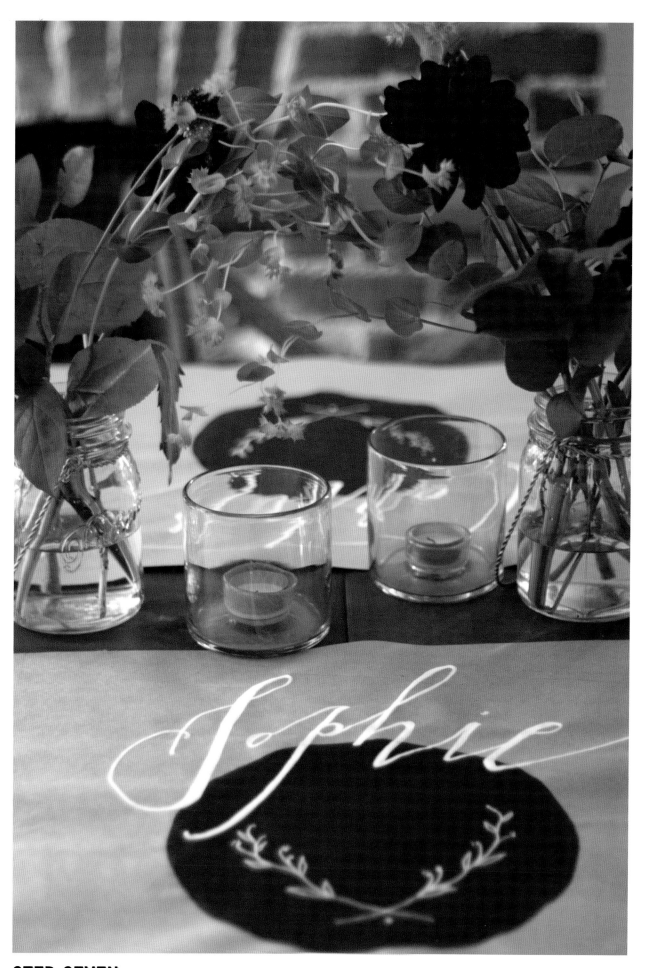

STEP SEVEN Add flowers and candles to dress up the table, and throw a party!

Also available from *Walter Foster Publishing*

978-1-63322-104-8

978-1-63322-486-5

978-1-63322-137-6

978-1-63322-192-5

978-1-63322-172-7

978-1-63322-343-1

Visit www.QuartoKnows.com